The Life, Art, & Music of Daniel Johnston

By Tarssa Yazdani & Don Goede

The Life, Art, & Music of *Daniel Johnston*

Copyright © 1999-2006 by Tarssa Yazdani & Don Goede
All rights reserved
No part of this book may be reproduced without written permission of the authors.

First Edition of 3,500 published by Soft Skull Press, January 2000 under the title:
Hi, How Are You? The Definitive Daniel Johnston Handbook ISBN:1-887128-41-7

Second Edition published by Smokemuse and Last Gasp November 2006

Last Gasp of San Francisco
777 Florida St.
San Francisco, CA 94110
www.lastgasp.com

Smokemuse
218 W. Colorado Ave. Ste. 103
Colorado Springs, CO 80903
www.smokemuse.com

Printed and bound in China by Prolong Press Limited
Distributed to the trade in the USA by SCB Distributors
Distributed in the UK and Europe by Turnaround Publisher Services

ISBN-13: 978-086719-667-2 ISBN-10: 0-86719-667-X

Credits:
Conception by Don Goede
All drawings and paintings used by permission
All Daniel Johnston songs published by Primary Wave Music Publishing
All photographs © each individual photographer
Cover and book layout by Don Goede
Second edition editorial management by Liza Tudor
Second edition layout assistance by Ashley Bowran

Special thanks to: Kat and Bob Tudor, Dick Johnston, Bill and Mabel Johnston, Jordy Trachtenberg, Jeff Tartakov, Ron English, Jeff Feuerzeig, Henry Rosenthal, Jeff Brivic, Joshua Keller, Jeana Farrell, Delaney Utterback, Vicky Gregor, Justin Kovach, and Brian Arnot.

For Mom, a big Daniel Johnston fan.
-T.Y.

For Daniel, thanks for the memories.
-D.G.

Daniel Johnston in Virginia, 1999

Don Goede

Table of Contents

Forewords
Don Goede, Ron English, Kramer — ix
1. **Introduction** — 1
2. **Personal History** — 5
3. **Creative Beginnings** — 33
4. **Mature Mythology** — 41

Color Art Section — 59

5. **Cult Phenomenon** — 67
6. **Collaborative Music & Art** — 81
7. **Visual Art** — 91
8. **Continued Story** — 101
9. **On the Road** — 107
10. **The Devil & Daniel Johnston**
 Interview with Jeff Feuerzeig — 135
11. **Walking the Cow** — 153
 By Andrew Hultkrans

Comics — 165

12. **The Notebooks** — 173

Doodles — 196

13. **In Daniel's Words** — 203

Discography — 220
Gallery Listings — 223

Don Goede and Daniel Johnston in Berlin

Henning Ness

Jack Medicine and Daniel Johnston jamming

Ron English

Wow! So much has happened since *Hi, How Are You? The Definitive Daniel Johnston Handbook* came out in 2000. After a series of book release parties and great visits with Daniel in New York, I became his tour manager and caretaker, a positon that seemed to come quite naturally. It didn't hurt that I thought the world of his parents, Bill and Mabel Johnston and Dan and I got along great (quickly solidified as friends after my initial visit to Texas in early 1999 to do research for the book). We always made time to do funs things together like comic book and record shopping and there was always time for song writing and just plain goofing around. I always made sure he slept and ate properly and that his medication was regulated. Our on the road adventures lasted almost three years and in Chapter nine you will find our travels documented with photographs and various memorabilia I saved after all these years.

For this expanded edition I also interviewed Jeff Feuerzeig, the director of *The Devil and Daniel Johnston*, about his recently released documentary celebrating Daniel's tumultuous and fascinating life. Back in 2001 Jeff called me and told me of his plans to go down to Waller, Texas where he hoped to spend some time filming Daniel and his family. He asked me if I would call them and put in a good word for him. The love Jeff had for Daniel's music and art was apparent both in the way he spoke of him and in the vision he had for his film. I had met Jeff months earlier, and I quickly realized that he and I shared a common love for Daniel's music and art. I have to say the documentary is quite beautiful and amazing. I had the pleasure of watching the film's premiere at Sundance with Daniel and his family and while I was crying, Daniel sat there laughing! He told Jeff later that he thought it should have a laugh track added. At any rate, I am sure it will help solidify Daniel's place in the art and music world. If you haven't seen the film, I highly recommend it. The perplexities of Daniel's mental illness (manic depression or bipolar disorder) are handled with sensitivity and love.

Daniel is one of the most honest artists and musicians I know, and I consider myself very lucky to have been even a small part of his life. It has been my absolute pleasure to add hundreds of new photos and images of Daniel's artwork to this book. You see, when the first edition came out, I was only privy to a sliver of Daniel's notoriety and story. I was a huge fan of about five of his albums (*Yip/Jump* is one of my favorite albums of ALL time), but I only found out about his art world when my co-worker and partner at Soft Skull Press, Sander Hicks, told me that Daniel was performing and having an exhibition of art with Ron English at CBGB's Gallery in Manhattan. I completely freaked out (as I knew Daniel shows were rare), withdrew $500, and went to the gallery. I was completely blown away by Daniel's artwork. It seemed as if the work came straight from his music. I talked Jonathan LeVine, CBGB's curator at that time, into selling me some of Daniel's work before the show opened. I didn't have the nerve to stick around after the performance, but I do remember going home that night in a state of Daniel euphoria and searching the web voraciously to find out whether any books had been written about him. I couldn't find a single one, and the next thing I knew, I was talking to Ron English in his Tribeca loft and putting together a proposal with his writer wife, Tarssa Yazdani. This edition includes the original text from the book by Tarssa, to whom I am extremely grateful. Not only did she get this whole story started, but she has also helped update her chapters for this edition. Also, if it hadn't been for her husband Ron, I don't think I would have met Daniel in the first place. Whether as partner in our band the Hyperjinx Tricycle, or painting the cover for Dan and my side project CD *The Electric Ghosts*, Ron is part of my story with Daniel, for sure. He is now a good friend and I will always be indebted to him. Anyway... I think it's time for me to stop writing and get this book to the printer!

Happy looking and reading.

Don Goede
(a.k.a. Jack Medicine)
August 2006

Daniel Johnston & Ron English in Virginia, 1999

Matt Groening, Ron English, & Daniel Johnston in Los Angeles, 2000

I met Daniel in the usual way. It was 1984 in Austin, Texas. My sister Susan had made friends with this odd singer/songwriter fellow. She played me some of his music. I liked it and told her I would like to meet him. Maybe I could provide him with some art for his next CD cover. Susan didn't want me meeting her new friend. Daniel Johnston was this fragile, sensitive, magical, artistic being who reverently worked at McDonald's, while I on the other hand was this wild, reckless outlaw rabble rouser who illegally painted billboards mocking McDonald's. Daniel would surely find someone like me upsetting. Daniel was Austin's little secret, but Austin was a small town and our meeting was inevitable. I was walking down the main drag with Susan and some friends when we spotted Daniel randomly handing out tapes to a line of hipsters in front of a club. Before Susan's reluctant attempt at an introduction, Daniel handed a tape off to me and introduced himself, "Hi, My name is Daniel Johnston, I'm the songwriter of the year." We were headed for a pizza parlor so we invited Daniel along, and Susan's trepidations were quickly eased as Daniel and I lagged behind the crowd enthralled in our own conversation about comics and our own universes of cartoon characters. We were instant friends; after all I have a sensitive artistic side and Daniel, as I soon discovered, could be pretty wild.

In all fairness, my sister Susan's trepidations were valid. She understood Daniel was in the beginning stages of mental illness and that I did regularly recruit people to go out on unlawful billboard raids, an activity probably not well suited for Daniel. I was always careful who I invited on my adventures. I wasn't completely unaware of mental illness. My grandfather had been in and out of mental hospitals. Seven people in my communal house of twenty were committed during the course of one semester. It was an inescapable part of life. My relationship with Dan was centered around drawing, music, matching imaginations. I did paint a picture of Dan on a billboard, but I never lured him up a ladder.

I left Austin for New York City in 1986, where I was overwhelmed by a city of millions where I knew not a single soul. Sitting alone in my 100 square ft. Soho loft, no windows, no possessions except a few art supplies, a small tape player and my Daniel Johnston tapes. It was then and there I came to understand what Daniel's music really meant to people. He was a musical Holden Caulfield, catching wayward souls at sanity's edge, luring them back from the abyss. Daniel was an important artist in the most serious sense. Daniel was there for you when you needed him most.

As my life in New York began to take shape, Daniel's tapes were shuffled out of sight; Daniel's memory slipped out of mind. It wasn't until the mid nineties that Daniel crept back into my imagination. Little snippets about mental institutions, a plane crash, getting lost in New York with Sonic Youth. When I started working on some conceptual music projects with various musicians, I knew it was time for me to find Daniel and get him involved. Unfortunately, I didn't know where the hell he was. Nobody did.

Daniel's last release had been *Fun* on Atlantic Records, but it was five years later and no one at Atlantic knew how to find him. I did manage to find his current manager Tom Gimbel and was able to contact him. Tom's cooperation was limited. He told me Dan was somewhere in Texas and he wasn't leaving Texas for any purpose. It was my sister Susan who finally found Daniel. He was living in Waller, Texas with his parents. She was living in Austin so she decided to drive the three hours over to see him. Seeing Dan reduced her to tears; he was in miserable shape. He'd spent most of the years since *Fun* in a debilitated state, rarely getting out of bed, completely out of creative commission.

I flew to Dallas where I teamed up with my musician brother-in-law Brandon Jemeyson and took a portable DAT recorder on a road trip to Waller where sure enough we found not the exuberant Daniel of the Austin days but a different Daniel, a vacant Daniel at the wrong end of the rainbow. A Daniel who was struggling hard to keep one foot in the door to reality. After dinner at a local diner, Dan wrote and recorded a short song for us. Soon after an emotionally and mentally exhausted Daniel Johnston asked us to leave. As we were pulling out of his driveway Dan came out of his house and handed a stack of drawings to me through the car window. It wasn't until later I realized what he'd really given me.

When I visited Dan I'd brought him a gift of a couple of my giclee prints on canvas. I'm sure Dan thought they were paintings and the stack of two hundred drawings was a fair exchange but of course it wasn't and I couldn't just keep them. What I could do was paint them. Didn't musicians cover his songs? Why couldn't an artist "cover" his drawings? Wouldn't it be great for Daniel's characters to meet my characters, for our artistic universes to collide on canvas? I don't know if Dan quite understood the concept, but he liked the idea. He wouldn't have to do anything but show up at the opening and make some money.

As the show date in Dallas approached I contacted Daniel about getting him to the opening and the possibility of performing live at the after party. He agreed to show up and to play, but as the date closed in on, him he became increasingly nervous. He hadn't performed live for years; the stress of the pending performance caused his mental collapse. Dan's parents committed him to an institution in Houston two weeks before the show.

Were my sister's trepidations ever valid. Her brother had driven the beautiful loser back to the looney bin. Before I flew down to Texas for the show, I called Daniel's father to see if I could come down and visit Dan in the hospital. "Actually, Daniel's home," his father replied, "The doctors in Houston put him on some new medication. He hasn't been this good since Austin. Dan would really like to do the show. I really think he's up for it."

It seemed Daniel had languished on the wrong medications for years. Daniel attended the art show, performed the concert, then we stayed up in a little room all night where he played me some new songs, filled in some old gaps, the story of the plane crash, ditching Sonic Youth for a solo New York adventure. I didn't understand it at that moment, but Austin's little secret was about to conquer the world. I was just glad to have an old friend back.

Ron English
June 2006

Ron English and Daniel Johnston collaboration poster

It's been a long, long time since I sat stunned in the control room of Noise New York, staring through the glass at a most unusual young man looming over my grand piano, making astonishing music while clearly on the verge of a major nervous collapse. Almost 20 years now, in fact. At the time, his reputation in music was deeply rooted in underground "DIY" lore, and few of us ever seriously thought it might someday gain a much wider audience.

I was most certainly one of those few. We were indeed few, but we were everywhere.

That album of songs we were recording in 1988 for my Shimmy-Disc label was called *1990*, and the man teetering on the edge of that grand abyss was Daniel Johnston. It was his first time in a real recording studio, and he was fully confident that it would sell a million copies and make us all "more famous than The Beatles" before the end of the following year.

As his producer, well, I chose not to argue the point, and did my best to share his sense of unbridled enthusiasm, which he seemed to exude in everything he did. Sure, he was clearly "not well," but even from within the confinement of his illness, his enthusiasm for every waking moment was infectious, to say the least. It was impossible to avoid being smitten by it. And, when he left the room, he took it with him. There was always something odd and unknowable about being beside him. It felt like nothing else.

Within days, he would be wandering the streets of NYC and handing his last remaining dollars to the homeless, while a good portion of the city's underground music elite would be searching for him in a noble crusade to get him out of the big city, back to the protective arms of his family, and "safe."

Daniel with never be "safe." Nor will his songs, nor anyone who hears them.

Once you have made direct contact with a song written by this mortally wounded troubadour, you will never be safe again. You may have devoted your entire adult life to cloaking yourself away from the smart bombs that decades of unrequited loves and failed passions have strategically aimed at your fractured heart, but all those efforts will have been for naught, should the stanzas of Daniel Johnston gain passage therein. He strips away the safeties we glue upon our souls.

When we hear a song by Daniel Johnston, we hold a mirror up to ourselves.

Since the recording of *1990* (and the subsequent *Artistic Vice* LP, made little more than a year later), Daniel and I have spoken by telephone at least once a month. We usually discuss the same things – when are we going to do another album together, do I want to produce his "album with Sonic Youth," whatever upcoming touring schedule or art opening he is nervously preparing for, and whether or not he feels well enough to tend to it all, which usually amounts to about half the time. These conversations take place regularly, like clockwork, and when more than a few weeks pass without hearing his voice, I try to call him, but I rarely get through. I'd just have to wait.

Things have changed a lot since those days. Daniel is now quite "famous," though not as famous as The Beatles, and although none of it happened overnight, it happened just the same. It really did happen. Daniel was right. He just had the timing a bit off.

Producer and Shimmy-Disc founder Kramer, Daniel Johnston, & Jad Fair during the *1990* sessions

Kramer and Daniel Johnston in 2002

In November of 2005, I received a phone call from Don Goede, Daniel's friend and supporter (and sometimes partner/collaborator), saying that Daniel's kidneys had shut down, and that he was in a coma-like state in a dreary Texas hospital that seemed ill-suited in properly caring for him. It was hard to come to terms with the notion that a fear which had remained little more than a fear within me, for so many years, had now become a painful reality–that Daniel was succumbing to decades of anti-psychotic medications and chemical treatments that had, to a certain degree, kept his illness under control.

Hope was all we had, so we reclined in our chairs of despair, and hoped.

Within weeks, Daniel had recovered, as he now stands poised at the foot of his greatest triumphs as an artist, with his work featured prominently at the latest Whitney Biennial, the release of an award-winning documentary based upon his life, and what seems like a never-ending series of tribute CD releases featuring throngs of well known bands and artists who cite Daniel's songs as a prime source of inspiration, or even THE source–that is, the original impetus for their having chosen to become songwriters themselves.

Inspired by (among other things) Daniel's full recovery, my record company will begin a new life as SECOND-SHIMMY, and the debut release will be a Various Artists compilation of Daniel's songs, entitled *I Killed the Monster*.

It is a celebration of pain, and not for the faint of heart.

The second track, "Worried Shoes," as performed by Danielson Famile's Daniel Smith and the incomparable Sufjan Stevens, is enough to make one re-think what music is capable of, and is a reminder of how so much of the magic that music can offer the independent-minded listener has been lost in a Metropolis-like "industry" that rewards and recycles what we've heard a thousand times before.

But, I digress.

Hope regained. The long delayed plans I have shared with Daniel to collaborate with him once again in the recording studio may soon be realized. The songs are ready and waiting, as is the aptly titled banner that will encompass it–THE HORROR OF LOVE.

Now, all we need to do is HOPE.

How can one write songs of abject pain and misery that bring such joy to the listener? Damfino. Go ask Daniel. Maybe he knows.

We all owe a debt to Daniel Johnston, and, barring our own immortality, none of us have any hopes of ever repaying it. Listen to Daniel's songs. Buy his music. Eat, drink, and sleep Daniel Johnston, and then watch what happens to you.

Fill your tank before it's too late.

Life is too short.

<div style="text-align:right">

Kramer
NYC (Spring 2006)

</div>

Kramer, his daughter Tess, and Daniel

1 | Introduction

"Hi, how are you?"
—Daniel Johnston

Ron English

Johnston Archive

Johnston Archive

Daniel Johnston feels better right now than he has in a long, hard row of years. He is writing music again, inching back into public consciousness and college radio play, and playing out more than ever before. His deeply lined face reflects the weight of his legend—a loner, a sorry entertainer, wounded by folklore and bound by inescapable cycles of mania and depression. No longer the young innocent waif who captivated strangers with his guileless persistence and sincere presentation, Daniel is fully grown, fully grayed, with a voice deeper and crackling with cigarette smoke and liters of Coca-Cola. Unable to reach the eerie, space alien falsetto of the early tapes, his voice is one with less range but more promise. He is mournful, hopeful, and forever honest. The legend turns a new page.

From carnival corn dog boy to mad, underground rocker to dark hill-country lone star, Daniel's career has already spanned over twenty years. Now in his mid forties, he is considered one of the pioneers of alternative music, not because he deliberately explored a different direction, away from the synthetic music of his time, but because he compulsively followed his heart, expressing the contents of his soul with a purity that has yet to be matched by anyone in rock 'n' roll. In this vast and jumbled sound-scape Daniel's music continues to find new lis-

Daniel and his beloved *Yip/Jump Music* — Pat Blashill

teners, attracted to and astonished by the clarity of his vision, which has never clouded throughout the dimmest years of his life.

Part of his legend is the do-it-yourself determination in the dissemination of the early tapes. Long before "indie" was a recognizable term, Daniel was making his music in true indie spirit. He recorded with a cheap ghetto blaster, and he endlessly dubbed tapes, giving them away like business cards to strangers on the streets of Austin, Texas. Some listened to the tapes. Some formed a circle of supporters who raised Daniel's music to a higher level of accessibility. Through dumb luck, timing, and the support of friends, Daniel was given his first shot at the holy grail of MTV mainstream long before he was ready. He watched himself on television for the first time from the state institution. He sputtered between manic creative outbursts and dead, depressive years.

His stories are well-known. In fact they are repeatedly told in song. From his desperate, unrequited love for a brown-haired girl named Laurie to his many breakdowns, secret longings, and sacred childhood icons, Daniel has held nothing of himself back in his music. This is the source of his appeal, the absolute laying bare of emotion, cutting through to pure human connection in a simple form, a lonely song, for anyone to understand or sing along, and many have.

From Sonic Youth to Kurt Cobain, from Eddie Vedder to Michael Stipe, Daniel enjoys the support of legions of fans, and he is regarded as one of rock's best-

Personal History

known secrets. He is the musician's cult musician; his art is appreciated for its utter lack of artifice and the undeniable simple brilliance of its melodic structure. The main reason Daniel is so highly regarded by those who know his music is that he is what he sings. There is no real distinction between the artistic persona and the man. This is a dangerous thing, something to be admired but not emulated, a "there-but-for-the-grace-of-God" bystander's thrilling recognition of The Real Thing, and it is both Daniel's blessing and his curse. He is unable to manipulate or rehabilitate his image because every thing is already in the public record, sung in his own voice. He is admired because he's not faking it, but he will probably always remain on the cult fringe of music simply because he can't fake it.

Today he is sure that science has saved him. A new antidepressant is allowing his most sustained creative effort since his illness manifested. His most recent music explores many of the same themes, but is recorded with the production values and technical support that the songs have always deserved. Now a seasoned, mature, properly medicated performer, Daniel is ready for his fabled second chance.

Visual art was his original mode of creative expression, and Daniel has continued to draw the signature cast of characters who crop up in his songs and populate his complicated cartoon myth world. Art and music together express Daniel's complete vision, and although every musical release has contained examples of his artwork, he has only recently begun to gain widespread recognition as a major visual artist. Through the help of friends (most notably ex-manager Jeff Tartakov, artist/musician Jad Fair, and painter Ron English) Daniel is enjoying a blossoming career in a creative medium much less physically taxing than music. During the years when he was unable to perform, his drawings were featured in many respected group exhibitions in the United States and Europe, where he developed a huge cult following.

Lithium and Olanzipine are Daniel's duty. Cigarettes and soda pop are his vice. He sits on his front porch in a small Texas town and waits for visitors. More and more have come by lately. He is feeling strong and stable, able to entertain, jam, record with good friends. For a man with as many ups and downs as he's had, Daniel has maintained a surprisingly high number of long-term relationships. He has reached out to friends to sustain him emotionally and artistically, resulting in many collaborative efforts and interpretations of his work by others. In effect this has kept his name, his music and art in the collective consciousness. His songs have been included in movie and television soundtracks, and college radio and certain eclectic stations (like Los Angeles' KCRW and Jersey City's WFMU) have given his music consistent airplay.

Whether Daniel will ever break through into the mainstream seems a less relevant question than whether his music will continue to reach new listeners. Hopefully, it will be plugged into the permanent record and spun into the musical continuum as something rarely heard but instantly recognizable: the shivering warble of a sparkling American Boy, with comic books and wild wide eyes. Something weird, something real, and something good. This is Daniel Johnston.

"Daniel's Duty"

Don Goede

2 | Personal History

"It must have been a happy time."
—Daniel Johnston

Daniel was the happy surprise for his parents, the fifth child, younger by 13 years than his oldest sibling. He was born January 22, 1961, in Sacramento, California, to William and Mabel Johnston, deeply religious, Christian, hard-working Americans. From station wagon vacations to the Grand Canyon, to a small piano their children learned to play in the living room, the Johnstons were normal in every sense of the word. The family moved first to Utah and then, when Daniel was five, into a house on a hill that William, an engineer, built for his family in New Cumberland, West Virginia. Years later, one of Daniel's first epiphanies about The Beatles was that "I felt they must have known—I was the fool on the hill!"

Daniel learned to play piano by watching his sister Margy, and his brother Dick taught him to read music. But, his earliest interest was in the visual arts. "I started drawing comics when I was about eight," he says. "Sometimes they were based on my cat. I made my cat a superhero. Sometimes I drew about Bible stories, and I loved Godzilla and King Kong. My mom bought me paper all the time." Daniel began a series of comic books he called Cool Comics Presents, laying down the basic infrastructure of his adult work, in which good battles evil in the form of monsters, dinosaurs, and superheroes that evolved from simple cats into caped masked wonders.

Daniel just months old

Mabel, Daniel, & Bill Johnston

Daniel's good versus evil themes were also shaped from his father's experiences as a World War II fighter pilot for the famed Flying Tigers. William shared with Daniel his love of flying, model airplane building, and his strict Church of Christ world view, in which the lines of good and evil are clearly demarcated, and heroes fight for good in all aspects of their lives. "My father used to bomb Japanese supply ships," Daniel says proudly. Daniel has associated William with idealized comic superheroes, particularly Captain America, for as long as he can remember.

Drawing was a way for Daniel to gain both acceptance and some measure of respect from his peers. Mother Mabel recalls that, "His graduation yearbook is full of his art. He was recognized as a unique artist even then." Drawing also helped ease the pain of the long periods of depression that began in junior high. "I always did want to be an artist," says Daniel, "but in junior high I started taking it seriously because I was really depressed, and it helped me."

In high school he discovered The Beatles. "I guess I was kind of late listening to them. First I heard a couple of Paul McCartney songs, and I loved them. Then I might have heard some Beatles, and I realized Paul was in The Beatles, so I started listening more carefully. It was the best stuff I ever heard." William bought his son the *Complete Beatles Songbook,* and Daniel learned The Beatles' chord progressions he would later incorporate into his own work. Eventually, the family piano was moved into the basement as Daniel became more and more obsessed with it, sometimes playing for hours on end.

He graduated from high school in 1979 and began attending art classes at the East Liverpool, Ohio, branch of Kent

Aircraft drawings by a young Daniel

A Cool Comics comic

Personal History

State University that same summer. It was at Kent State that he connected with Dave Thornberry. "He was never normal," says Thornberry. "Never. Where that becomes insanity is for professionals to say, but when we used to hang out, his most normal behavior would be judged by most people as at least eccentric. He lived to draw attention to himself. One time Daniel started yelling things at some people across the street, calling them hicks and hillbillies. The guy came out with a gun and pointed it at us and said he was gonna kill us if Daniel didn't shut up, and Daniel didn't shut up until I dragged him into the house. He was guinea-pigging the guy, seeing how far he could push him, which was Daniel's favorite game. I don't think he really got it. He had no social skills at all."

By the time he entered college, Daniel had decided to major in art. "We took drawing and sculpture classes together," says Dave Thornberry. "That's how we met." Into one of these classes walked the love of Daniel's life, a pretty girl named Laurie. "She was very nice," says Thornberry, "an average pretty girl, kind of cheerleadery, all-American white bread, nothing earth-shattering," but Daniel was floored. Laurie smiled, sat next to him, and instantly Daniel equated Laurie with true love and everything decent in the world. Laurie was engaged to the son of the local undertaker. Soon she was pregnant and married, still taking college classes with Daniel and Dave. Daniel drew cartoon portraits in her notebooks, wrote amusing ditties, and tried to woo her with self-deprecating humor. At some point he began sharing with Laurie and Dave little songs written for Laurie's amusement. She encouraged his efforts, and he began recording the songs and compiling them into albums. The first, *Songs of Pain*, was completed in 1981, quickly followed by *Don't Be Scared* and *The What of Whom* a year later. *More Songs of Pain* followed in 1983, during what would prove to be the most productive period in his life thus far.

The songs were recorded on a $59 Sanyo cassette recorder with Radio Shack tape stock. Daniel did most of the instrumentation and overdubbed the vocals himself. Recorded deep in the privacy of his basement, or in the midst of family chatter (some of it chiding and argumentative), the sound is horrifyingly lo-fi and amateurish, a one-take, bumbling, desperate bid to get these creations out of his head and onto the record of human experience. While the sound on his early tapes is bad, the most shocking thing about the tapes is their intense intimacy. The songs themselves are personal, full of shared secrets, but Daniel's early recorded performances reveal every follicle and pore. They are portraits done too close to flatter, cringingly personal matters are revealed, recorded, and later given away to strangers in such an innocent, careless manner that it continues to boggle, fascinate, and seduce new generations of listeners who now order the tapes over the Internet in an anonymous, yet extremely intimate, form of exchange.

As his manic depression began to manifest, Daniel found it impossible to continue attending his college classes, and eventually he moved to Houston to live with his brother Dick. There he got a job at Astroworld working on a ride called "The River of No Return." He continued to write songs and recorded *Yip/Jump* music in his brother's garage. "I had always liked the word 'Yip,'" says Daniel, "and 'Jump' came out of the album *1984*

from Van Halen, just a goofy thing to say."

After some tensions between Daniel, his sister-in-law, and his brother, Daniel moved to San Marcos to live with sister Margy. There he recorded *Hi, How Are You?* in the midst of his first nervous breakdown. The cluster of "Joe" songs on the album documents much of the tension within his family at that time. The Johnstons discussed options for treating Daniel's now obvious manic-depressive illness, but, rather than let himself be committed, Daniel chose to leave town with a traveling carnival.

He sold corn dogs for nine months and traveled the Southwest, from Arizona to Colorado, to New Mexico, and back to Texas. When the carnival landed in Austin Daniel decided to stay. He had heard that the city was a Mecca for underground comic artists, an aspiration Daniel held as a more feasible possibility for himself than music. In fact, he was largely unaware of the dynamic, well-established Austin music scene. Daniel had no immediate luck publishing his drawings, but he soon began hanging out on "the drag" (Guadalupe Street), handing out his homemade tapes and introducing himself to pretty girls or anyone who looked interesting. He became something of a local legend.

"Austin was always kind of a friendly hippie place," says Brian Beattie, leader at that time of one of Austin's most popular and influential bands, Glass Eye. "There was the State Hospital right there too, so there's lots of interesting people asking for money on 'the drag', and to the average person walking by [Daniel] might have seemed like another crackpot." To those who actually listened to the tapes they were given, Daniel had achieved a certain cult respect based on the quality of his song craft, if not his recording techniques, the almost voyeuristic, embarrassingly personal subject matter, and the shaky, sincere performance of his songs.

Brian Beattie remembers that the first tape he was given was *Retired Boxer*. "He was so utterly accessible because everything he was expressing was so clear and simple. No one at that time dared to be so bluntly emotional." Soon afterward, Beattie called Daniel and arranged for him to open for Glass Eye, which was Daniel's favorite band. His three-song set at the Beach was much anticipated by the Austin music community, which by this time was becoming familiar with the strange, innocent, persistent character who handed out Radio Shack tapes he called albums, shook hands with his local musician idols, and introduced himself incessantly to anyone who would stop to listen.

Marie Javins, now a travel writer and comic book editor, was in Austin for a three-month internship at *The Austin Chronicle*. She remembers how her 20 year friendship with Daniel began with her stopping into the local McDonald's. "I noticed this guy cleaning tables. He kept cleaning the same table near me. After a while I looked up and saw him grinning at me. Needless to say I left immediately. Later that same day I was giving a ride to a friend from *The Chronicle* and he saw Daniel walking and yelled out and offered him a ride. That's when I realized who he was. I had already heard his music. As I got out to let him into the back seat, he said 'Oh wow, you're that girl from McDonald's today!'" Daniel was proud of his McDonald's job. Since leaving San Marcos, he had traveled, gotten an apartment, held a job, and was swiftly infiltrating the cliquish Austin hipster scene. He has repeatedly described this period as

Personal History

On break from McDonalds

Video still from Dan's MTV appearance **Glass Eye**

the happiest in his life.

His first live performance at the Beach was attended by much of Austin's musical elite and many others who had already heard the giveaway cassettes. "Everyone was there," says Beattie. "Every contingent from singer/songwriters, to wannabe New York Doll types, to trashy punk rockers, everyone wanted to see him there. He played three songs and

Jeff Tartakov
Jeff Tartakov

it was absolutely electric, not because of the performance, but because it was just astonishing to see him up on stage looking like he was about to have a nervous breakdown. He managed to claw his way through three songs, then left the stage and ran into the bathroom." Daniel climbed out the bathroom window that night, afraid to face his audience. A magnetic, yet fragile, performer was born.

Within the Austin music scene, Daniel's star was suddenly on the rise. Soon after his first performance at the Beach, MTV came to town to focus on Austin for the show *The Cutting Edge*. "I don't think he was even initially accepted as one of the acts for the show," Beattie recalls, "but he insinuated himself so successfully to everyone that was around that I'm sure the MTV folks just thought, 'He's here, we might as well film him.' Then when they're sitting back in their editing rooms I'm sure they went, 'Oh my God, this is by far the most entertaining stuff we have!'"

Daniel's first studio session was arranged by flamboyant music producer Kim Fowley, the man behind Helen Reddy and the Runaways. Fowley recorded Daniel with Texas Instruments, but exercised too much control over the sessions for Daniel's taste. In the end, Daniel bought the tapes from Fowley and broke off the association. Some of these songs were released as part of *Continued Story*. In 1985, Daniel began a long informal business relationship with Jeff Tartakov, owner and founder, since 1980, of a small record label called Stress Records. One of his first actions as *de facto* manager was to set up Daniel's publishing. Daniel already had well over 200 songs, and Tartakov organized and registered the material. "I thought his stuff was brilliant. I really related to this lonesome guy locking himself up in a basement recording all this stuff." In 1986, Tartakov began distributing Daniel's tapes.

In March of '86 Daniel was voted "Songwriter and Best Folk Artist of the Year" in *The Austin Chronicle* "Reader's Poll." The honor meant a great deal to him. Longtime friend Susan English, then a striking 21-year-old student, recalls, "I was standing in line to get in somewhere on the strip and up walks this guy handing out tapes to every third or fourth person in line. He gave one to me and said 'Hi, I'm Daniel Johnston, Songwriter of the Year.' I took it home and listened to it. The next night I saw him again and I walked up to him and thanked him and told him how much I liked it. I don't know if he remembered giving me

a tape, but he seemed really pleased that someone actually listened to it." The two friends would later spend hours in Daniel's cramped one-room apartment, talking, drawing, and endlessly dubbing tapes on a bottom-of-the-line two-deck ghetto blaster. "He used to say they were better than business cards."

One day Daniel wandered into the House of Commons, one of the many huge Victorian houses in Austin cut up and converted into cooperative housing. There he met Wammo, now a renowned spoken word artist, and a friendly girl named Caroline who was later immortalized in the song "I Did Acid with Caroline." Wammo recalls, "He used to come in and play the piano and visit Caroline. She was pretty intense then. She was hanging around the Butthole [Surfers] at the time. I think she turned Daniel on to acid at a Butthole [Surfers] gig, and after that they just started doing acid all the time." Daniel remembers his first time seeing the Butthole Surfers perform live. "This girl put me on the stage. She thought I was gonna get crushed or something. I was just sitting on the stage, and it was so weird. I already loved the music because I had a record. After the show I walked up to Gibby, and he said we ought to record sometime."

Friends and family have often pointed out that Daniel's behavior pattern seems to be one of successes followed in short order by extreme mania and eventual breakdown. Wammo noticed that Daniel "started never changing his McDonald's uniform. It was brown already, but it became shiny like sharkskin with french fry grease." Dave Thornberry visited Daniel in Austin in '86 and recalls that, "He wasn't well. We got in a huge fight. He thought I was under the control of Satan, and [he] tried to beat me up. I had to call a relative in San Antonio to come get me."

A trip to visit family in Abilene did not go well. Daniel's sister put him back on a bus to Austin, and as Daniel looked out at the landscape dotted with cow skulls, he had a realization that "the Devil has Texas," later immortalized in the song "Spirit World Rising." Shortly thereafter, in Austin and under the influence of LSD, he attacked an acquaintance with a lead pipe, attempting to cast the devil out of him, resulting in his first institutionalization at the Austin State Hospital. His friend luckily recovered from the incident.

Daniel badly wanted out of the hospital in time to watch his second appearance on MTV's *The Cutting Edge*, in December. Instead, he spent Christmas as an inpatient on a mixture of lithium and various antidepressants. Upon his release, he initially seemed better, but he began to lose control again quickly. Final-

ly, Tartakov summoned William Johnston to Austin; he flew down in his little plane to transport his youngest child home to West Virginia.

Daniel did not perform again for a year and described himself as retired. In the meantime, Jeff Tartakov aggressively pursued placing Daniel's music in standard record stores, on movie soundtracks, and in the hands of well-known musicians who might cover a tune. As a result, Daniel's fame and influence grew during his retirement. His songs were covered by prominent Austin bands such as Glass Eye, True Believers, the Reivers, and the Butthole Surfers. Tartakov began a correspondence with Jad Fair, of Half-Japanese, after attending an Austin gig and slipping Fair a tape. Fair wrote back, thinking Tartakov was Daniel, graciously thanking him for the gift. The misunderstanding was sorted through, and Jad Fair then sent Daniel several of his releases. Around this time Tartakov also received a fan letter from Steve Shelley of Sonic Youth. That letter set in motion a series of events that would later define, for good or bad, the persona of Daniel Johnston, Mad Underground Rock Star.

It was arranged for Daniel to visit New York, play three shows, and record at NoiseNY, a studio run by indie producer and Shimmy-Disc founder Kramer. Tartakov did not accompany Daniel on his first trip to New York, which was supposed to last less than a week. Steve Shelley agreed to put him up, but Daniel stopped taking his medication almost as soon as he got to New York. After a particularly frightening gig at Piers Platters record store in Hoboken, during which, according to witnesses, Daniel ranted about Satan and seemed aggressively delusional, Shelley decided he'd had enough and asked Kramer to watch Daniel for a few days.

The first day Daniel spent at Noise-NY, Kramer watched him "give a bum a $100, bill then burst into tears and prayer." Days later Daniel announced he was going back to Steve Shelley's house in Hoboken and packed his guitar and left before Kramer could verify the invitation with Shelley. "About three days after that," recalled Kramer, "as I drove through the Holland Tunnel into Hoboken, I saw him by pure coincidence dashing across the entrance ramp to the NJ Turnpike in oncoming rush-hour traffic. I followed him into a hotel room at the Tunnel's entrance, but was accosted by the manager as I knocked on Daniel's door. He wanted him out and said he had called the cops. I banged on Daniel's door and warned him the cops were coming before I got back in my car and drove back through the tunnel. The next day Lee Ranaldo called to tell me that Daniel was at a men's shelter on the Bowery. Then I heard he was found wandering without his guitar and, more importantly to him, his Bible, which he said were stolen from him after he was beaten by 'a crazy person' at the shelter. The cops were called, and they helped him get back his guitar, but not his Bible. It was a terrible, terrible time."

Years later Daniel remembers the period more pleasantly. "They had great food at the shelter. There were some crazy people there, but everything else was pretty cool."

Blast First, Sonic Youth's record label, had recently signed Daniel and was preparing to release *Hi, How Are You?* Apprised of Daniel's increasingly erratic behavior in New York, and besieged by angry, demanding phone calls from Daniel himself, Blast First backed out of the deal.

Personal History

Cat Club/Pier Platters poster

Cassette from NoiseNY session

Kramer, Daniel, & Jad at NoiseNY

Months later another label, Homestead, stepped in, releasing *Hi, How Are You?* as Daniel's debut CD.

The recording sessions for what became *1990* were erratic. Kramer remembers it being "like pulling teeth," trying to relax and focus Daniel to bring about a state of mind conducive to recording. It was during this visit that Daniel met Jad Fair face to face for the first time. Noticing the many similarities in their music and how well they jammed together, Kramer suggested they record a dual album at some later point. Jad introduced Daniel to his friend Moe Tucker, original drummer for the Velvet Underground. At the time she was recording *Life in Exile After Abdication* and invited Daniel to play drums and sing back-up on "Pale Blue Eyes," with, among others, Lou Reed.

"I missed Lou Reed by one day, can you imagine?" says Daniel. In fact he was deliberately taken to see the Statue of Liberty so as to avoid any uncontrollable encounters with the star. He was arrested, but not taken into custody, for vandalizing the Statue of Liberty with Anti-Satan graffiti. He was fined and ordered to clean it off. A few days later, after a street argument with a stranger, he was committed to Bellevue but released the next morning. Kathy McCarty, lead singer of Glass Eye, remembers seeing Daniel during this time "at the Knitting Factory when we played with the Indigo Girls, and Daniel was like a runaway at the time. He didn't have anywhere to live. It was crazy." Friends had tried to put him on a bus for home, but Daniel, having too much fun, simply ran away. Finally, three weeks after his arrival in New York City, and after playing a short gig at CBGB's opening for fIREHOSE, Daniel decided to go home.

Getting closer to The Dakota

Outside The Dakota

I ♥ NY

Traveling light

Giving away money

All photographs by Monica Dee

Right before the anti-satan graffiti incident

In the park

Various photographs from the NoiseNY sessions

All photographs by Macioce

Daniel and Jad

Back on his medication he stabilized, and in August of 1988 traveled to Maryland to visit and record with Jad Fair. The record, titled *Jad Fair/Daniel Johnston*, was later released on 50 Skidillion Watts Records, and contains some of Daniel's and Jad's sweetest, most lilting work. At some point, however, Daniel stopped taking his medication again. Jad put him on a bus home, and he got off the bus in Chester, West Virginia, close to New Cumberland. From there he didn't go immediately home. Instead he walked around all night, apparently looking for a friend's house, becoming more and more confused. By morning he found himself in front of an apartment building, making a ruckus. An elderly woman stuck her head out of her window and told him to keep it down. Daniel instantly became convinced she was possessed by the devil and decided to help her exorcise it. He climbed the apartment stairs, broke down the door, and entered the apartment to cast the lady's demon out. Backing away from him, she tumbled out of her second-floor window, breaking several bones. Daniel was hospitalized again, this time in Weston, West Virginia. After several months he was put into a halfway house and given day trip permission.

Old friends began to visit again. Dave Thornberry dropped by to take Daniel to the movies. Marie Javins, now living in Ohio, drove in occasionally to spend the day. Daniel took his medicine and stabilized. Over the summer of 1989, *Yip/Jump Music* and *Jad Fair/Daniel Johnston* were released on CD. In January of 1990, Shimmy-Disc's *1990* was released. In February, Daniel participated in a WFMU broadcast performance on Nicholas Hill's "Live Music Faucet" show, heard live in New York City. Yo La Tengo set up equipment in the studio, and Daniel called the station from West Virginia. Through an intricate telephone set-up, they recorded a live version of "Speeding Motorcycle" that became a hit in the U.K. Daniel was invited to play at the Austin Music Awards in March. He and his father flew down together in Bill's small plane.

The show went well, but flying back to West Virginia, Daniel at some point became delusional. Believing his father was under the command of Satan and was taking Daniel to be executed, Daniel tried to wrest the controls from his father, forcing him to crash land in a field in Arkansas. It took all of William's considerable skill as a pilot to bring the plane down without loss of life. Incredibly, they suffered only bruises and scrapes. The plane itself was totaled, the wings sheared off, the bottom

Bill Johnston examines the wrecked plane

Personal History

ripped by trees. Daniel was briefly committed in Arkansas, and when stabilized, brought home to the hospital in Weston, West Virginia.

After months of healing and recuperation, Daniel invited Kramer down to West Virginia to record new music close to home. He recruited a back-up band from local church-goers. "He asked everyone he knew if they wanted to be in his band," says Marie Javins, who visited during the sessions. "It got to be a really big band." The sessions, which became Artistic Vice, went smoothly. Daniel was in high spirits. Marie remembers it as being perhaps the happiest she has ever seen Daniel. That upbeat spirit is reflected in the album, considered by many to be his very best release. But Daniel was not stable for long, soon teetering between severe mania and depression, able to perform only infrequently, with unpredictable results.

In early '92 the elder Johnstons retired and moved closer to their children, settling in a small town near Houston and taking Daniel with them. Tartakov worked relentlessly and creatively to further broaden the audience for his client's music. He had given a tape of *Yip/Jump Music* to an experimental filmmaker in Los Angeles, who made a short film us-

Love Defined ballet scene

ing the music as its soundtrack. This was seen by world-renowned choreographer Bill T. Jones, who was eventually commissioned by the Lyon Opera Ballet to create a ballet set to the music of *Yip/Jump Music*, called Love Defined. The piece premiered in France in the spring of 1992 and was later performed in several European countries, coming at last to the Joyce Theater in New York. Daniel, however, refused to see the ballet. Given a video of one performance, he expressed little interest in watching "a bunch of weird people jump around."

Undoubtedly what sealed Daniel's reputation as a musician's musician was the image of Kurt Cobain accepting his MTV Award wearing a T-shirt emblazoned with the logo "Hi, How Are You?" complete with Jeremiah the Frog peeking through the over shirt. Tartakov asserts that Cobain "was a big fan. He had several drawings stuck on his refrigerator." Daniel has never been a huge fan of Nirvana, but was very proud of the picture, photocopied from a magazine, sent by Tartakov.

Matt Groening, creator of *The Simpsons*, *Futurama*, and the seminal comic strip "Life in Hell," was chatting with rock critic friend Mike McGonigal about an article McGonigal had written on Dan-

Artistic Vice

iel. Groening was intrigued. "I went to Rhino Records in L.A. and got whatever had 'King Kong' on it. And after that I got everything I could find. The content is so strong that people who like it are driven crazy by it. I edited little compilation tapes of his stuff that I play for friends. One of my tapes starts out with the crummiest sounding fidelity and gets to his really slick stuff towards the end. I ordered all his tapes from Stress Records and the guy wrote me back a nice letter saying Daniel really liked my stuff too." Early on, Jeff Tartakov began a continuing tradition of writing a note to each person who orders tapes, a gesture that syncs nicely with the very personal, low-tech product. The tapes are still hand-dubbed by Jeff, who runs the mail-order business from home.

Daniel lived in Austin the next two years, in and out of the State Hospital, while Tartakov fielded major label record offers, all the while working without a written contract. Daniel would fire and rehire his manager daily, sometimes several times a day. No one who knew either man paid it much attention, and no one stepped in between them to mediate disputes. "Sometimes I would run into Jeff at the Post Office," recalls Wammo, "and I'd ask him what's going on. He'd say, 'Oh, Daniel's fired me twice today already.' Everyone sort of knew that was part of their relationship."

Jeff began negotiations with Elektra's Terry Tolkin, a big fan of Daniel's music, at a time when, says Tartakov, "in the eyes of the label, all the pieces of the puzzle were in place for Daniel to have a major impact. Kurt Cobain was wearing his shirt, The Lyon Opera Ballet was touring, Daniel had just had an indie hit single in the U.K. with the Yo La Tengo collabora-

Kurt Cobain & the shirt London Features

Daniel says thanks

tion, fIREHOSE and the Pastels and Sonic Boom had just covered his songs; Daniel was perceived as a phenomenon waiting to happen."

Atlantic also expressed interest in Daniel, entering the game as the Elektra deal began to fall into place. Incredibly, as an artist well-known within music circles for his erratic behavior and inability to tour, Daniel was soon the object of a bidding war between Elektra and Atlantic. Tartakov finally hammered out a six-figure agreement with Elektra that included unheard-of terms favoring the artist. Daniel would not be required to work during periods of instability, would not have to tour, and would, in general, be treated like the fragile genius he was perceived to be. One of the requirements of the contract, though, was that he formally retain Tartakov as his personal manager.

At the time Daniel was manic and becoming increasingly delusional. He expressed the fear that another Elektra band, Metallica, was in league with Satan and would kill him if he signed with Elektra. According to Tartakov, Elektra even offered to have someone from Metallica contact Daniel to assure him they were not Satan worshippers. But Daniel refused to sign a contract with Tartakov, and Elektra refused to sign Daniel without his manager. "I think plain and simple he has a fear of success," says Dave Thornberry. "When it comes right down to major level achievement, I don't think he really wants it. That's the only way to explain it."

Daniel and Jeff had a close, somewhat dysfunctional relationship. Jeff was his all-around manager, handling personal affairs, art placement, music issues, and at Stress Records, tape duplication and distribution. According to everyone associated with him, Jeff was absolutely honest in his business dealings, but there was some disagreement within the Johnston family as to why Tartakov's share of Daniel's revenue was higher than the standard manager percentage.

"Bill didn't understand how the music industry works," says Kathy McCarty, referring to William Johnston. "He thought if you didn't make any money off a record, you were being ripped off. He never realized that the industry has accounting procedures in place that structure the whole thing so you don't see any profit from a record unless you sell over 100,000 units." Also as both Daniel's manager and his record label, Tartakov was entitled to a higher percentage. At any rate, after the final firing, William Johnston did not encourage his son to go back to Tartakov.

"I needed a new manager," says Daniel. "I was walking around Austin and I saw this sign on a building. It said 'Amazing Records.' I thought what a great name, so I went in and gave this guy a tape. Later he became my manager." According to both Beattie and Tartakov, what Daniel actually did was open the Austin phone book and look up record labels. Amazing was listed first. Daniel gave a tape to the receptionist and walked out, followed by Tom Gimbel, a young employee at Amazing who had overheard the brief conversation and recognized the name. Tom introduced himself and gave Daniel his card. Months, later Daniel called and offered him a job.

"He said he thought I was a nice guy, an honest guy," says Gimbel. "I told him I didn't have much experience with management, but he was pretty persistent, and I decided it was something that I would try to do." Gimbel quickly realized what he had with Daniel, an artist on the verge of major success who had

Daniel Johnston and Yo La Tengo 7"

Metallica Elektra Records

Yves Beauvais, Daniel, & Tom Gimball Johnston Archive

recently been the object of a six-figure bidding war. Gimbel did not honor the unspoken understanding among the music community not to step in between Tartakov and Daniel, but in all fairness to Gimbel, Daniel did insist that he become his manager. Tartakov retained the right to distribute the tapes as Stress Records, but Tom Gimbel now took over the quest to land Daniel a major label deal.

Jeff also gave back all drawings entrusted to him at that point. He then went to all the record and comic stores where he knew Daniel had traded for goods or sold drawings cheaply, and bought everything back. These drawings he continued to place in art shows around the world. Over the years Jeff managed to have Daniel's art included in prestigious exhibits in Seattle, Philadelphia, New York, Cincinnati, The Netherlands, Germany, and France, all without Daniel's participation. He continued to dole out Daniel's share of sales, minus what Tartakov had paid for the work. Presently Jeff handles Daniel's art placement and tape distribution but plays no part in his musical management.

Atlantic wanted Daniel badly, but offered an inferior deal to Elektra's. Tartakov had already refused the terms. But with Elektra out of the picture, Gimbel now accepted the Atlantic offer, and within weeks of signing with Gimbel, Daniel found himself sharing the same record label as Led Zeppelin. There were no provisions in the Atlantic contract for dealing with Daniel's illness, and they wanted their album as soon as possible.

Yves Beauvais, the Atlantic A&R executive who first brought Daniel to the attention of Atlantic, had been a fan since seeing Love Defined in Paris the year before. He has called Daniel "an absolute American genius, able like Hank Wil-

liams to convey extraordinarily beautiful things with very simple language and basic chords and find a way to never repeat himself." Beauvais was aware of Daniel's precarious mental state but felt that with the right producer and recording conditions the album could be made. Hoping to facilitate his vision and hasten the album completion, Beauvais brought in Daniel's old friend Paul Leary, of the Butthole Surfers, to produce the long, tedious series of recordings that would become *Fun*.

"Daniel had some trouble playing," says Leary, understating the seriousness of Daniel's condition at the time. "I wish he could have played every instrument, but he couldn't. He showed me the parts, we worked them out, and I played most of them back in the studio." According to Beauvais, Daniel was suffering severe lithium tremors, and his hands were too unsteady to play piano, the instrument on which he had composed most of the songs for *Fun*. Daniel showed Leary the song structures on guitar, managing to communicate not more than basic chord progressions. Leary worked out the instrumentation, laid down the guitar tracks in a local studio owned by Willie Nelson, then brought the tracks out to Daniel's garage, where he sang over them.

Paul Leary also enlisted the services of Butthole Surfer band mate King Coffey on drums and Willie's sister and band mate Bobbie Nelson on piano. He hauled recording equipment out to Daniel's house and set up a makeshift studio in the garage. "We had to unplug the meat freezer to get the vocal tracks down. The hard part was remembering to plug it back in when we were done." The sessions went on for most of the summer and yielded many recordings that were

Dale Dungeon, Paul Leary, & Daniel

Atlantic Records release *Fun*

Paul & Daniel laying keyboard tracks

Kathy McCarty's *Dead Dog's Eyeball*

deemed as unusable. "There's some pretty spacey, shocking stuff," says Leary. "There were some sentiments that it wouldn't be appropriate for his album or his career."

Daniel, under enormous pressure to complete the album, drifted deeper into depression. He had begun chain-smoking menthol cigarettes, which were having extreme consequences on his voice. As a result, *Fun* has a fractured feel, very competently done yet with an unreal, unwell quality to it. The instrumentation, while spare, has a very sophisticated feel. The arrangement for "Happy Time" in particular stands out, with Daniel's voice accompanied only by cellist John Hagen. The cello was Beauvais' idea. "Happy Time" was originally recorded with a kazoo accompaniment, Daniel's idea, but the kazoo was ultimately deleted from the mix.

"He had a really good batch of songs then," says Brian Beattie. "But I don't like it all around as a record because it doesn't have any of that peculiar and mysterious kind of thing that his other tapes have." Others have described it as artificial sounding, but still *Fun* reflected a true sense of "what Daniel was going through at the time," according to Leary. It represented the first truly accessible, widely available, promotable Daniel Johnston album.

One week after *Fun* was released, Kathy McCarty's tribute album *Dead Dog's Eyeball* came out on Bar None Records, comprising stunning, fully instrumented interpretations of many of Daniel's oldest songs. "At first I was worried," says McCarty, "because I figured my album would be buried under his, but I actually got to ride the Atlantic coattails a little bit. Sometimes our albums were reviewed together." Daniel did not participate in *Dead Dog's Eyeball*. "He was totally crazy when I started. By the time I finished he was a little better and about to make *Fun*." McCarty gave Daniel a

Daniel's press photo for *Fun*

copy before the pressing. "He thought it was great. He said how much do I owe you for doing this? I always thought that was such a great compliment, that he felt like he should pay me for making it."

Neither album was heavily promoted by major league standards, and sales for *Fun* fell far below expectations, topping out at 12,000. Radio play was minimal, and one rather bad $20,000 video was made, with Daniel lipsynching out of time. Atlantic lost money on the album. Daniel could not tour; he could barely get out of bed. He grew heavier, a combination of soda, sugar compulsions, and inactivity. He was plagued by fear that Atlantic would drop him if he didn't produce another, better-selling album. There were long periods of time when he never got out of bed and produced neither music nor art. In 1995 Brian Beattie came out to Daniel's house and produced "Casper," written for the soundtrack to the movie *Kids*. Daniel called Beattie frequently after that, imploring him to come back and jam, record and produce more work. "I'd say it was probably the lowest point in his life," says Beattie. "I started working with him to get together tapes to send to Atlantic, which wanted something to use as a production starting point for the next album." Over the course of two years, Beattie recorded on and off with Daniel, sending Beauvais a collection of material, all of which Beauvais rejected.

"I know Yves loves Daniel," explains Beattie, "but I think what Yves had in mind was more of a Brian Wilson kind of thing, where Brian Wilson was obsessed with making everything perfect, and to Daniel just the fact that he played it at all was good enough. Real fundamental difference." Beauvais insisted that the song quality was not up to par with the ear-

Daniel during the *Fun* era Yves Beauvais

lier work and implored Daniel to record some of his classic material. "He had 200 great songs," says Beauvais, "but he didn't want to sing them, or couldn't, I don't know." This had also been a problem with *Fun*. Paul Leary has said, "One song we were working on was called 'Frankenstein Love' and it was going to be the centerpiece of the record. Coming from the heart and soul as it all does, some of the lyrics started to freak him out. So we ended up nixing that from the record."

During this time Daniel very rarely played out, and when he did, he was an extremely fragile presence in spite of his ever-growing bulk. Still his legend was part of the local fabric of Austin. Although he didn't play at SXSW '94, his "Jeremiah the Frog" motif was part of the official image of the festival that year. New York painter Ron English was in town for the opening of his exhibition at Wunderlich Gallery the evening before the festival

began. An old friend, he immediately recognized Daniel's images on promotional banners and posters. "I thought for sure I'd run into him somewhere, but nobody I asked knew anything about it. It's like he was the phantom of the festival." English decided to look Daniel up, but it took two years to actually get hold of a phone number. When he finally located Daniel, English gave the number to his younger sister Susan, who visited Daniel for the first time in eight years later that week. "He had changed a lot, was really heavy, living with his parents. It was nice to see him. He showed me a video of when he was Songwriter of the Year. He was still so proud of that."

English began visiting Daniel once a year when he was in Dallas for family vacations. Usually he enlisted the help of friend and musician Brandon Jemeyson, of the Sutcliffes. Together they would make the six-hour drive south, spend the day with Daniel, and drive back the same evening. English recalls seeing Daniel for the first time in eight years. "I remembered this dark-haired waif. He always loved The Beatles and he used to look like one in the early years. Then I saw him later and he was huge, white-haired, unshaven. But we got to talking and I recognized the old Daniel, the innocent, sincere, fun-loving guy."

"Sometimes we would play good cop/bad cop," recalls Jemeyson. "I got to be the good guy and let Daniel have a Coke or smoke a cigarette. We never brought him cigarettes, but he always had a pack hidden somewhere. It was pretty useless trying to get him not to smoke. We would get these intense lectures from his parents, especially his mother. She'd say 'You boys understand Daniel cannot have any sugar, he's a borderline diabetic, and he's gonna want candy bars and Cokes but under no circumstances can you let him have them, and no alcohol, cigarettes, and no marijuana, he's on medication.'

"We'd take him to the local diner when we were in town. Once we were there and I had a hangover, I was exhausted and freaked out, and I decided to hell with it and ordered a beer. Ron was in the bathroom. Daniel immediately ordered a beer too. I didn't know what to do. When the beer came, Daniel glugged it down, burped and ordered another one before the waitress had time to walk away. The next beer came and Dan glugged it down just as fast and ordered another one. By this time I had a real sick feeling in my stomach, a combination of hangover nausea and dread. The third beer came and he did the same thing. Ron came out of the bathroom and looked at me funny and nodded at the three empty beer bottles in front of Daniel. We got out of there fast. But Daniel seemed satisfied. He wasn't drunk at all and he was happy the rest of the day. I guess all he wanted was to have something forbidden, and when he had his fill, he never went overboard."

In 1997 art collector and businessman Leonard Sotomayor commissioned a CD-ROM chronicling 20 years of Ron English's art. "I liked the idea," says Ron, "I could condense my art into something as compact as a CD." Sotomayor was also part owner of Global Beat Records and planned to use tracks for the CD-ROM from the Global Beat catalog, but Ron insisted on using his favorite bands to create new tracks. Of course, this included old friend Daniel Johnston.

"When Ron first came down," recalls Brian Beattie, "it was pretty tenuous. Daniel was freaked out. I don't see how

Personal History

Ron and Dan in Charlie Brown shirts

anyone—I live 130 miles away, not 1,600 miles. I can drive there in a couple hours, but for someone coming down from New York to try and get something precious out of him, I learned to give up on that, go out and know I'm gonna get something usable that day." Eventually English and Jemeyson were able to record Daniel singing a short collaborative composition he and English made up on the spot, the sad, haunting "Still Life," included on English's compilation album and CD-ROM soundtrack POPaganda.

After one particular visit, as English and Jemeyson were getting into the car, Daniel, on a whim, asked them to wait and ran back into the house. He emerged with a stack of drawings for Ron, a gift in exchange for Ron's earlier gift of a set of prints. "I didn't know what to do. It was insanely generous. I couldn't refuse them." Back in New York, English decided to show the drawings to art dealers he knew to facilitate sale. "I didn't feel right about owning 200 Daniel Johnston drawings, so I figured I'd try and get something going for him if I could."

Daniel was hospitalized several times during this period and in spite of the efforts of himself and Beattie, did not meet the expectations of Atlantic Records. Soon after a particularly chilling performance at SXSW '97, where he screamed to the audience, "We're all gonna die!" then abruptly left the stage, Daniel was officially dropped from the Atlantic roster. Friends thought it was for the best. "He slowly began to get better after that," says Beattie, "without that heavy existential pressure to produce something for them that just wasn't in him. I had stopped working with him after Atlantic had rejected everything I did because there was no point. But after Daniel was dropped, we started working again together, and after his last bottoming out and hospitalization he seemed to get better."

Ron English happened to show the Daniel Johnston drawings to Dallas art dealer David Quadrini, in English's New York studio selecting pieces for an upcoming one-man show at Dallas' Angstrom Gallery. Quadrini, a longtime fan of Daniel's music, immediately asked English to do some collaboration with Daniel for the show. "I was pretty miffed," says Ron. "I already had a fantastic show and suddenly he wanted something completely new. I didn't know how to col-

Brandon & Daniel

Ron's interpretation of Dan's work

laborate with Daniel. He lived a thousand miles away and he didn't really paint." But English was sufficiently intrigued with the idea to eventually create a series of work based on Daniel's drawings. "His stuff had this uncontrolled frenetic emotional energy that was almost the antithesis of my own slick, intellectual agit-pop style. The trick was to retain the psychological tensions of Dan's line work and the eccentricities of his characters, bringing them to life in my surrealist Disneyesque universe, where they could interact with my customized pop culture characters. It actually worked out very well. Dan was extremely pleased with the results."

Just before the Christmas of 1997 English and Jemeyson again ventured down to pick Daniel up and bring him to Dallas for a gig with the Sutcliffes, but Daniel was sadly unable to travel. Soon after he was hospitalized again. His medication was reevaluated, and an antidepressant called Olanzipine, new to the market and extremely expensive, was added to his regimen. After his release friends noticed a distinct difference. He had begun to play piano, write songs, and draw again. Ron English became cautiously optimistic that Daniel would be strong enough to attend the Dallas opening of their collaborative art exhibition.

"He amazed me," says Brandon Jemeyson. "All this time I knew him as this barely functional person, and then when we brought him to Dallas he had all this energy. He made it through a rehearsal with the band, the entire art opening, then a long gig at the Bar of Soap. We didn't stop playing till 2:00 in the morning. I felt like that night was a real turning point for him." With the Sutcliffes as back-up, Daniel played his first full set in five years in March of '98 to a packed house. One week later Daniel performed successfully at SXSW '98 as part of the Tim/Kerr Records showcase.

Manager Tom Gimbel negotiated a deal with indie label Tim/Kerr Records to put out *Rejected Unknown*, culled from

Daniel's original drawing

the many hours of recordings made with Brian Beattie. In November of '98 Daniel and his father traveled to New York for a one-night gig at the Knitting Factory, as part of the College Music Journal festival. Yves Beauvais, who has remained on good terms with Daniel and his family, put together an all-star back-up band at Daniel's request, featuring Jill Sobule, Joseph Arthur, and James Mastro. Father and son arrived at Ron English's Tribeca loft, located a few blocks south of the Knitting Factory. They gathered an entourage of friends and walked to the gig. Just before he went on stage, Daniel realized he had lost his song lyric notebook, upon which he was totally dependant. He refused to play without it.

From the stage he asked audience members to look around for it. Several obliged. Someone from English's party ran back to the loft to locate it, but it was suggested that Daniel could have dropped it on the street when he reached down to give money to a homeless person on the way to the gig. The notebook was not found in time, and Daniel played two songs from memory without the band, apologized profusely, and left the stage, to the puzzlement of fans who had gathered in tense anticipation of a rare live performance. Fans weren't totally disappointed, as by now Daniel's erratic reputation was perhaps part of the appeal. The notebook was eventually found where Daniel had placed it, on top of a tall ladder in English's loft. Father and son left for home the next morning.

Angie Edwards, a young Austin disc jockey at U.T.'s KVRX, first met Daniel in April of '97 when he accepted her invitation to appear on her radio show. After becoming friendly over the course of a year, Angie decided to try and facilitate a limited tour for Daniel. Traveling with another Austin band, the Brown Whorenet, Daniel managed a full set show in Houston and New Orleans in late November of '98. "For me," she says, "my efforts come from being a fan. When I see him on stage with the audience loving him, nothing else matters, like the minor annoyances of traveling with him." These annoyances included Daniel's habit of chain-smoking inside cars with windows shut tight against the winter cold, his insomnia and incessant night pacing, and his wild spending sprees at local comic book and record stores. At one gig, she recalls, "They gave him $700. I knew that was a mistake. I thought, he doesn't even have pockets. He wears sweat pants!"

The next month Angie launched a mini-tour of the West Coast, with stops in San Francisco, Portland, Seattle and Los Angeles, where he played at Al's Bar and was introduced to Matt Groening face to face. Matt gave Daniel a specially dedicated copy of his book *Love is Hell*.

Daniel at the Knitting Factory

"I thought that was appropriate for him," says Groening.

English negotiated with CBGB's Gallery to bring the Ron English/Daniel Johnston art show to New York in February '99. Daniel spent a week in New York City, carefully chaperoned by English, where he attended the overflowing art opening, did radio interviews with WBAI and WFMU, and played gigs at both the Sidewalk Café and the Knitting Factory where free admission was offered to anyone with a ticket stub from the earlier CMJ show.

After a wildly successful week-long tour, Daniel returned home and was reunited with Jad Fair for a two-week recording session in Texas. Recording was sporadic, as Daniel's voice was badly damaged from chain-smoking throughout a three-month-long chest cold, and his habit of sleeping well into afternoon precluded working in daylight hours. At this point many friends expressed familiar apprehension, waiting for the next phase in Daniel's well-established pattern of breakdown or unmanageable mania after a series of successes. Luckily, living with his parents, who tightly control his medication and vices, warded off any out of control behavior. In May of '99 Daniel traveled to Washington DC for the third Ron English/Daniel Johnston art show. Relaxed and upbeat, he played two shows at the Museum of Contemporary Art, Georgetown, stayed for the weekend, and returned home.

Tim/Kerr Records reneged on releasing *Rejected Unknown*. Family troubles and a lawsuit with a larger company distracted the tiny label, and eventually Brian, Daniel, and Tom decided to shop the album to another label while printing small quantities of the already finished album for stage sales and small retail ventures in Austin, such as the Sound Exchange, where Daniel had a long standing relationship. Brian formed a label, New Improved Music, to house the limited run of *Rejected Unknown* and several other projects, including a Kathy McCarty release. Gimbel eventually took the project to Which? Records, a small indie label that at the time counted Brian Jonestown Massacre as its breakthrough act. Which? Records folded into Gammon, a label run by Jordy Trachtenberg, which eventually released *Rejected Unknown* in 2000, Daniel's first new recorded offering in years.

As the new century progressed, Daniel, stabilized with appropriate medication and under the care of well-meaning and competent companions, managed to emerge as a rediscovered man behind the myth, making up ground for all the early derailments and eventually wildly surpassing the original trajectory of his career. Bill Johnston steadily began taking on the role of business manager, with help from son Dick, and Tom Gimbel's contract was not renewed, although he remains a trusted advisor to the family. Don Goede handled tour management and saw to Daniel's needs on the road, as it became increasingly feasible for Daniel to travel, first throughout the US, and, by 2002, throughout Europe, with a stop in Japan by 2003.

In a weird twist for a previously unmarketable outsider persona, Target featured a Mary Lou Lord cover of Daniel's "Speeding Motorcycle" in a series of commercials in 2001. During an Austin gig the same year, Daniel was introduced to filmmaker Jeff Feuerzeig, a longtime fan who immediately began to pursue the idea of making a movie about Daniel. The documentary that resulted was 2005's

Personal History

The *Rejected/Unknown* band

Daniel Johnston's *Rejected/Unknown*

Daniel performs at Moma in D.C.

Changing strings in Virginia

Danny and the Nightmares debut

Danny and the Nightmares *Freak Brain*

The End is Near Again

The Devil and Daniel Johnston, which won the Best Director prize at Sundance and a distribution deal with Sony. It has also helped to catapult Daniel from a subculture secret into a living artistic legend.

Daniel was reunited briefly and most pleasantly with Laurie Allen at the SXSW Austin screening of the documentary. Laurie, in the audience, was called up to the stage, where a disbelieving Daniel beat a hasty retreat to gather his courage, only to return and engage in an hour-long and years-overdue conversation. More recently, a new play titled "Speeding Motorcycle," featuring Daniel's music, funded by the Rockefeller Foundation through a MAP fund grant and produced by Infernal Bridegroom Productions, premiered in Houston in May of 2006.

Daniel's musical output has continued gathering steam, with consistent support from Don Goede, Jeff Tartakov, Jordy Trachtenberg, Kramer, and Mark Linkous of Sparklehorse. Gammon Records released *Fear Yourself*, produced by Linkaus, in 2003 and a year later unveiled a double CD set titled *The Late Great Daniel Johnston: Discovered Covered*, which yielded covers by Beck, Tom Waits, and others, packaged with Daniel's original recordings of the same songs. A set of Daniel's early recordings was released on CD by Dualtone in 2003, and Daniel has collaborated on a number of projects as a member of Hyperjinx Tricycle, Danny and the Nightmares, and the Electric Ghosts. Kramer intends to release another CD of Daniel cover songs, called *I Killed the Monster*, in late 2006, and Gammon will release *Lost and Found* soon after. A long-awaited greatist hits CD called *Welcome To My World is now* available by Dick Johnston and Jordy Trachtenberg.

The medium in which Daniel may

Personal History

still realize the greatest success is in art. Although he ceased acting as music or tour manager many years ago, Jeff Tartakov maintains his role as informal manager and advocate for Daniel's art, placing his work in prestigious exhibitions worldwide. Some of these exhibitions attracted the attention of prominent artists and curators. As a result, Daniel was introduced to the Clementine gallery, and, ultimately, he was included in the 2006 Whitney Biennial, long regarded as a supreme launching vehicle for the American artist.

Durign this time, Daniel's health had held for the most part, though he did suffer from a couple of significant setbacks. During a hospital stay in late 2005, he lapsed into a coma for a few days. The coma was thought to have been caused by an infection that threw Daniel's medication levels off balance. But, since 1999, Daniel has been properly medicated and cared for, managing to achieve a certain degree of independence and indisputably the greatest, most long-lasting string of successes in his career thus far. He currently lives in a family built home behind his parents, which Daniel has stocked with his favorite comic books, pared down considerably from an unmanageable collection previously housed in the Johnston family garage. In addition, Daniel has access to his piano, guitar, tapes, art supplies and drawing table, and he welcomes frequent guests, old friends, and new admirers, all of whom stop in to visit, pay respects, and take him out for a movie once in a while.

Gammon's release of *Fear Yourself*

Discovered/Covered

***Welcome to My World*: greatest hits**

Various manifestations of Daniel's Dead Dog's Eyeball obsession

3 Creative Beginnings

"I am a baby in my universe."
—Daniel Johnston

Comic books and monster movies, Bible stories and The Beatles, Daniel is an artist rooted in the iconography of his childhood. From various fractured pieces of mid-century Americana he constructed an elaborate mythological paradigm to organize the world outside himself. This is not uncommon among children, but Daniel never totally grew out of his boyhood sensibilities. Instead, he grew deeper into his inner world. As an adult man he is still navigating the circles he drew as a child. He receives comfort and a great deal of joy from his idealized memories.

From "Happy Time,"

The sun would shine
The candy bars
The Kool-Aid flowing like wine
The comic books
The TV shows
The bubble gum
The kitty cat.

Even the more bizarre memories of Daniel's childhood are given matter-of-fact treatment in his adult work, retaining a sense of wonder and acceptance of the non-negotiable absolutes of life and death. Daniel recounts the story of seeing a dead dog hanging on a swing set: "He got himself caught on the rope and got hanged. I asked this girl where was her dog and she pointed over at him and

said right there. It was pretty weird. I ran back over to my Grandpa's."

From "Catie,"

*I saw the dog hanging
On a swing set
I asked the girl
Where was your doggie at?*

This experience is alluded to also in "Dead Dog Laughing in the Clouds" and is referred to in the title of Kathy McCarty's tribute album *Dead Dog's Eyeball*. Kathy says, "When we first met Daniel, whenever some bizarre coincidence happened to him, he'd say 'Dead dog's eyeball!' That's what he says to mean fateful coincidence." She used the term as title to denote the happy synchronicity of the two albums, *Dead Dog's Eyeball* and *Fun*, being released at the same time.

Daniel Johnston is a mixture of baffling innocence, childlike willfulness, and frighteningly adult anger. Severe manic depression manifested in his early twenties, but even before this Daniel seems to have experienced some perhaps undiagnosed form of arrested development. He is neither fully a child nor completely grown; he interacts with the world but frames it within old childhood reference structures that, instead of dissolving in adulthood, evolved into a sort of parallel universe of absolutes, having more to do with obsession than intellect. Daniel can be witty and insightful, able to bring an audience to tears or extract favors from family and friends. But his world view is still based on simple contrasts of good and evil established early in childhood, black and whites of desire and duty, a world where gray areas are less a sign of existential conflict and more a simple

Creative Beginings

> AND SO MAN BECAME SMARTER, WISER AND 'HIPPER' UNTILL FINALLY THEY WERE SUCCESFUL IN SENDING MEN TO THE MOON... WHICH WAS DISCOVERED TO ACTUALLY BE JUST A HUGE DEAD DOG'S EYEBALL.
>
> AND SO THAT BRINGS US TO TODAY AND MODERN TIMES.
>
> TODAY IN MODERN TIMES IT SEEMS THAT JUST EVERYBODY AND HIS BROTHER ARE POPPIN' EYEBALLS.
>
> WELL MY ADVICE TO YOU WOULD BE TO STAY AWAY FROM EYEBALLS, THEY CAN ONLY MESS UP YOUR MIND IN THE END.
>
> ANYWAY I WOULD ALL PROBABLY BE AMAZED TO FIND OUT THE EFFECT DEAD DOG'S EYEBALL HAS ON JUST YOUR EVERY DAY LIFE.
> — NOW, JUST THINK FOR A MINUTE... HOW MANY OF YOU GO EYE-BOWLING IN YOUR SPARE TIME? HUH? TELL ME HOW MANY OF YOU HAVE PURCHASED RECORD EYE-BUMS? I HAVE QUITE A COLLECTION MYSELF.
> — AND OF COURSE WE ALL HAVE THE CONVENIENCE OF A TELEYE-VISION, IN THE COMFORT OF YOUR HOME.

DEAD DOG'S EYEBALL WAS JUST A PASSING FAD

> NOW... SOME OF YOU MIGHT BE SITTING THERE THINK.. "WELL, JUST WHAT DOES DEAD DOG'S EYEBALL MEAN TO ME? — JUST WHAT IS DEAD DOG'S EYEBALL ALL ABOUT?"
>
> WELL, LET ME TELL YA...
> IT'S LIKE THIS...
> LIFE IS A DEAD DOG'S EYEBALL
> ALL YOUR LIFE DEAD DOG'S EYEBALL HAS BEEN WATCHING YOU. IT KNOWS WHAT YOU'VE DONE AND WHAT YOU HAVEN'T.
> WHEN THE GIANT DEAD DOG'S EYEBALL APPEARS IN THE SKY, WILL YOU BE READY FOR IT?
> IF YOU WOULD COME FORWARD NOW, BECAUSE TOMORROW MAY BE TO LATE AND CONFESSED THAT YOU BELIEVE IN DEAD DOG'S EYEBALL AND DO BELIEVE, YOU MAY BECOME A DEAD DOG'S EYEBALL....
> — THANK YOU

Daniel explains Dead Dog's Eyeball

failure to clarify one's mission.

The fire and brimstone religion practiced by his family provided an early basis for Daniel's understanding of the world. It was an understanding that actions had consequences and evil existed in a perpetual battle with good. Humans constantly made mistakes because base inclinations overrode desires to remain decent, and some personification of evil, whether Satan, Lucifer, or various demons, was at the root of human foibles. Church was a staple of Daniel's early life, and his language is still peppered with Gospel quotes and invectives against Satan, things he heard as a young child and internalized over the years. "His mother used to call him an 'unprofitable servant,'" says Dave Thornberry. "He got used to the idea that he was a sinner, doomed or something, and that u-turned on him and came back out as this Satanic thing."

From "Sorry Entertainer,"

Drove the demons
Out of my head
With an organ and a pencil full
Of lead
And when I'm dead
I'd like to have it said
He drove the demons out of his head.

The superhero comics of Daniel's childhood superimposed seamlessly onto the Biblical structure. Daniel was drawn to the work of Jack Kirby, creator of the Fantastic Four, the Incredible Hulk, Mighty Thor, and most particularly for Daniel, Captain America, who represented the World War II idealized values of his parents. Superheroes were saviors of mankind, enforcers of the Golden Rule, and mighty foes of Satan. For most boys,

at some point in adolescence superhero worship is transferred to sports stars. But, like many artists, Daniel never followed sports. Instead he continued reading comics and drawing his own, inventing characters and plots which became more complicated and interactive over the years.

"He told me once," says Marie Javins, "That he thought Jack Kirby and his wife were up in heaven reading comic books. He still has this incredible memory for obscure moments in the comic book sequences of his childhood. He can tell you different aspects of some fight between Cap and Red Skull, who drew it, inked or colored it." Monster movies were another source of inspiration, with many underlying Biblical aspects similar to comics, but monster movies also introduced Daniel to the problems of the misunderstood big-hearted beast: uncontrollable rage, misbegotten love and the aftereffects of irresponsible science.

From "The Creature,"

> It just ain't right sometimes
> The creature's panting
> Through his gills
> Can't you see the plead in his eye
> He says if you want me to I will
> Just don't ask him why.

Daniel appropriated many themes and characters from early sources of inspiration. Captain America, The Incredible Hulk, Frankenstein, King Kong, and Casper the Friendly Ghost all became interactive creatures in their own right within Daniel's mythological structure. "He's got this whole origin worked out," explains Javins, "where he was Captain America's son or he was an aborted fe-

Daniel as a Beatle Ron English

tus who was somehow saved by Captain America and at some point when he was dead he was Casper, ghost of the dead boy. Of course he doesn't literally believe it. This is just the world he's worked out for his characters." Daniel took ideas he responded to from existing mass-market children's products and animated them with a unique individuality, a process he also applied to his musical influences.

Daniel listened to the music of his era, a member of the first generation to grow up with an indiscernible radio mix of current and classic rock. He stumbled upon The Beatles later than most kids his age but soon became properly obsessed, and his later compositions reflected the spectrum of Beatle musical growth.

From "Rock n' Roll/Ega,"

> My heart looked to art
> And I found The Beatles
> Oh God I was and am a
> True disciple
> Look for the fun and you'll start
> A happy cycle.

"You can hear it clearly," explains Marie Javins. "He went from 'I Wanna Hold Your Hand' to *The White Album*. A lot of his songs have that Beatlesque clean melody with the choruses that repeat, and then he gets into this weird experimental stuff." Daniel also began to pore over the lyrics, noticing odd little insider hidden meanings and phrases, from "I am the walrus" to the "Paul is dead" rumor. This kind of referencing in Beatles work later influenced Daniel's own song craft and art, as he began stringing together melodic clusters and a regular cast of characters. Daniel spoke about song referencing to writer Andrew Hultkrans, who visited the singer in 1992, during one of his incarcerations at the Austin State Hospital. "In The Beatles songs," said Daniel, "I saw how they would refer to different things in another song. Like John Lennon said 'the walrus was Paul.' I started referring to other songs that I had written and started to make an epic of songs that were referring to each other, then the drawings referring to the songs and the songs referring to the drawings."

Daniel's devotion to The Beatles is still evident in his music. He participated in the Shimmy-Disc tribute to the Rutles, *Rutle Highway Revisited*, and many of Daniel's own songs have that same Rutles feel. His songs are not quite a Beatles parody, but they are almost a mirror musical statement; from time to time a listener will experience a feeling of deja vu after having heard a riff of this or that somewhere before in the Beatle's A to Z stack. He has recorded, and performs, many covers as part of his regular act, from "Got to Get You Into My Life" to "Tomorrow Never Knows," "Hide Your Love Away," and a recent hilarious reworking of "Live And Let Die:"

> I often thought that a
> Store-bought product
> Had as much to give as any
> Loved one
> But you know it's true, you
> Know it is
> You know it is
> But then I found that life
> Was a bit more complicated
> Makes you give it a try
> Live and let die.

Daniel always considered himself a visual artist first and a musician almost

by accident. He insists that if he hadn't met Laurie, he would not have been inspired to write songs in the first place, let alone a vast cluster of songs documenting 20 years of obsessive, unrequited love. But he did meet Laurie and spent much of his time and creative energy trying to impress and amuse her with self-deprecating, naturally melodic songs that shone in spite of Daniel's less than perfect delivery. He has recently begun another prolific songwriting phase and is still using his carefully preserved memories of Laurie as inspiration. "The thing about it is," he explains, "I just for some reason was real obsessive about her and when I write music I think about her. I don't really think about her when I'm not playing."

From "Mind Contorted,"

Every time I think of you
I feel like writing a song
And if I could win your heart
I never thought it'd take so
Awful long.

Much has been written about the link between creativity and mental illness, particularly manic depression, with its wild mood swings from intense productivity to near catatonia, a condition frequently accompanied by obsession and compulsion. While mental illness is certainly not in itself a creative force, some aspects of manic thinking have been linked in clinical studies to grandiose creative expression. Several research studies, such as those conducted by Dr. Ruth Richards of Harvard, Dr. Nancy Andreasen, and KR Jamison, have focused on what exactly it is about manic depression that facilitates creativity. One factor may be that mania produces a heightened state of concentration, allowing the artist to develop a single minded focus on a project, effectively over producing the normally functioning people who tend to sleep longer and generally devote more of their time to non-artistic endeavors. Mania also facilitates intensity of feeling and rapid free-association of ideas.

Brian Beattie recalls the first time he and Kathy McCarty were invited to Daniel's Austin one-room apartment. "Here's this little room filled with millions of notebooks filled with song lyrics, spiral notebooks with comics in these epic adventures, really wonderful stuff, and it was just crap he was tossing off. When we first went up there, he said 'I gotta tell you something, to understand me you have to read this,' and he took out his journal of psychological terminology or whatever it was, something he had dug out of a dumpster, and he said 'this is me,' and he read us the definition of a manic depressive."

Periods of mania enable the sufferer to accomplish a great deal within the usually short timeframe that they manifest. Debilitating depression follows, during which the bipolar person can accomplish little if anything. "I always sort of figured out his mental state by seeing whether he was producing art or not," says Kathy McCarty. "Daniel went years without producing a scrap of art or writing songs."

From "Going Down,"

To think of all
All the times I felt so low
Every time I got feeling better
I got naïve and thought that it
Would stay.

But during manic periods Daniel wrote songs by the dozens and produced hundreds of drawings, constructing his elaborate, interconnected myth world out of favorite childhood trinkets and ideas, some more random than others. He remembers finding an old rubber stamp box while working at Astroworld that "had a picture of a frog on it and it said 'Hi, how are you?' That's how I discovered Jeremiah." Obviously, the name was appropriated from *Three Dog Night's* "Joy To the World," but with that almost incidental found object, Daniel created a cluster of songs referencing both the frog and the phrase "Hi, how are you?" On Daniel's original recording of "Walking the Cow," he can be heard playing a children's farm animal toy. Immediately after the voice intones, "Listen to the frog," Daniel repeatedly chants, "Hi, how are you? Hi, how are you?" "I realized later it's just something everybody says, but I remembered it from 'Grievances' so I started using it a lot."

Hi, How Are You? and *Continued Story* contain many songs directly animating Daniel's cast of cartoon characters from "Casper," to "Fly Eye," to the several "Joe" numbers. Music and art are the two forms of media used to express the same creative experience. His art is less accessible than his music, because his art is much more codified. Music is always a very direct form of communication, and Daniel's music especially is plaintive, heartfelt, and to the point. But while most of Daniel's songs are easily interpreted recounts of his life experiences, he does sprinkle in many different allusions to his stock cartoon characters. Understanding what these creatures symbolize provides deeper discernment of the songs themselves and their place in the ever expanding cluster structure.

4 | Mature Mythology

"Lucky stars in your eyes."
—Daniel Johnston

Music and art interrelate to express Daniel's internal reality, personifying and attempting to integrate his compartmentalized feelings. Subject matter in his music and art overlap, with entire song clusters built around recurring characters in drawings and song lyrics incorporated as text in many compositions. The underlying structure of Daniel's fully realized mythology is biblical in nature, expressing life in a spinning continuum of evolution, from innocence through experience, corruption, evil, death, and eventual redemption on the spiritual plane. Good is constantly threatened by evil and is avenged by supernatural power.

Kramer has called Daniel "our century's William Blake," and the comparison is striking. Blake and Daniel both combine the media of art and language in their work, and both have devised elaborate mythologies following the evolution of innocence into cosmic redemption. Blake, in his *Songs of Innocence* and *Songs of Experience*, used simple, stark language to express universal truths. Daniel has never read Blake, but much of his visual art in particular reflects one of Blake's dominant themes: the struggle to balance the imposing presence of evil with the fragile, childlike expression of good.

In Daniel's mythological paradigm, creatures continually evolve into their opposites, then back again, and the key to understanding much of his work is rec-

ognizing the origin of each character and then gauging its stage of evolution. The states of being range loosely from pure innocence (from which Jeremiah the Frog originates) to various levels of experience (in which Joe the Boxer, the Good Monsters, and the Superheroes exist) to pure evil as personified by Satan, Lucifer, and Vile Corrupt. Last in the cycle is the manifestation of spiritual redemption, found in Casper the Ghost and his girlfriend Wendy the Good Little Witch.

One of Daniel's most well-known motifs neatly sums up the life cycle process. The lonely stump of a once-great tree trunk lies in a field barren and desolate but for one tiny twig sprouting just in front of the trunk. This is Daniel's symbol for eternal and undying hope, and it is also the subject of his most famous painting, shown on the cover of *1990*. Daniel paints infrequently, but he keeps that piece in his studio for inspiration. "It's such a great painting," says Brian Beattie. "It has that same smeared-on feel as Van-Gogh. The shape is so vibrant and the colors buzz up against each other. I wish he would paint more." *(See page 63 and 70)*

Various other symbols that repeat frequently in Daniel's art include baby blocks (a reference to childhood and innocence), and stars, which indicate night and also a mystical connection to God and heavenly creatures. Daniel has worried that his use of stars might be interpreted as Satanic, as sometimes he draws them upside down, but he insists that "stars are stars and I've drawn them this way since second grade," so nothing more should be read into them. Sometimes the skies in Daniel's drawings are populated by mysterious black holes, into which characters fall and reemerge. This is a reference to The Beatles' "Yellow Submarine" and "Revolver" motifs and fits nicely into Daniel's visual vocabulary, already heavily stocked with dangerous magical trap doors. Pyramids and swastikas also sprinkle compositions in reference to the life force and the mysterious watchfulness of God.

The central core of Daniel's iconography is the eye, which connects the body to the soul. The ichthus, the fish symbol for Christ, is prevalent in his drawings, both in its pure form and as a double fish icon. The fish are superimposed tail to head and form an eye, which Daniel has called the "Eternal Eye". This symbolizes to him the incomprehensible beauty of his own soul, everything he can neither articulate nor analyze. "It's a mystery to

Mature Mythology

me too, what I do," he has said. Daniel coined the term "Eternal Yip Eye" for his publishing company, to house his song lyrics, and has put together several incarnations of his ideal back-up band, called "Eye."

"I put the 'Yip' in because Snuffy Smith characters said it a lot and I thought it was a fun word." So the "Yip" and the "Eternal Eye" together embody an underlying theme in Daniel's music and art, the quest for fun, good humor, and the benevolence of God and all his mysteries.

There is a strong need to counterbalance good with evil in Daniel's work. The simple pure eye evolved further into the "Flying Eye", symbolizing a supernatural watchfulness over Daniel that is both comforting and sinister at times. "The 'Flying Eyes' are always watching me," he says. "It's like I'm in a movie all the time." In some drawings 'Flying Eyes' crowd the star-sprinkled skies like bats beginning their dusk flights. In other drawings one or two 'Flying Eyes' hover in clear daylight, surreptitiously recording the action below.

Daniel recorded one haunting, disturbing song called "Fly Eye," on *Hi, How Are You?* It's a minor chord dirge set to a skipping drum machine. The lyrics drone softly, like a hopeful, exhausted mantra:

Fly eye, into the night
It's all right.

He has called them "good/evil" creatures and in the song seems to be casting a gentle spell to transform them into less ominous constant companions.

Another variation on the single eye theme is what Daniel calls the "Weirdie," one-eyed, one-legged smiling or screaming creature. Its presence exerts less power than the "Flying Eye" on the central characters in the compositions. The "Weirdie" seems more of a nuisance or begrudging companion than a distinct threat, almost a personification of an old nightmare, one which has long ceased to terrify yet won't go away.

The presence of multiple eyes is a good gauge in recording the evolution of characters in different stages of innocence and experience. The more eyes a character grows, the more corrupted in the ways of the world that character has become. Eventually even Jeremiah the innocent two-eyed Frog becomes a living embodiment of evil, the multi-eyed beast Vile Corrupt. Daniel says, "The more you

Mature Mythology

see, you have to grow more eyes to see it. I was always fighting that." Many drawings feature Daniel in various battles with multi-eyed beasts, clearly the "sad sac" underdog.

"To understand Daniel's art," says Dave Thornberry, "you have to find him, literally what figure he is, in it." Every drawing is in some way a self-portrait, and therein lies the compulsive quality of his art, this mantra, this need to address the endless internal dialogue Daniel is engaged in with his many compartmentalized selves. "Daniel is the guy without a head," says Thornberry. "He's the frog, or the duck, the polka-dot underwear guy, or anyone ever being trod upon or completely humiliated by women." Frequently he appears with the top of his head missing, and text scrolls out of his brain uncontrollably. This is a literal metaphor for much of his art and music, an inability to hold anything back, spilling forth embarrassingly personal expressions of vulnerability. He is a man without a shell to hold in his feelings. But so much of Daniel's art is a cycle of desperate love, brutality, lashing out, then a bouncing back to happy idealistic states, and in many drawings the Daniel character is perfectly content, surrounded by his innocent, self-contained, happy companions.

Creatures of Innocence
Jeremiah the Frog

Jeremiah is Daniel's id and also his signature image, representing pure innocence unadulterated by experience. Jeremiah has two eyes on tall stalks and short amphibian legs. As Jeremiah becomes wiser to the world, he begins to grow more eyes, "so he won't be so naïve," Daniel says, and Jeremiah's legs sprout to first lizard then human proportions. Jeremiah in full evolutionary bloom appears as a human figure with frog face and many eyes, struggling to reconcile his childlike spirit with the corrupt world.

The Duck

The duck in its pure form is a simple phallic symbol, "a cock and two balls," as Dave Thornberry describes it. The duck is not completely innocent, but is simple, well-meaning and good-natured. Daniel insists he had no idea the duck was phallic until Thornberry pointed it out to him. "My friend said they were phallic and I guess I realized he was right. But I kept drawing ducks and eventually they

became highly intelligent, with arms and legs. They can operate machinery, and tanks, and computers, and play rock 'n' roll music. I thought, wow, look at that." Like all of Daniel's creatures, the ducks at some stage in the creation cycle take on a life of their own, which Daniel is fascinated to witness. The duck is one of the few creatures to occasionally evolve into female form. The female duck functions on the same curious interactive level as the male duck but is rarely the featured subject in a composition. In the full end cycle of evolution, the duck appears as a multi-eyed, multi-headed beast, capable of terrible destruction, yet a monster of reason and humor. Frequently the duck-beast's many heads converse with each other and show a spectrum of expression from anger to glee, as if giving voice to the total range of its personality imbues the duck with a terrible, wonderful, uncontrollable power.

Sassy Fras the Cat

The cat is possibly Daniel's earliest character and is based on his childhood pet. In Daniel's early comic book narratives, Sassy Fras begins life as an innocent cat, then evolves into first a girl, then a man, then a superhero, fighting off evil forces. In Daniel's adult work, Sassy Fras does not evolve but remains a benign, comforting presence, rarely the central figure in a composition.

Creatures of Experience
Polka-Dot Underwear Guy

The "Polka-Dot Underwear Guy" is one of Daniel's earliest alter egos, begun in high school. The character appears as a no name, faceless, sometimes completely headless stand-in for Daniel or anyone embattled by life and its capriciously powerful creatures, especially, of course, women in all their many forms.

Joe the Boxer

The "Polka-dot Underwear Guy" evolved into Joe the Boxer sometime in the early eighties. He is Daniel's "everyman," an average guy trying hard to defeat his demons. A massive song cluster has been written about Joe, which talks about fighting darker forces, feeling overwhelmed and outmatched in a no win

battle. "Hey Joe" offers badly needed consolation to the battered fighter, urging him to think of life in a better light:

> Hey, Joe, don't make a sad song
> Even sadder
> Than it already is.

The song concludes with hope and heavenly inclusion for the weary misfit and his sad outcast companions, anyone who has loved, lost, battled or been misunderstood:

> There's a heaven and
> There's a star for you.

Joe may lose round after round, but he keeps getting back up. "You're Gonna Make it Joe" was the first song in the cycle. Daniel recalls, "I drew pictures of boxing monsters and traveling with the carnival when I first got to Austin, and I was thinking, 'I'm tough.' Then I boxed in a fight and this guy hit me and gave me a concussion, so I called the next album *Retired Boxer*." Sometimes Joe is himself multi-eyed, having evolved after innumerable fights into a wiser, better boxer, but more similar to the monster he's fighting than perhaps he would like.

Frequently Joe is further handicapped by his open gaping skull, making the match even more overwhelming, frightening in the sense of loss of physical control. In many of the Joe songs, the character struggles to control his anger, with mixed results. In the songs, he names his monsters; he's clearly battling his own illness. From "Keep Punching Joe," a rousing lounge-type ballad, comes this:

> My soul's like running water
> Hot or cold now one or the other
>
> I guess I lean toward the excessive
> But that's just the way it is
> When you're a manic-depressive.

Later Joe expresses his pent-up anger at the futility of fighting a battle he's not equipped to win:

> I got some things to get off my chest
> How am I supposed to give love
> When I never got love
> And what the heck am I punching for
> How am I to look
> God in the face
> When I feel so much disgrace
> That's better off my chest
> Than out of my mind
> Keep punching Joe.

In possibly his angriest Joe song, "No More Pushing Joe Around," Daniel vents his rage at family and friends. He has given up the fight against his darker forces and is tired of feeling apologetic

and ashamed of his condition. If he has to exist in a state of rage, so be it; he's fed up with feeling put down because of it:

> He knows how to be angry now
> Ever since his nervous breakdown
> Everybody's been pushing Joe around
> He was always apologizing
> You could hit him in the face
> And he'd just say I'm sorry
> But now he's changed his story
> He sees no glory in pain
> And he's come to like the sunshine
> Better than the rain.

Of course, the song ends with Daniel chanting repeatedly in mock contrition:

> I take it all back
> I take it all back....

Joe knows his anger is inappropriate, but once in a while even the most resolute fighter breaks down, gets a little angry, and regroups before the next battle, the life-consuming fight for self-control against debilitating illness.

Good Monsters

There are many variations on the Good Monster theme, including Frankenstein, King Kong, and the Incredible Hulk. "They're not bad people," explains Daniel. "Even a monster can be good. You never know about people." Large, benign, clumsy monsters express Daniel's sense that "most people are all right. They might have a little something troubling them and it comes out in a bad way. But if it was gone, that bad feeling, they'd be all right people."

In many ways akin to Joe the Boxer in his angriest, most frustrated incarnation, the Good Monsters struggle with an inability to communicate or establish a connection with the objects of their desire and frequently act out in destructive ways, against their best intentions. They desire to be good but are not equipped with the capacity to function within the parameters of proper, constructive behavior.

From "King Kong,"

> When he saw the woman
> He took her without question
> Because after all
> He was the King
> And he loved the woman
> He loved the way she looked
> But she wouldn't stop her screaming.

Mature Mythology

In the truest sense of the original Frankenstein, the Good Monsters are lonely beasts with minds large enough to comprehend the impossible conditions in which their hearts long to live and love.
From "Frankenstein Love,"

*And there was the night
The monster battle fight
They swore they cut me open
I said you must be joking
Just look at my scar
I've been pushed around
But I'm on the rebound*

*Someday maybe I'll
Come out o.k.
And I can be a hero in the end
But I'll always remember
What I can't forget
You can't kill my spirit.*

Good Monsters ally themselves with evil inadvertently because their desires and emotions overwhelm their better judgment. Frequently they find themselves in battle with Superheroes, who will inevitably, by definition, defeat them in the name of greater good.

Superheroes

Superheroes harbor no ambivalence as to their true nature. Their only internal conflict lies in whether they are strong enough to carry out their mission, which is to avenge evil and facilitate good. They are one step devolved from the true supernatural and consequently have superpowers but are not completely invulnerable. They are more Christlike than Godlike. Spiderman is a repeated motif, but Daniel's signature superhero is undoubtedly Captain America, symbol of Divine Glory and the American Dream. This

Daniel equates with God and the Chosen and also with a sense that all is right and happy with the world. In "Happy Time" he recalls the favorite and most magical fractured dream memories of childhood.

*The picture drawing
The pretend heroes
My favorite was
Captain America
The little girl
The flowers in the yard
The dog and cat
The welcome mat.*
Captain America is the ideal

superhuman, capable of an occasional misstep, but always clear in his quest to save good from evil. Daniel has often equated his father with Captain America, indicating extreme hero worship of the elder Johnston, a decorated war veteran. Bill Johnston has found himself playing into the delusion at times when it proved expedient. "I used to think my dad was Captain America," Daniel has said, "back when I wasn't thinking right." Bill Johnston agreed with a solemn chuckle. "That's how I got him to take his medication. I said Captain America wants you to take it."

more sides of something at once. Some people think they know more about a person than the person knows, and that's not right. It's not right to bug people about things." The name itself was conjured from an early cartoon Daniel drew of Captain America defeating a snake-eyeball creature. The text read "You vile corrupt!" From there the name stuck.

Daniel's music makes frequent mention of personifications of evil and the dangers inherent in getting too close to these monsters. "Don't Play Cards With Satan" offers playful but well-heeded advice for the novice:

Creatures of Evil
Vile Corrupt

Evil has many forms and many names, from Satan, to Lucifer, to Vile Corrupt. It takes the form of the traditional cloven-hoofed Devil, or the multi-eyed beast, or any number of nightmarish beings. It is frequently depicted torturing the innocent, corrupting small creatures, lusting after female torsos, and boxing poor Joe. "Vile Corrupt," says Daniel, "is what the innocent frog could become if he developed more eyes. I think it's evil to see

Don't play cards with Satan
He'll deal you an awful hand.

And later Daniel, feeling cocky in a rare moment of perceived victory over his demons, insists that his battle is over and won.

From "I Killed the Monster,"

I know it's right, I learned to fight
I killed the monster
Let it be said when I am dead
I killed the monster
He put me down through

*Many rounds
But I have found a good thing
I killed the monster.*

The song, recorded during a short time of happiness and stability, predicted events that have sadly not come to pass as yet. After *Artistic Vice* was recorded, Daniel wanted to have the song excluded from the record because he realized, sometime after the recording and before the record release, that the monster was in fact not dead after all.

Creatures of Redemption
Casper the Ghost

Existing on the spiritual plane, in the last and purest stage of the evolutionary cycle, is Casper the Ghost, "a close personal friend of mine." Star subject of another vast song cluster, Casper, along with his girlfriend Wendy the Good Little Witch, personifies the redeemed spirit and appears in many drawings as the helpful voice of encouragement, compassion, and hope. Since Casper is dead he is truly invulnerable. In "Casper the Friendly Ghost," Casper never shows animosity toward those who abused or underestimated him. Now in the afterlife, he lives on as the closest thing to an angel in the paradigm, still committed to the service of mankind, ministering to the sad and disaffected, and to the many Daniels.

*And now they say
We'll never forget what he learned us
We were mean to him but he
Never burned us
Love lives forever
Thank you, Casper the
Friendly Ghost.*

Casper is a playful companion who "majored in music in heaven" and "likes the number seven." He amuses and comforts Daniel, who is proud to know him.

From the upbeat "I Know Casper,"

*He always comes to see me
Almost all the time
He's my friend
He jumps into the TV
Pretends he's in the movie
I go to change the channel
And he's on every station.*

Taking the song cycle to its logical conclusion, "Casper the Holy Ghost" completes the deification:

*He's the ghost with the most
He's the best at being the best
He's the one and only Host
He's Casper the Holy Ghost.*

In the drawings, Casper evolves into God himself, portrayed as a tiny naked bald man, smiling, one hand outstretched, surveying his world. It is nearly impossible to tell where Casper leaves off and God takes over.

The Orb and the Lightbulb Man

Daniel has recently begun creating new characters to populate the spirit realm. The Orb, which he also calls the Oracle of God, appears as a one-eyed, slump-shouldered humanlike creature with a big mouth that very rarely smiles. The Orb is not a central character in the compositions, but instead takes in the action and reports it back to God. Daniel has described him as sad because so much of what he sees "makes him want to cry."

The Lightbulb Man is less a thinking, feeling creature and more a literal personification of the idea or ideal of God or eternal goodness, that which the other characters aspire toward in their bumpy journeys through evolution and self-revelation.

Women

Women are nearly always objectified in Daniel's art. They are not part of the dynamic, mutating world the rest of the characters exist in. Women are static, frozen in posture and form, yet exert enormous power over the accompanying characters. Most frequently women are depicted as headless, limbless torsos. Daniel says this image came from looking at pictures of poorly preserved ancient statues, the "Venus de Milo" in particular. But his torsos have more of a "Venus of Willendorf" feel, with massive breasts and thighs. Women very rarely participate in the evolutionary process. When they do, it's usually a devolution, where women grow snake and lizard bodies. They are usually imposing, totemic creatures, which personify a certain frustration and

Mature Mythology

lack of understanding on Daniel's part, as well as an idealized, chivalrous, inviolate admiration.

Many drawings feature torsos with lightning bolts shooting out of their severed limbs. In his dehumanization of the woman, Daniel has also imbued her with supernatural powers, thus further intensifying his awe, fear, desire, and distrust of these strange, powerful, utterly inscrutable creatures. Even when women are drawn in full human form, they are nearly always naked and are being acted upon as the objects of love or hate. Daniel's fascination-from-afar depiction of women in his art is also clearly reflected in his music. Women are unreadable glorious creatures with the superpower to bestow happiness and fulfillment if only Daniel can win their hearts. And this he tries through sincerity, flattery, and persistent worship.

From "Grievances" comes the famous motto:

*If I can't be your lover
Then I'll be a pest.*

Partly to temper his obsession, Daniel likes to recite a brief list of names of women he's written songs for throughout the years. However, he would never deny that the bulk of his art, music, and life force have been spent longing for another chance with his mythical Laurie.

Laurie the Eternal Muse

It is testament to the power of Daniel's creative obsession that he still manages to define his music, and indeed his mental health, in terms of remembering his relationship with Laurie. As is clear in the many different song clusters about Laurie, their friendship was brief and never more than platonic. But, sometimes a muse takes on a life of its own, far removed from its source, never changing, frozen in crystal clear remembrance, as if the power of creative devotion has produced a living entity from a cherished long ago experience.

"Who would have thought," says Brian Beattie, "that you could wring so much out of one little thing. Daniel is a microcosm, he was like this simmering blob of energy and Laurie was the big bang, and it all kept expanding upon itself from there. I think he holds onto the memory of the feeling and instead of trying to put it behind him, he analyzed it all so carefully that it's like some kind of elegant model he can examine different aspects of, and think about, and draw, all from one little experience to make another song out of."

"It was weird," says Daniel, "but she invented me for some reason. She defined me. I became somebody because of her." Daniel began writing songs in college to woo and amuse Laurie, who encouraged his creative endeavors. "She knew I was

hooked on her and she handled it pretty well." At the time, Laurie was dating the son of the local undertaker. Soon after, she found herself pregnant and married, and the undertaker's son took over the family business.

"He's been writing songs about her for 20 years," says Dave Thornberry, "and he probably hasn't seen her in 18 years. I don't think he's thought about the real Laurie in a long time." It would seem that Laurie's actual life is less essential to Daniel than the mythological objectification of a real person into a forever young muse. Daniel keeps up with Laurie through friends and family, and he has received an occasional phone call from Laurie herself over the years. He dedicated Artistic Vice to her and sent her a copy. He was later thrilled to hear that she liked it, and that response fueled the Laurie song cycle over the next several years.

Having recently learned of her divorce, Daniel quoted to a friend the lyrics of an untitled, unfinished song:

*I heard she got a divorce
and I'm hoping I'm next in line of course.*

Although Daniel was briefly and happily reunited with Laurie at a showing of the documentary *The Devil and Daniel Johnston*, he remains unconditionally devoted to the Laurie of his imagination. In his heart and his art, Laurie is forever the kind, beautiful woman who sat down next to him in art class and instantly became the symbol for everything good about himself and the world. Brian Beattie said, "I know Daniel is feeling better when he starts writing songs about Laurie again." Daniel himself agrees. "I'm trying to get some new subject matter going, but for some reason it's always still there. I can't help it!"

Laurie Allen lives in the mid-west, works in the computer industry, and is the mother of two nearly grown children. She has followed his career some; she gave her children the copy of *Artistic Vice*. She says her children appreciated the music "more than most would. They thought the 'Laurie' song was neat." She thinks highly of Daniel but seems to have little idea of the enormity of her impact on him. "I walked into the classroom and next thing I know we're friends and having fun and hanging out. He used to draw little characters in my notebooks and have them say things. He was trying to get me to leave my boyfriend. It was a scream!"

Laurie considered their friendship "a very positive thing. I worked in the bookstore at Kent State, and he came in to see me a lot. It was always flattering and never got harmful or made me feel fearful. I never had to tell him to leave me alone. And I kept all the notebooks he drew on. It really was a nice thing." Laurie has never listened to Daniel's entire body of work and so has little inkling that the vast majority of his songs are directly about her. When apprised of her unwitting influence on Daniel's songcraft, Laurie says, "I'm blown away by that. It's nice to know I had a positive impact in whatever small way. I don't talk to him much, but I do think of him and I'm glad he's writing good things that stem from his past."

The Laurie songs fall into two categories. The General Muse are nonspecific love songs which are based on Laurie but reveal little about their actual relationship. Then there are the exquisitely,

excruciatingly autobiographical narrative songs, which are true-life down to the last detail. In the first category comes the melancholic yet hopeful "True Love Will Find You in the End:"

> *Don't be sad, I know you will*
> *But don't give up until,*
> *True love will find you in the end*
> *This is a promise with a catch*
> *Only if you're looking can it find you*
> *True love is searching too*
> *But how can it recognize you unless*
> *You step out into the light.*

In the autobiographical category comes a vast cluster of songs built around actual experiences that Daniel is compelled to relive over and over, an endless memory loop.

From "Laurie,"

> *She worked at a store, I'd often*
> *open that door*
> *Just to see her face*
> *She always made me*
> *feel at home*
> *I never felt out of place*
> *But she already had a boyfriend*
> *An undertaker was he*
> *And they got married and*
> *Had a little baby.*

The funeral home/undertaker theme dominates much of the song cluster. For Daniel the fact that "My baby cares for the dead" is an irony without equal.

Later from "Laurie,"

> *I became obsessed with death,*
> *My friends*
> *Certain it would happen to me*
> *Then I would be in the hands of*
> *My dear Laurie.*

The funeral cycle in fact has become a signature image for Daniel. The simple, rousing "Funeral Home" is one of Daniel's most requested and recognizable songs.

> *Funeral home, Funeral home*
> *Going to the Funeral home*
> *Got me a coffin, shiny and black*
> *I'm going to a funeral*
> *And I'm never coming back.*

Daniel recounts the story of seeing Laurie again at the funeral home "hanging coats for the guests" in minute detail. "The Startling Facts," from *Artistic Vice*, recorded nine years after the actual event, lays out the experience in as clear recall as if it happened the day before:

> *She looked so beautiful*
> *I walked up to her and shook*
> *Her hand*
> *And I said Hi how are you*
> *At the graveside services during*
> *The prayer*
> *I looked up to look at her*
> *And the undertaker popped me*
> *The finger*

*I never will forget
Such a striking predicament
The feeling of it
The body in the casket.*

Part of this story is also told in what Daniel describes as his "first good song, the one that really came together," a song from which many others spring forth
From "Grievances,"

*And I saw you at the funeral
You were standing there
like a temple
I said Hi, how are you, hello
And I pulled out a casket and crawled in.*

Song Clusters

Throughout his songwriting career, Daniel has referred to phrases and characters in earlier songs, in effect creating a shorthand language. Although most of his songs are easily deciphered and stand on their own merit, deeper insight can be gained by following the arc of the song cluster.
Again from "Grievances,"

*And the librarian said
You can't buy no respect
I said hey lady what can
you expect
When I'm lying on the floor.*

This fragment is alluded to in "Casper the Friendly Ghost:"

*Nobody treated him nice
While he was alive
You can't buy no respect
Like the librarian said
But everybody
respects the dead
They love the friendly ghost.*

"Grievances" ends with the petulant promise that "If I can't be your lover, then I'll be a pest." This is referred to again in "She called Pest Control," from *Hi, How Are You?*

*She called pest control
And when she was sprayed
She never was bothered again.*

"Keep Punching Joe" also mentions Joe's self-admitted, sometimes pest like behavior, with a "Dial P for Pest Control" toss-off refrain. "Hey Joe" mentions the "nervous love" featured in an earlier song of the same name.
From "Hey Joe,"

*I know you're thinking
of your nervous love
I know exactly what you're
thinking of.*

What he's thinking of is "Nervous Love," also from *Hi, How Are You?*

*I've got a nervous love
Worry is all that I do.*

"Walking the Cow" was inspired by an illustration of a little girl on a Blue Bell ice cream tub pulling the reins of an uncooperative cow. "To me," Daniel has said, "this meant responsibility or your burden. It's like she's out there walking her burden or doing her duty."

*Try and point my finger
But the wind keeps turning
Try and point my finger
But the wind keeps turning*

Mature Mythology

Me around
In circles, in circles
Lucky stars in your eyes
I am walking the cow
I really don't know what I
have to fear
I really don't know what
I have to care
Oh, oh, oh, I am walking the cow.

In "Keep Punching Joe," Joe explains what he's been up to since the last song:

Listen folks I gotta tell you now
I've been singing the blues
And walking the cow.

Perhaps no other song crystallizes the experience of Daniel Johnston more concisely than "Museum of Love," a jaunty, haunting up tempo romp through the "hall of sadness" into "the exhibit of madness" which has preserved his unrequited nervous love for all to see.

This is right here where
He stood
When he said those
Sacred words
And he made a holy vow
And these are the drawings
And the library card
And this is the cow.

There are many other examples of references and allusions to earlier songs in Daniel's body of work. His music and visual art exist in tandem, organized into a complicated, codified structure that facilitates easy expression through use of symbolic language and repeating images. More subtle shadings are found through slight variations or evolutions in the themes or characters. Certain songs may

Borden cow and walker taken from a Daniel Johnston notebook

Another cow walker and inspiration for *Walking the Cow*

tell the exact same story, but express different emotional outlooks. Drawings may contain the same characters but at different stages in their evolution. Since Daniel's supreme focus in his art is to address his internal dialogue relating to his experiences in the world, it helps to understand that the entire body of work functions as a complete vessel, from which individual exquisite teardrops fall into tiny holographic tales of love, loss, fear and wonder.

Digital Daniel

Early work of Daniel Johnston

Various styles of Daniel Johnston

Various watercolors by Daniel Johnston

Early Paintings by Daniel Johnston

Selections from the Whitney Biennial 2006

Various photographs of Daniel Johnston

Jeff Tartakov

Don Goede

Maurice Narcis

Johnston Archive

Jeff Feuerzeig

Jeff Feuerzeig

5 | Cult Phenomenon

*"I'm a loner.
I'm a sorry entertainer."*
—Daniel Johnston

Austin, TX 1985 Deb Pastor

Austin has always been a lively place. It is both the state capital and the home of the flagship campus of the University of Texas. The college students that flood the city often stay past graduation and settle into the city's livable, hippie, high-tech, country blend of sensibilities. As a result, Austin is a medium-sized city with a small-town, yet highly educated, feel and more than its fair share of entertainment. Live music is played in roofless clubs and kids, freaks, cowboys and civil servants mix it up on "the drag" near U.T.

The Austin music scene has flared into national consciousness more than once, but it has never been strip-mined, co-opted, and devalued like Seattle was in the early nineties. Austin's first national export was the late seventies outlaw country sound of "Waylon and Willie and the Boys." In the mid-eighties, jangle rock coexisted with blues, country and punk. "It was the post-punk time..." recalls Brian Beattie, "Everything was settling into a few different directions. A few years before, everyone was trying to be original, but at that point there was a trend toward the traditional, with people getting back out their rock 'n' roll guitars."

At that time Glass Eye stood out as a quirky, arty, funk band that went for irony rather than the more prevalent sincer-

ity rock. "They had the tightest rhythm section," remembers spoken word artist Wammo, "and the duality between Brian [Beattie] and Kathy [McCarty] was nice. They were my favorite band." Glass Eye was also Daniel's favorite band. To this day he ranks Glass Eye with his true idols: The Beatles and Bob Dylan. Daniel gave both Brian and Kathy tapes of his music, but Kathy didn't listen to hers. So, when Daniel approached her soon afterward, soliciting a response, she was flustered. Having never heard the tape, she went ahead and told Daniel that she liked it and she offered Daniel an opening slot at the next Glass Eye gig. When she finally did listen to the tape, she was not disappointed. "I was blown away," she says, "I just knew he was a genius."

"I met [Daniel] at McDonald's," says Wammo, "and of course he gave me a tape. Then I heard him play at the Beach.

Homestead Records publicity photo of Daniel

Daniel with fans at McDonalds

Cult Phenomenon

He did a song about packing all his clothes in a garbage bag and joining a carnival. I thought, holy shit, what is this?"

From "Broken Dreams,"

*When I was out in San Marcos
A year ago today
They probably would have put
me in a home
But I threw all my belongings
Into a garbage bag
And out into the worldness
I did roam.*

The quivering performance at the Beach signaled Daniel's arrival onto the Austin music scene at the same time that MTV, then still in its infancy, gave local musicians a slot on national television. Bands included Glass Eye, Timbuk-3, still a couple years from their breakthrough single "Future's So Bright (I Gotta Wear Shades)," Zeitgeist, Dino Lee, Brave Combo, and True Believers. Footage was shot of Daniel standing on Sixth Street, introducing himself to the camera. Less than a year after leaving the carnival, Daniel graduated into the local musical elite. His first appearance on MTV's *The Cutting Edge* aired August 25, 1985. Daniel appeared again on the show in December of '86, but by that time he was deep in an acid-soaked downward spiral.

While Daniel was innocently humble about his actual big-fish-little-pond status, he was also borderline delusional. He imagined a role for himself as John Lennon's musical heir. "He was believing in his own myth even back then," says Brian Beattie. "He is so willful. He willed his fantasy world to happen in the same way that he can take a dreamy attitude and turn it into poetry that transports you, he does the same thing with making things happen for him."

From "Psycho Nightmare,"

*It's a tired and slow song baby
Don't be upset
Just remember the future
Has not happened yet
Every shiny thing of good luck
Could be made true
Every single thing you dream up
Could happen to you.*

Daniel's persistence, his complete lack of embarrassment in approaching people, and his canny ability to size up who could help him further his ambitions have served him well. From the original core of people who first came into contact with his music, Daniel built a long-lasting network of friends, supporters, writers, and musicians willing to cover his tunes and spread his name far outside of Austin. He even attracted at least one parodist. Ken Lieck, longtime writer and music critic for *The Austin Chronicle,* used to perform as "Not Daniel Johnston." According to Wammo, "When *Hi, How Are You?* became a phenomenon, Ken put out this tape with exactly the same cover. It said 'How Hi Are You?' and 'Not Daniel Johnston,' with a picture of a dead frog run over by a car. Lieck used to perform as Not Daniel Johnston, and sometimes they performed together." Presently, several other musicians use soft satire or more upbeat renditions of Daniel's music in their core act, notably the Reverend Vince Anderson, who as his signature encore transforms "Funeral Home" from a medium tempo dirge to a Holy Roller communal frenzy.

The legend of the tapes, the crude charm of the recordings, the inaccessibility of Daniel due to his illness and incarcerations, and the rare, unpredictable attempts at performing were all part of his original cult appeal. But what validated him was not his persona or his performance, but the music itself, personal, simple songs in skeletal arrangements that set off an intuitive melodic gift. On the original tapes, the low-tech handling, the strange warbling off-key voice and the occasional screech of "Satan!" have amused five successive waves of college kids. However, listeners have also viscerally connected with the voice and subject matter, and have been eager to share the cult secret, almost a litmus test, a standard by which to measure honesty in other music. "If I can imagine," says Matt Groening, "a song being sung over a car commercial, I find it very hard to take. And, unfortunately that encompasses most of rock 'n' roll. Daniel's music is an authentic expression of his passion with no calculations like you find in the rest of pop music." No word on whether Matt appreciated the inherent irony of Daniel's music shilling for Target in 2001, but undoubtedly Groening wishes Daniel financial as well as critical success.

Daniel went through countless Radio Shack tapes, handing them out free to strangers during his shifts at McDonald's even while the tapes were selling out across the street at the Sound Exchange, which carried *Songs of Pain*, *More Songs of Pain*, *Retired Boxer*, and *Hi, How Are You?* R.E.M.'s manager Jefferson Holt bought multiple copies of each at the Sound Exchange during a stop in Austin. Michael Stipe counts himself among Daniel's many long-time fans.

Butthole Surfer's *Stickmen with Rayguns*

Daniel Johnston's *1990*

Daniel Johnston's *Artistic Vice*

Cult Phenomenon

Gibby Haynes and Johnny Depp's *P*

The Dead Milkmen's *Bucky Fellini*

Genius + Love = Yo La Tengo

The Butthole Surfers were recording the compilation album with friends that became The Texas Trip in Paul Leary's living room when Daniel and Caroline stumbled in, tripping on acid. Daniel wandered up to the mike and began singing his own songs to the Buttholes' music, and a long informal collaborative friendship was begun. In 1985 the Butthole Surfers found themselves in New York without a bassist on the eve of a European engagement. Kramer stepped in and did the tour. Later as a renowned producer and founder of Shimmy-Disc Records, he would record Daniel twice and include his work in several Shimmy-Disc compilations.

Kramer sometimes worked the sound board for Sonic Youth when Wharton Tiers was unavailable. He recalls, "I had all the cassettes. Considering my activities at the time, I'd assume that I first actually heard Daniel in the Sonic Youth van on the way to some gig somewhere. I think I recall playing them Galaxie 500 and them playing me Daniel in the same trip to Boston."

Lee Ranaldo of Sonic Youth remembers "those early tapes that we heard way back on trips through Texas, with the hand glued-on paper covers. The music was so pure, simple and heartfelt that it didn't matter if it sounded a bit amateurish. It was obviously the work of a very great musical seer. The songs all resonated with us, and we played those tapes, *Hi, How Are You?*, etc..., over and over again. Even when we were laughing at the funny chord organ sounds, we were marveling that great art could be made in a bedroom if the songs were good enough and one's heart was in it. The thing was, the chord organ sounds weren't funny, they

were significant because they weren't trying to disguise what they really were. This was all, of course, long before the 'low-fi' revolution came along. Daniel was way ahead of the curve."

After Jeff Tartakov set up Daniel's publishing, he worked out a strategy for placing Daniel's tapes into the hands of other musicians who might be interested in covering his songs. "I thought Daniel would, over the years, stand a better chance at a regular income from other peoples recordings [of his lyrics]." Jeff gave *Hi, How Are You?* to Jad Fair after an Austin gig, and, eventually, a long and fruitful musical and artistic association between Daniel and Jad was spawned. After the two met at Kramer's studio in New York, Jad introduced Daniel to Moe Tucker who went on to cover one of Daniel and Jad's songs on her next album.

Gibby Haynes of the Butthole Surfers formed a side project band with Johnny Depp called *P*, and they covered Daniel's song "I Save Cigarette Butts." The Dead Milkmen covered "Rocketship" on their 1987 breakthrough album *Bucky Fellini*. Yo La Tengo's live radio performance with Daniel became a hit U.K. single, and they eventually included on their 1996 best-of album *Genius + Love = Yo La Tengo*. In 1992, Kurt Cobain began appearing at photo opportunities wearing a *Hi, How Are You?* t-shirt, introducing thousands of music lovers to Daniel's signature image. A few years later, Matt Groening was asked to write a pop culture recommendation for *Rolling Stone's* "Back to College" issue. His choice pick was Daniel Johnston.

Yves Beauvais saw the Bill T. Jones ballet set to *Yip/Jump Music* and brought Daniel into the major label recording elite

Richard Linklater's *Slacker*

Music from "My So Called Life"

***Kids* soundtrack**

Cult Phenomenon

School House Rock! Rocks

Yip/Jump: Number 35 on Kurt's Cobain's favorite albums list

Some of Daniel's medication

a year later. Atlantic at the time was run by Danny Goldberg. "Danny, who used to manage Nirvana," says Beauvais, "knew who Daniel was through Kurt Cobain. I don't think he'd heard his music, but he knew there was something hip there, and this was at a time when Atlantic was trying to be hip, so he supported my signing Daniel to Atlantic."

Richard Linklater cast Kathy McCarty as the Anarchist's Daughter in his seminal Austin comedy of manners, *Slacker*. In the movie, Daniel's music can be heard playing through the door of his beloved Sound Exchange. Later Linklater would include McCarty's recording of "Living Life" in his *Before Sunrise*. Bug Music, which administers Daniel's publishing, placed his music in 1995's *Empire Records* and television's "My So-Called Life." When casting songs for 1995's *Kids*, London Records contacted manager Tom Gimbel, "They knew Daniel had a song about Casper. One of the characters in the movie was named Casper, so they ended up using an old song and a new one." Ron English released two compilation albums in which Daniel participated with Tripping Daisy, Patti Rothberg, Phoebe Legere and Kathy Geary. In 1997 Daniel participated in ABC's *Schoolhouse Rock! Rocks* with an upbeat rendition of "Unpack Your Adjectives."

In short, Jeff Tartakov's original plan worked. Daniel's music began to be widely, almost mythically, distributed. Through an informal circuit, Daniel Johnston seeped into the homes and minds of beguiled listeners, some of whom were in positions to further advance his career. Many tried, only to back away when Daniel's long periods of illness proved impossible to work around. Manic depression is not curable,

and controlling it means finding just the right combination of drugs to restore the brain chemistry balance. Even the right combinations lose effectiveness over time, as organic brain chemistry changes subtly. To complicate matters further, Daniel has not been the best at taking his medicine throughout the years. He has derailed his career more than once due to extended psychotic episodes and subsequent hospitalizations.

Daniel's tumultuous mental health, his crazy genius, and his reputation as a tortured artist has undoubtedly added to his cult mystique, . To his friends and associates his mental illness has been a nearly insurmountable obstacle to true success, either cult or mainstream.

From "A Lonely Song,"

*Well you've heard about the time
I was in the insane asylum
And you read the magazines
I've been wounded by folklore
But I bet you never knew
What I went through
And what I had to do
Just to bring you a lonely song.*

Daniel has achieved a certain level of success in music and art not because of but despite his illness. The mad genius label is not something conjured up by a publicist. It is, like everything else he sings about, very real and a big part of his life, something he wishes more than anything to finally overcome.

From "Going Down,"

*To think that I once had it all
There's a man inside me
I'm gonna destroy
And he will be no more*

Jad Fair — David Fair

Kramer — Macioce

Roky Erickson — Unknown

Cult Phenomenon

*He'll be dead and I'll be free
I unlock the door.*

Kramer, discussing the *1990* sessions, wrote, "I wanted to make recordings that would stand aside from his personal struggles and chemically based hardships. I wanted to make something that would be truly great without the knowledge of his illness accompanying it. I did not want Daniel to become more and more famous because he was so terribly sick. I wanted him to be famous for the fact that his songs were so very stunning, so very original, beautiful, and touching. His illness, though clearly a strong source of a good deal of his inspiration, should not, I felt, be connected to the listening process."

From "Like a Monkey In a Zoo,"

*The days go so slow
I don't have no friends
Except all these people who
Want me to do
Tricks for them
Like a monkey in a zoo.*

Daniel has been compared by many culture and music writers to Austin's other unpredictable rock casualty Roky Erickson, leader of the sixties band 13th Floor Elevators. Roky apparently took too much LSD, necessitating electroshock treatment, and has since lived on disability benefits and the occasional royalty check. Daniel visited him once. "We watched TV together," he recalls. "His mom was real nice." Daniel has also been compared to Brian Wilson, an acknowledged damaged genius in the highest sense, but both of these comparisons focus on the persona of the artist rather than the art. Daniel is more a simple pop songwriter in the

Brian Wilson — CMP Entertainment

Wammo — Unknown

Brian Beattie — Seela

old sense of the word, less interested in instrumentation and layered sound than in melodic construction and concise language. "He sees himself as a tin pan alley type," says Brian Beattie. "Someone who writes songs all day, just spits them out, and maybe one or two will be a hit. Daniel knows he's dipping from a long musical tradition, and he's proud of that."

"I see him more as a classic pop songwriter," says Jad Fair, "like from the fifties and sixties, that type of writing. His choice of words is like no one else, and he puts so much feeling into his songs."

For Wammo, Daniel's appeal was always, "The complete lack of bullshit. He just completely peels off his skin, every compulsion, every need, fear, it's right there, the heartbreak with a little dash of humor and a twist of irony and bitterness. And he has this amazing knack of being able to squish 25 words into a bar, four beats. It cracks me up. He'll be singing along and everything will rhyme and suddenly one line will just go off on a completely different tangent and hit you right in the forehead."

Brian Beattie is fond of Daniel's ability to coin new word usage to fit his song requirements. "On *Rejected Unknown* he has this word he pronounces 'davonare.' First I thought he meant debonair, but he said, no, it was a new word, it meant something like a clever businessman. He's always doing stuff like that, twisting things to get what he wants out of them." One of Daniel's most famous songs, "Rock n' Roll/Ega," which he pronounces "Egg-ah," also employs this sense of coinage. In truth, Ega is an acronym of the chords used, E-G-A, but Daniel considered it such an essential part of the song that he included the word in the title.

As a performer Daniel has always been erratic. But over the past several years he has played out more than ever before and is enjoying a newfound self-confidence that comes with successful performing and interaction with fans, many of whom are seeing Daniel perform for the first time. His fan base ranges from the insider musician crowd to the mildly obsessed and the downright Mooney-esque, from people interested in covering his work to those eager for contact, proximity, and a memento.

During the New York Ron English/Daniel Johnston art exhibition, dealer Jonathan LeVine was caught unprepared for the overwhelming audience reaction. He had taken the precaution of photocopying Daniel's drawings and mounting these on the gallery wall rather than the originals, which were kept in plastic sheathing out of public reach. Most of the 75 drawings were sold midway through the opening, and shortly thereafter LeVine noticed that the photocopies were also disappearing. "I can't believe they stole the copies! Now there's no other documentation that the work existed. Some of that stuff was 15 years old. It'll never be chronicled, it was never photographed. It breaks my heart. By the next day every single photocopy was gone and the show still had another month to run. I was pissed because I had no other documentation of the work and also because I'd worked so hard on the layout and now I had a blank wall."

The next day LeVine posted little signs on the wall which read, "Due to theft we are unable to show you the Daniel drawings." LeVine points out incredulously, "And they stole the signs too! They stole the label tags off the paintings! I'm

glad I bolted Ron's paintings to the wall or I'm sure those would have been gone too. I wasn't prepared for that kind of reaction. Those people were weird. Strange and freaky. I deal primarily with a type of art called 'Low-Brow,' illustrative, graffiti-based, people like Robert Williams and Frank Kozik, and these people have fans, believe me, but I've never seen anything like this."

Daniel's fans were eager to interact, but many kept a respectful distance. After the CMJ gig at the Knitting Factory, as Daniel stood outside while Gimbel negotiated his payment with club management, a shy beaming fan approached holding a beat-up organ. He asked Daniel to touch it. Daniel obliged. The fan smiled, satisfied, and walked away.

New York club promoter Lee Klein describes the bumpy night spent shuttling Ron and Daniel between gigs at Sidewalk café, the Knitting Factory, and the after-hours party at Cheetah night club arranged by Klein: "I made it to the first gig already underway with a packed audience overjoyed to see the jovial songster in fine form." The evening at Lach's "Fort" at Sidewalk Café, a venue long famous for its devotion to "anti-folk" music and its open-mike night, was a celebration of Daniel's music. After his short set and the ritual passing of the tip jar, which soon overflowed, the open-mike began, with performers taking turns doing covers of Daniel's songs.

English, Johnston, and Klein did not stick around. They wandered next door with Marie Javins into a deli for a soda, surrounded by fans. "It was a surreal scene," says Klein. "In the grocery aisle Daniel stood trying to assemble his tip money into some semblance of order while people flashed cameras and a homeless man tried to serenade him out of his money. Meanwhile, this circus was all visible on the grocery store's security monitors like an unplanned special brought to you by in-store television."

The party headed over to the Knitting Factory for the next gig. Afterwards, at Cheetah, Daniel did a two-song set in exchange for a $100 payment that Klein had bargained from club management. He did one encore number then settled into a seat in the back, surrounded by admirers and one particularly pushy young woman. Daniel asked Ron if he could take her home. After an emphatic "no," Ron and Daniel finally ended their evening, returning to Ron's loft. Later, Klein happened to notice the young woman flashing a $100 bill. "When she told me Daniel had given it to her, I got very angry. I had worked hard to arrange for that money. The club hadn't wanted to pay him anything. I couldn't believe she was flashing that bill around."

Daniel has always had a hard time hanging onto his money. He loves to buy rare comic books and bootleg albums, and seems to enjoy handing out money to fans and strangers as a gesture of generosity. Friends and family know this and have desperately tried to curtail his wild spending habits in hopes of building a more secure nest egg for Daniel to live on in later years. His octogenarian father is his most constant traveling companion, but many of Daniel's friends and fans have also facilitated his touring and performing by taking on roles as personal caregivers, financial planners, drivers, guides and sitters, doing it for the sole purpose of seeing Daniel succeed. By 2002, Bill's older son Dick was making the transition into

the role of Daniel's day-to-day manager and tour coordinator. Dick now handles most of Daniel's management needs, including catalog and publishing issues, contract negotiation, scheduling, press access, and maintenance of the Johnston family's hihowareyou.com website.

Daniel Johnston's cult fame centers around his innocent inability to come off as anyone but himself, a strange, lonely, fun-loving kid trapped in a body that doesn't obey but follows warped rituals all its own. He is a perfect cult legend in every way except for the fact that he's still living, and this is something that those who care for him and his music are determined to keep current. Daniel does not have a death wish. He wants to be healthy and famous, professional and rich. This may never play out exactly to his dream specifications, but hopefully, with the support of the strong network of admirers and facilitators, he will continue to play, record, and interact to a safe degree with the legions of listeners who love him.

The extraordinary success Daniel has achieved, since beginning an upward psychological swing in 1999, suggests that with proper support, Daniel's professional life may have fewer limits than any of his friends and family had previously imagined. Within the last five years, Daniel has been the subject of an acclaimed documentary; his music, art and mythology have been the centerpiece of a stage musical; he has played his music in prestigious venues throughout the world; he has exhibited his art in solo and group shows in museums and galleries worldwide; and he has achieved the pinnacle of success for an American artist: inclusion in the Whitney Biennial in 2006. Through a confluence of support from influential and creative admirers and people in positions to offer help, Daniel has become the beneficiary, and the subject matter, of the art of others—an utterly appropriate reciprocal gift for a man who embodies the struggle of the socially alienated to communicate with the world at large his very personal, ultimately universal story of himself, the story of an artist.

Daniel's reflection

Daniel's Jeremiah the Frog mural in its Sound Exchange days in Austin, Texas

How it looks in 2006 after a Save-the Frog campaign and a gracious new owner

Daniel and Jad

David Fair

Jad and Daniel's *It's Spooky*

Moe Tucker's *Life in Exile*

Jad Fair & Kramer's *Roll Out the Barrel*

6 | Collaborative Music & Art

"Giving it up so plain."

–Daniel Johnston

Daniel has always depended on the kindness and interest of friends, fans and supporters to facilitate his career, and friends have been happy to help, motivated by love of the man and his music. This has resulted in collaborations and reinterpretations of his work by others. Paul Leary and Brian Beattie both went so far as to haul professional recording equipment out to Daniel's garage, beginning a tradition that continues today of visitors arriving at Daniel's parents' house bearing guitars, amps, and DAT recorders. Over the years Daniel has combined forces with others to produce very striking work. His recordings with Jad Fair, however, come closest to true collaborations. Jad's music is similar to Daniel's in that each mines the sensibilities of boyhood to create low-tech, idiosyncratic, slice-of-life material.

Daniel and Jad first came together in 1988 with unfinished songs, completed them together, and composed others on the spot. One of these dual compositions, "Do It Right," was covered by Moe Tucker on her *Life in Exile After Abdication*. Daniel and Jad also covered two Glass Eye songs, "Come Back" and "Kicking the Dog," on their dual album *Jad Fair/Daniel Johnston*, and Jad put his own spin on Daniel's

"King Kong" for his collaborative effort with Kramer, *Roll Out the Barrel*. Recently Jad returned to Texas for another series of recordings with Daniel, to be released possibly on 50 Skidillion Watts Records. "It was fun," says Daniel. "We did a couple shows in Austin and Houston. We each wrote songs and took turns singing lead and playing drums." They formed a band called The Lucky Sperms.

Also a visual artist, Jad has been curator for several group shows, always including Daniel's art in the mix. In 1999, the two attended a summer art opening and performance in Berlin. Jad works primarily with intricate paper cuttings. Juxtaposed with Daniel's loose, emotional lines and mythological subject matter, the paper cuttings are strikingly dissimilar, precisely patterned and painstakingly rendered. Jad and Daniel have never collaborated on visual art, although they have exhibited together frequently. Both have erected their highly personal visionary universes, but they have, to this point, kept them separate.

Less a collaboration, and more an interpretation and furthering of artistic vision, is Kathy McCarty's *Dead Dog's Eyeball*. "Since I first heard Daniel's songs, I had wanted to make it," explains McCarty. "I just never had time. Glass Eye broke up in '93, and I thought, well, I've had projects I've wanted to do, and now I have time. It was the next thing I did." Produced by Glass Eye partner Brian Beattie, the songs were culled from the early tapes favored by McCarty, primarily *Songs of Pain, Hi, How Are You?*, and *Yip/Jump Music*. "I never listened to the later stuff that much," she says, "the Shimmy or Atlantic stuff. I'm most familiar with his

The Lucky Sperms' *Somewhat Humorous*

Kathy McCarty's *Dead Dog's Eyeball*

Kathy McCarty's *Sorry Entertainer*

very early recordings, the West Virginia and early San Marcos periods. God, I'm talking about him like Picasso! The Blue Period! His early Blue Period, I think."

Daniel did not participate in the recordings. The effort was not collaborative in that sense, but McCarty and Beattie used what they considered to be the essence of Daniel's intent as a jumping off point for their own musical interpretations. "One of my criteria in picking songs," Kathy says, "was I didn't do any songs I thought I couldn't improve or clarify in some way. Like people have asked me why I didn't do 'Speeding Motorcycle.' I think Daniel's version is really good and anything I did would just be a copy. The songs I did were ones that I felt people would really like if they could hear them past the low fidelity. One thing I noticed as time went by was that other artists could listen to the tapes and totally hear the song, but to most other people it sounds like some horrifying noise, like listening to someone have a nervous breakdown on tape, this disturbing thing, and they don't really hear the song."

Beattie and McCarty sampled musical ideas from Daniel's repertoire, applying them where it made sense and seemed appropriate to the original intent. Says McCarty, "I would think about what Daniel was trying to do, like here he's playing on a chord organ and singing, but in his mind if he had vast and unlimited musical resources, how would he want it to sound, and that's what I would try to do. Like 'Rocketship,' I thought the song always seemed to be leaning toward the Bowie-esque. Other songs like 'Grievances' are absolutely plain, just with piano. I think that's how the song was supposed to be." The album is gorgeously done, and many listeners have ironically cited *Dead Dog's Eyeball* as their favorite Daniel Johnston release. "What's my favorite Daniel song?" says Marie Javins, half in jest, "'Living Life' by Kathy McCarty!"

Kathy sings in a strong clear alto that at times sounds remarkably similar to Daniel's voice. She did not change the gender of most of the pronouns, and her performances interpreted the songs like a brilliant beaded tapestry from a ballpoint drawing. She and Beattie added layers of sound and meaning but stayed true to the intent of the songs, even performing "Running Water," like Daniel's version, to the accompaniment of actual running water. Her version was recorded in a University of Texas bathroom.

Although Kathy admits *Dead Dog's Eyeball* has been her best-selling album to date, she has no plans to record another collection of Daniel songs. In other ways, though, she and Daniel remain connected. They dated very briefly after they first met, and have maintained a close friendship throughout the up and down years. Daniel shared with Kathy the poetry written by his old West Virginia friend Dave Thornberry. "She liked it," recalls Daniel. In fact Kathy fell in love with Dave's poetry long before they met. In 1986 she traveled through Ohio during a Glass Eye tour and stopped over to meet Dave and his new wife. The chemistry between Kathy and Dave was undeniable, but their timing was off by years. They fell out of touch until a decade later, when Dave, now divorced, called Daniel for Kathy's number and invited her to Wyoming, where he now lived. "They came together after a while," says

Daniel, "and I started drawing Kathy and Dave pictures." The two were married in Cheyenne, Wyoming in the summer of 1998. Recently they rented out their Austin house and decided to pack it in for Wyoming permanently.

"I had a good time," she says. "I'm proud of the album and I was particularly happy when musical ideas would work out. For me his appeal is definitely the songwriting, his sense of melody and his lyrics. I just wanted to make the elements more noticeable, like coloring in a black and white photograph."

A visual equivalent of *Dead Dog's Eyeball* is the series of small paintings made by Ron English, using Daniel's imagery and compositions as a starting point. "You can't really call it collaborative," says English. "We don't work on it together. It's more like I'm doing covers of his original drawings. I take his ideas to the next level and put my own spin on them. I combine and reinterpret our characters in compositions, my Marilyn-Mickey-Mounds with his Joe, my Burning Sunflowers with his Swirling Eye Guy. We originally got together because he knew my sister and she thought our drawing styles were similar, so she introduced us. I matched him creature for creature. Our heads were in the same place, so it fit like a glove. I hadn't ever planned to do interpretations of his work, but when the opportunity presented itself, it seemed a natural thing to do."

The series of paintings range from literal renderings of Daniel drawings done in oils with the technical mastery of a mature artist, to juxtapositions and combinations of Ron's and Daniel's stock figures, to looser interpretations of English's primary imagery, done with more frenzied lines against backgrounds of layered color utilizing abstract techniques he developed over the years. The paintings are small and, by English's standard, inexpensive, partly due to size and partly because the artist does not consider it his signature work. "I wanted to help him more than anything, to get him out of his house, help him be a part of things. Including him in my art was the best thing I could think of, especially because I respected his art, too."

Ron English's imagery explores repeated iconography based on Americana, as does Daniel's, but Ron's primary focus is the interaction of pop culture and private meditation. Superheroes and comic book monsters, Mickey Mouse and Marilyn Monroe are recontextualized into new guests at the Last Supper or bombing victims at Guernica. By juxtaposing these images, English forces the viewer to synthesize the reaction to a certain cultural image with a personal and unpredictable interpretation that is triggered by memory association. He is less interested in addressing an internal dialogue than in using commonly held, loaded images as metaphor to communicate darker undershades of meaning and the after-effects of American pop culture global infiltration. The images are carefully selected and combined to create, by their relationship to each other, a complete visual idea. This he has done with the collaborative paintings, taking Daniel's deeply private characters and turning them outward, having them interact with pop culture at large, retaining their mysteries yet exerting a more powerful presence on the brash, visually overwhelming public dialogue.

Collaborative Music & Art

The exhibitions have gone over well, providing Daniel the opportunity to travel, perform, and earn money from the sale of his drawings. At most of the exhibitions his drawings have sold out, prompting Daniel to produce more art and concentrate on improving its esthetic quality. "I think he's working harder on his drawings now," says English. "He has that impetus, the perception that people are really interested in his work. He sees it as another type of connection, a real, solid piece of him that people can take home, frame and hang on their wall. They can stare at it while they play his music. He loves the idea of that." In July of 2006 Daniel reunited with Ron English and Gibby Haynes for a group show called "Power Pathos" at Houson's Station Museum. Although the art exhibited was not collaborative, the artists, along with fellow exhbitiors Clark Fox and Anthony Ausgang, did produce one group painting which was auctioned off with proceeds benefiting the Museum

Ron English has gradually explored the medium of music. "Daniel can do things I can't," the painter says, "and I can do things he can't. I helped him see what his art could look like with a mature technique. I showed him some of the possibilities there are for him in the art market. And when I started looking around at music as a medium for me to work in, there was Daniel helping me." After English's first compilation project, *POPaganda*, in which Daniel participated with a sad, halting number that reflected his deeply depressed state of mind, English conceived a retelling of the Christian myth based on the Gnostic Gospels and set in present day Third Millenium eve.

Popaganda

Revelations Book II

Hyperjix Tricycle debut

"I studied Christianity and theology for a long time," he says. "I had a deep interest in it, not because I'm religious but because I'm an artist, and so much great art has come out of it." English wrote a series of lyrics describing the birth, life, pop deification and death of the new Christ, and chose musicians whose sound and sensibilities he felt fit the lyrics. The musicians wrote the music and recorded the songs. "I wanted Daniel to play Baby Jesus because I had that song 'I am a Baby in My Universe' in my head when I wrote his verse, 'Tomorrow's Child.'"

Ron enlisted Brian Beattie's help in producing Daniel's number. For Brian, the garage-recording process was second nature, and Daniel's track was easily done. He was upbeat and eager to participate after an initial hesitation concerning the album's theme. "He wanted to make sure it wasn't anti-Christian," says English. "When I told him it wasn't for or against, just a recontextualization, he seemed kind of puzzled for a bit, then decided that was good enough for him." The album, titled Revelations Book II, was released in November of '99 release on Which? Records, the indie label which also houses *Rejected Unknown*. The album, titled *Revelations Book II*, was released in 1999 by Which? Records, and became the first in a string of collaborative musical efforts between Daniel and a successive series of bands.

Musicians in the know have always had fun covering Daniel's music, but 2004's *The Late Great Daniel Johnston: Discovered Covered* represents the most ambitious cover project to date. Produced for Gammon Records by Mark Linkous, who had previously worked with Daniel on *Fear Yourself*, the album sought to reach new audiences by appealing to the larger though not dissimilar fan bases of such artists as Tom Waits, Beck, Teenage Fanclub, the Eels, Bright Eyes, and others. Inclued as counterpoint to the covers is a second CD which carries Daniel's original recordings of each song covered on the first CD of the set. Plans are in place for a late 2006 release of another cover CD, this one produced by Kramer, on Kramer's newly reconstituted label SECOND-SHIMMY, called *I Killed the Monster*.

Daniel counts himself a member of four bands to date: Danny and the Nightmares, comprised of town friends, The Lucky Sperms, with Jad Fair, Hyperjinx Tricycle, with Ron English and Jack Medicine and most recently *The Electric Ghosts*, another side project with Jack. Although he has been playing out and traveling more recently than ever before, Daniel stills spends the vast majority of his time at home and is always eager for visitors, who come by, drink soda, swap stories, and enable him to live out a life of creativity and fun, the "happy cycle" he calls it.

SECOND-SHIMMY's *I Killed The Monster*

Collaborative Music & Art

87

The *Hyperjinx Tricycle*
Maurice Narcis

Greetings from the Hyperjinx Tricycle

Speeding Motorcycle, a musical based on the lyrics of Daniel Johnston chronicles the adventures of "everyman" Joe as he struggles to win the affections of Laurie, his true love, who has rejected him and married an undertaker. Despite moral support from angels, Jeremiah the Frog, and Captain America, Joe becomes convinced the only way to be with his true love is to die. So... he dies. What happens next is a phantasmagorical journey through Limbo. Will Joe survive his own funeral?

www.infernalbridegroom.com

Hyperjinx Tricycle *Alien Mind Control*

Scene from the musical *Speeding Motorcycle*
George Hixson

The Electric Ghosts

The Stress Records cassettes (missing: Frankenstein Love, Live in Berlin)

Early publicity shot

Daniel in his Austin apartment

Outside the hospital

Jeff Tartakov

In Austin

J. McConnico

THE EVIL

COMING SOON TO A THEATRE NEAR BY

Daniel Johnson PRODUCTION

7 | Visual Art
"Every shiny thing of good luck."
—Daniel Johnston

There is now a huge market for a type of art called "outsider" or "visionary" art. This is a broad term that runs the gamut from tribal to folk or naïve, from prison art to tattoo flash, from the art of serial killers to the art of the insane. It basically applies to art created outside the parameters of the accepted art establishment. The validity of such work and even of such a classification of art has been called into question repeatedly. It has been thoroughly ridiculed in high art circles and will probably never be shown in the most prestigious galleries across the world, but nevertheless the demand for such art is very strong.

In part it may be a backlash against the conceptual, intellectual, reactive art of the last few decades, which has effectively excluded many would-be collectors from participation in a medium that has become so self-referential as to utterly confuse the distinction between what is valid and what is pleasing to the eye and to the soul. The appreciation of high art has functioned as a way of elevating the elite from the masses, so art can sometimes serve as a secret handshake among highly educated peers. But this excludes the people looking for something completely different in art, a truthful, intuitive experience made without artifice by

simple yet magical people.

There is a sense among collectors that outsider art is made for the right reasons; it is not motivated by factors such as ambition, the quest for fame, or artistic validation. Instead, it is art inspired by the compulsion to express the mysteries of the heart's experience. Visionary artists ignore or are unaware of the conventions of post-modern sensibilities, and their work exudes a timeless, primitive quality. The definition of visionary art is quite elastic, but there exist a few loose criteria for establishing outsider credibility as an artist. The first is lack of formal training. As in any classification of art, there is a fine line between eccentricity and incompetence, but in the outsider milieu particularly, the success of the artist is inextricably linked to the skill of the dealer/promoter precisely because there seem to be no real and recognizable measures to judge the artistic merit of the work. Much of the appeal of outsider art falls into the "I know it when I see it" category.

Therefore the second, perhaps most ridiculous, criteria is also very important; the persona of the artist, preferably someone completely outside the cultural norm. Insanity, extreme eccentricity, or diminished mental capacity is an important subcategory within outsider art. In fact, originally the term was used to describe specifically art of the insane. It is considered a valid paradigm of expression and is highly sought after because it seemingly exists as pure art, free from intellectual interpretive restraints.

A third criteria is the intent of the artist in creating the work. Of course, this can never truly be established, but ideally art is made not for commercial purposes but to express intuitive, magical experience. The last criteria is subject matter, which is always related to experience, either personal or magical. Visionary art does not comment on intellectual pretensions; it flows from a natural compulsion to organize the experience of the artist into something visually complete even if it is not structurally coehesive.

Daniel's work seems to fit snugly into the visionary genre, but there is some disagreement from old friends, perhaps out of concern that somehow being termed an "outsider" diminishes the validity of his work and brands him as a "special" artist. "He's somewhat formally trained," says Dave Thornberry, former college art classmate and now college art instructor. "Outsider art approaches things from a naïve point of view, like they don't understand perspective and proportion. But Daniel has the basics down. He's a completely original artist with a wild animated, volumetric line, and his art is not primitive at all."

Friends also bristle at the inclusion of Daniel's art in the category of art of the insane. Kramer, in discussing recording sessions with Daniel, wrote, "I wanted Daniel's artistic vision to become untangled from his illness for long enough that I could present it as pure art, without the accompanying social stigma and trappings of the terrible disease that he was suffering from, which helped make him so famous." While labeling Daniel's art as "outsider" is a blatant recognition of his mental troubles, it doesn't necessarily diminish the value of his work. Rather, it renders it comprehensible and accessible to others, providing an alternative context to that of the art school graduate functioning within the gallery system.

Only history will decide which art is the more valid.

"He may have to be another Van Gogh," says Ron English. "It might take another population of people to understand him. That's what happens. People change. Collective experience changes. The general population gets smarter. They thought Van Gogh was a bad Impressionist. Now that we've had all these other movements we see that Van Gogh wasn't an Impressionist at all. He was an Expressionist. When you look at him as that, he makes total sense. Hopefully that's the way people will look at Daniel. Someday he'll be seen as one of the pioneers of the movement that came after this one."

Another interesting aspect of Daniel's persona that works well in the outsider milieu is that of the artist/singer/songwriter. This is almost a subcategory in itself. Daniel has exhibited, thanks to ex-manager Jeff Tartakov, in several group shows with other musician/artists, including John Lennon and David Bowie. Daniel and Jad Fair, in addition to recording music, have exhibited their art together on several occasions in the U.S. and Europe.

Daniel's style, subject matter, and intent have always been grounded in experience, internal dialogue, and the rendering of magic, the metamorphosis of the spirit. That, combined with his very real technical skills as an artist, would seem to ensure his marketable future within the realm of visionary art. Jonathan LeVine, the curator/art dealer who staged the New York Ron English/Daniel Johnston collaborative exhibition, is cynical of the outsider art classification but very optimistic concerning Daniel's chances for success in the art market.

"There will always be a vast demand for this type of art," says LeVine, "which encompasses a much larger group than, say, graffiti art. Daniel definitely fits the profile. He does good work and has this persona of fragile instability. But he's actually quite a good artist, and I think only a handful of people in this field are the real deal. Daniel's one of them. His work has an extremely compulsive quality to it. He's compelled to draw the same themes over and over. He doesn't care if he's drawing on nice paper or old mimeograph paper he pulled out of the dumpster. This stuff is just pouring out of him in free association stream of consciousness."

This combination of technical skill, interesting sense of composition, energetic, animated line, and ongoing compulsion to draw the same themes and characters over and over, addressing the never-ending internal dialogue, makes Daniel's art uniquely appealing even within the highly idiosyncratic visionary genre. "So much of this kind of art is crap," says LeVine. "But Daniel's doing stuff that would be interesting on any level. Still I don't know that I would have dealt with him if I didn't know he was also a well-known musician. What I find most interesting about Daniel is the entire package. Most people buying his drawings are buying it for his music as well."

Jeff Tartakov agrees, "Most people who buy his art already know who he is because of the music. They're buying it for the music, not because they're in love with the art." Tartakov has worked tirelessly over the years attempting to compile and chronicle Daniel's art into something of a manageable form in order to stabilize its value. This has been a feat

constantly undermined by Daniel himself, who would frequently walk into Austin comic book stores and trade drawings for comic books. "I've really shied away from approaching galleries in Texas," says Tartakov, "because Daniel bottomed out the market. What gallery would agree to sell drawings for $100 when they knew other places were selling them for five dollars?"

Perhaps the most famous visionary artist is recently deceased backwoods Georgia folk artist the Reverend Howard Finster, who, although not a musician himself, owed much of his recognition to the patronage of such bands as R.E.M. and Talking Heads. Finster's work has graced album covers for each. "I would put Daniel up there with Finster," says LeVine. "Finster mixes weird flat images with text. It's religious. Daniel's work is similar in that it's about experience, the verbal experience, the message. Daniel's work is about how he's processing information in the outside world, whereas Finster's is about a higher power. But the work is similar."

Finster's art crossed over long ago from outsider niche into the mall gallery mainstream. Still, he may have topped out at what some refer to as the Peter Max level: fame, fortune, name and style recognition, but far short of acceptance in the most exclusive art circles. The reason for this shortcoming may have to do with volume and accessibility of product and venues in which the work is shown. Finster has yet to be exhibited in the most elite galleries.

Henry Darger, another visionary artist, however, is breaking through the outsider barrier decades after his death. Orphaned early in life, Darger grew up in an institution for retarded children. He spent his adult years as a recluse, doing menial odd jobs and attending regular Catholic mass until he died in 1973 at the age of 81. He lived alone in a Chicago rooming-house, where he painted in solitude for 50 years, never intending to show his paintings to anyone. His landlord discovered the work after Darger's death, and the rest is art history.

Darger's subject matter epitomizes the outsider milieu. He painted the same themes repeatedly with only slight variations, images of little girls and warrior maidens in complicated epic battles between good and evil. The paintings are large, striking, and well-done.

"I would think," says Jonathan LeVine, "that Daniel could do very well in this market, but he would need to paint in order to break through to a higher level." Daniel paints very infrequently and usually in acrylic. There is a very strong bias in the art community favoring works in oil on a large scale, as if material and scale imbue a sense of importance to the work. Ron English explains, "He needs to make his work seem larger. It doesn't have to be oils. It could be collage. But it must be bigger, at least, to make it seem more worth the money, and to do this, he needs an art manager, a facilitator, but not necessarily a collaborator."

As Daniel's mental state stabilized, his output has increased exponentially. It is certainly possible that Daniel will enjoy a sustained career as artist. In the past few years his family has begun taking the prospect of Daniel's art career more seriously; they now ensure that Daniel uses archival paper, ink and markers. Of course, for Daniel to truly succeed, he will need the support of a

reputable gallery. This he has probably found in Clementine, a well established Chelsea gallery. Leigh Ross, assistant director at Clementine, explains, "One of our artists, Taylor MacKimens, was a big fan and had worked as curator for one of Daniel's shows. He told us about Daniel, and then two months later we heard about him again from one of our clients, who works for Sony. He had just bought the distribution rights for 'The Devil and Daniel Johnston,' and he said that this guy's work would really complement our sensibility. So, that was our introduction to Daniel, by two people whose opinions we trusted." Daniel's first exhibition at Clementine, in March 2006, neatly coincided with the Whitney Biennial opening, less than two weeks later.

 A visual artist need not tour, entertain, or maintain an appearance that is considered pleasing to the public. In art, an eccentric, unpredictable persona can be an advantage. Still, music will always be the more accessible art form, and without the fame and cult status Daniel's musical body of work has conferred upon him, it is uncertain how strong his art career would be. But since his visual art is so inextricably entwined with his music, the art is a handy reference source for decoding some of the music and serves as a tangible memento of Daniel's eerie, gentle, sometimes heartbreaking presence.

Various doodles by Daniel Johnston

More doodles by Daniel Johnston

Even more doodles by Daniel Johnston

8 | Continued Story

> "Dropped his last dime in a wishing well."
> —Daniel Johnston

The MTV photoshoot
Pat Blashill

Pat Blashill

In classic Arthurian fashion, Daniel caught a glimpse of the big time, MTV, and major label stardom, before he had acquired the necessary life skills to seize and hold onto his success. Young, gifted and unstable, he missed his moment in the early nineties when his unique low-fi sound synchronized well with the overall musical landscape, dominated by grunge and alternative rock. His career eventually stalled after wild manic spurts of great creativity and equal destruction gave way to sickening, time-stopping depression.

From "Worried Shoes,"

> I took my lucky break and
> Broke it in two
> Put on my worried shoes, my
> Worried shoes
> And my shoes took me so
> Many miles
> And they never wore out
> My worried shoes, my
> Worried Shoes
> I made a mistake and I never
> Forgot
> I tied knots in the laces of my
> Worried shoes
> And with every step
> That I'd take
> I'd remember my mistake

*As I marched further and
Further away
In my worried shoes.*

But Daniel still has a shot at mainstream success, something he wants desperately. It's a remote possibility, considering the recent climate in music, with major label consolidations and too many eggs in baskets of young interchangeable Pop Stars de Jour. It's unlikely that word of mouth, which has served him so well on the elite cult level, will ever lead to the multi-platinum retail sales numbers that major labels bank on. Says Kramer, "I don't think mainstream success is in the cards for Daniel. People cannot be made to appreciate art they have no means to digest. Daniel is not a VH-1 artist, nor should he be. His activities in the business are coincidental. He is a true artist."

And now he is also the subject of an acclaimed documentary, a prize winner at Sundance short-listed for an Academy Award. *The Devil and Daniel Johnston* is not a flattering movie, although it is achingly sympathetic. It is also not a movie with huge mainstream appeal. But, it has honorably and impeccably presented Daniel's personal story as inextricably tied to his artistic output, where one does not exist without the other. And, it is the highest tribute that can be paid an artist, when his life story cannot be told without a simultaneous examination of his art, his reason for being.

"Daniel really needs his own movie," said Matt Groening (creator of *The Simpsons*) years before Jeff Feuerzig met Daniel and began acquiring the stunning audio and visual recordings used in the film. "Someone should do the Daniel Johnston story. There are a number of eccentric outsider driven musicians out there, and I can appreciate the different ones, but Daniel is an absolute genius. Melodically his songs are brilliant and lyrically they're funny and moving and authentic. He's my favorite songwriter."

From "Story of an Artist,"

*Listen up and I'll tell a story
About an artist growing old
Some would try for fame
And glory
Others aren't so bold
Everyone and friends and family
Saying hey get a job
Why do you only do that only?
Why are you so odd?*

If Daniel remains stable, continues his limited touring, and writes more songs equal to or stronger than those written in his most prolific period (the early eighties) it is also possible that another major label might take a second look. "I think that in 20, 50, 100 years," says Beauvais, "people will look back at his work, his home recordings specifically, like we have in our time looked back on Robert Johnson as one of the great American legends. And, another label might be interested in recording Daniel soon while he's still around. But, for now, what's best for him is a small label which doesn't place such a huge financial investment in him that he's forced to sell one million units in order to be allowed to make another record."

Over the years several record labels have expressed great interest in obtaining, archiving, and digitizing the original Stress Records masters,

THE CHAMPION HERO!

Daniel Johnston

which are to this day nothing more than Radio Shack tapes themselves; some are on an even cheaper tape stock called Certron. It is now possible to buy most of the early recordings on CD, as well as more recent well-produced studio and live recordings.

"I always believed," says Jeff Tartakov, "and still do believe that Daniel could somehow break through and become as big as somebody like Beck if he had a coordinated approach to things." Daniel is sure he could handle mainstream success, should it ever come his way. His greatest long-term goal is, "to get more and more professional. If God would give me another chance in three or four years to really make the big time, maybe by then I'd be good enough to sound really good. That's my dream."

He's come a long way, most of it in circles, but he's got a lot to show for his travels. There are hundreds of songs and thousands of drawings in public circulation. Daniel will probably never become a household name, but to those he's touched with his music and art, the connection is deep and permanent. He has held nothing back from his work, expressing his soul with such sincerity and commonality of feeling that, in the end, everything he says registers as the plain, funny, beautiful truth. At some point in life everyone is, or knows, a sad boy who feels different, who loves a girl from afar, who reads comic books, gazes at dark starry skies, and looks for guidance from God and salvation from rock 'n' roll. His stories belong to everyone. They are so personal that they're rendered universal by the specific harmonic recognition of having heard that plaintive line before, somewhere in a secret daydream, a buried longing, a Daniel Johnston recording.

I am a baby in my universe
I'll live forever.

Daniel Johnston

9 | On the Road

"And the wind will blow him away again."
—Daniel Johnston

I began working with Daniel in 1999. This chapter chronicles my adventures as his friend, band-mate, publisher, tour manager, and caretaker.
—Don Goede

Immigration photo outtakes

A Grog Shop ticket stub

Me and Dan in a Chicago photo booth

Book release party NYC
April 18th 2000
Book release party LA
May 2000
Pickled Egg Tour
November 2000
Johannesburg, South Africa
June 14th, 2001
Bumbershoot Festival
Sept. 2001
Rejected/Unknown US Tour I I
Nov. 23-Dec. 11th, 2001
Sweden
February 2002
Rejected/Unknown US Tour II
Feb. 22nd- March 9th 2002
European Tour
Oct. 7- Nov 10th 2002
Japan
February 2003
US Tour Fear Yourself I
April 9th- April 25th, 2003
US Tour Fear Yourself II
May 14- 31st, 2003

Daniel gets ready to sing at Tonic

Dan, Lach and Don at The Sidewalk

Producer Adam Lasus and Daniel

Dylan ticket from the scrapbook

Book Release Party
NYC Tonic
April 18th, 2000
May 30th, 2001

After our initial meeting in Washington D.C. in 1999, Daniel and I really hit it off. We became close friends and, eventually, after I earned the trust of his family, I became his caretaker and tour manager for almost three years. Tonic, the avant garde/experimental jazz club in New York City's Lower East Side, was right next door to Gary Huswit's Incommunicado bookstore; it was also the future home of the Soft Skull Shortwave bookstore/gallery, so it was a natural place to have this party. That night at Tonic was incredible. The poet Todd Colby kicked things off, Brady Brock performed, as well as Chris Harford, and The Band of Changes and the amazing Nyqwill headed by Emilio China. These musicians were also producers on our Hyperjinx Tricycle debut album. We had an art show in the basement comprised of Daniel and Ron's artwork and Tarssa Yazdani signed books. The next time we were there our pal Eef Barzeley of Clem Snide and Diane Cluck opened up for the show.

Highlights:

Every time we were in New York we went to the Sidewalk Cafe to see our old friend Lach, and Dan would always play a set of music. On all our trips to New York Dan had to go record and comic book shopping at St. Mark's Place. On one trip I even got Daniel to try sushi. On another visit we recorded at Adam Lasus's Fireproof Recording Studio in Red Hook, Brooklyn, and Daniel insisted on playing trumpet. Some of these sessions later became Electric Ghosts' releases. In the summer of 1999 I bought Dan, Ron English, and me tickets in to go see Bob Dylan and Paul Simon at Jones Beach. That was a blast! Daniel always seemed especially at home in New York.

-DG

On the Road

Daniel outside The Viper Room

At the Beverly Laurel

Tacos with Matt Groening in East L.A.

Book Release Party
L.A. May 2000

Our first trip to L.A. together was a lot of fun. This is where Dan, Ron English, and I first met Matt Groening. The people (and audiences) were amazing, and they proved that counter-culture is alive and well in L.A. despite the overwhelming glitz and glamour of Tinsel Town.

Highlights:

We got somewhat mobbed at the Viper Room (it's extremely small), and I asked this nice couple if we could hide in their booth. The couple ended up being Bobcat Goldwait and his girlfriend. It was his birthday, and she had given him tickets to the show as a present. I rented a convertible Mustang (they were running a special) and Dan loved driving up and down Hollywood Boulevard waving at all the pretty girls. We went to Silverlake to some great record stores, and who could miss a chance to shop for comics at Golden Apple and Meltdown? We had tacos with Matt Groening in East L.A., and we played him The Simpsons *song we wrote for him as the Hyperjinx Tricycle. I think he liked it.*

-DG

Viper Room
May 25th
Ma Art Space
May 26th
Al's Bar
May 26th
Zero One Gallery
May 27th

110

Daniel and Toast at Al's Bar in L.A.

Daniel and Abby Travis make the L.A. Weekly

Daniel at The Viper Room

On the Road

Ticket stub from the Van Gogh Museum

Lindsay, Nigel, Daniel & Tanya

Pickled Egg Tour
November 2000

Man, was this tour a blast! We traveled to Europe to promote a double vinyl of *Rejected/Unknown* after it was put out by Nigel Turner's Pickled Egg Records label. Nigel's gang (Lindsay and Tanya) took great care of us while we were there. We traveled around the country in a little tour bus, and we took a giant ferry over the English Channel.

Highlights:

Nigel took us to the Van Gogh museum in Amsterdam, and Daniel and I got to walk around and talk about Vincent. It was also on this trip that Graham Dolphin took us to the famous Abbey Road for photographs. Watching Dan take the same stroll as The Beatles had for their famous photograph was absolutely incredible. Daniel was so happy and excited! In Paris, the promoter of the show paid Daniel directly at the end of the night even though I was the Tour Manager. When I went to collect the money from Daniel he refused to hand it over, because he loved just giving it away and buying ridiculously expensive things! I wanted Daniel to actually have some money left when he got back home (to put in the bank), so I started telling all promoters and club managers that Daniel couldn't handle any monies. When Daniel found out the new order of operations, and he got really mad at me. We got in a horrible fight, but he later apologized and said he understood. That night we ate at the only restaurant open near The Columbia, and all that was on the menu was fish. Daniel saved the skins from our dinner because he sometimes liked to collect shiny things. I had to throw them away a few days later because they started to smell!

—DG

Zwemmer Gallery Exhibiton
Nov.- Dec. London
De Kelk
Nov. 3rd Brugge
Paradiso
Nov. 4th, 2000 Amsterdam
The Nova Cinema
Nov. 5th, 2000 Brussels
The Maroquinerie
Nov. 6th, 2000 Paris
The Garage
Nov. 8th, 2000 London

The Paris audience: quiet as mice

The Hulk in Brussels

Daniel climbs to our room at The Columbia

An Abbey Road stroll

Daniel and I way too early in the morning

Performing at The Garage in London

King Kong advertisement

Daniel as Kong — Jeff Feuerzeig

Unmasked — Fortunato Procopio

Johannesburg, South Africa
June 2001

From the Chisenhale Gallery Website:

Peter Friedl's film King Kong wove together a complex web of histories and affinities. By embracing two specific versions of the King Kong theme, Friedl investigated divergent forms of cultural representation.

The first reference in the work was to the song 'King Kong', a laconic and fatalistic retelling of the King Kong story, written by US musician Daniel Johnston.

As a second reference, Friedl recalled an important and controversial moment in South African cultural history, the 1959 jazz opera 'King Kong.' Based on the tragic life of boxing champ Ezekiel 'King Kong' Dlamini, the opera's story was located in Sophiatown – then the 'Little Harlem' of Johannesburg.

Friedl's film depicted Daniel Johnston performing, for the first time in public, his 'King Kong' song at a public park in today's Sophiatown.

Johnston performed a one-off, sold-out gig at Bar Risa in Bow on the night of King Kong's preview.

I was worried that Peter Friedl's film was going to showcase Daniel and his song in a negative light, especially considering the comparison and contrast to Dlamini's story, hence the statement "investigation of divergent forms of cultural representation." When I mentioned my concerns to Bill Johnston, all my plans to accompany Daniel on this trip were halted. I guess, in the end, it didn't matter either way, because Daniel's show sold out completely, and by all accounts he and his father had a great time!

—DG

On the Road

Ron English
Popaganda
Release Party
July 7th, 2001

Ron English held his book release party for *Popaganda* at The Key Club in Los Angeles. To help celebrate, Daniel was invited to perform and have an art show at the Zero One Gallery. Jeff Feuerzeig and crew were there, and a lot of the footage from that weekend ended up in *The Devil and Daniel Johnston*.

Highlights:

Matt Groening invited us all down to relax at his house in Malibu. We all had a blast swimming in the ocean, and Daniel even played a few songs. This is where we took a lot of our publicity shots for the Hyperjinx Tricycle 7" Greetings From the Hyperjinx Tricycle.

—DG

The Hyperjinx Tricycle in Malibu

Matt and Dan

Bumbershoot Festival
Sept. 2001

By all accounts this show was incredible!

Daniel at Bumbershoot

This was my first real trip/tour with Dan; at least, it was the first one where I handled everything. Christian, owner of The Kork Agency, did all the routing and took great care of us while we were out on the road. I printed out maps that included the distance between each city so that Dan could understand just how long we would be in the car each day. We scheduled plenty of pit stops and time for healthy meals, and I realized very quickly that Daniel was an amazing traveling companion! He was rarely grumpy, and most mornings he didn't have any trouble getting up at the crack of dawn to get a head start on the drive to the next town. I brought along recording equipment and interviewed Dan any chance I got, so I have hours and hours of him talking about how he wrote his songs. Our schedule was pretty rigorous but we always found time to hit each city's best comic book or record store, and I am proud to say we never missed an appearance or show on this tour.

Highlights:

On our way through South Carolina to visit our friend and Hyperjinx Tricycle Executive Producer, Stuart Bagwell, I was pulled over for going 5 miles over the speed limit. The officer asked to search the car. Upon his inspection he noticed the bottles and bottles of Daniel's medication I kept inside a duffle bag alongside the plastic weekly pill holders. The State Trooper informed me that administering medication without a license was against the law and that he could take us in. I explained my job description, the details of Daniel's illness, and I even handed him a copy of The Daniel Johnston Handbook as evidence of our situation. After flipping through the book, he suddenly changed his tune, asked Dan for an autograph, and let us go with a warning. Whew!

–DG

Rejected/Unknown US Tour Part One
Nov. 23-Dec.11th, 2001

Emo's
Nov. 23 • Austin, Texas
Mary Jane's
Nov. 24 • Houston, Texas
El Matador
Nov. 25 • New Orleans, Louisiana
The Earl
Nov. 26 • Atlanta, Georgia
WRAS 88.5 Radio Appearance
Kings
Nov. 27 • Raleigh, North Carolina
Ottobar
Nov. 28 • Baltimore, Maryland
Northstar
Nov. 29 • Philadelphia, Pennsylvania
WZBC 88.5 Radio Appearance
The Knitting Factory
Dec. 1 • New York City
Maxwell's
Dec. 2 • Hoboken, New Jersey
The Second Floor
Dec. 3 • Pittsburgh, Pennsylvania
Beachland
Dec. 4 • Cleveland, Ohio
Magic Stick
Dec. 5 • Detroit, Michigan
WCBN 88.5 Radio Appearance
Little Brothers
Dec. 6 • Columbus, Ohio
Schubas Tavern
Dec. 7 • Chicago, Illinois
Sursumcorda
Dec. 8 • Minneapolis, Minnesota
Bottleneck
Dec. 9 • Lawrence, Kansas
Green Door
Dec. 10 • Oklahoma City, Oklahoma
Rubber Gloves
Dec.11 • Denton, Texas

In Lawrence, Kansas

Daniel Johnston
Rejected/Unknown Tour
Nov. 23- Dec. 11th, 2001
Part One

Sweden
February 2002

I started receiving e-mails from this fellow named Gustaf who, along with his partner Sverrir, wanted to bring Dan to Sweden. They were inviting him over my birthday, so I thought, "why not?" I had proven to Bill, Dan's dad, that our tours could be profitable and that it was good to get Daniel out to see the world, so it was agreed that we would go. We ended up having wonderful hosts. Sverrir let Dan and I have his apartment during our stay, and they took us all around the city. The night of the show blew away all my expectations. It was impossible for me to count all the fans who had come out to see Daniel perform; I am sure it was a sold out concert.

Highlight:

In the film The Devil and Daniel Johnston *there is a scene at the end of the movie where Daniel does a "Devil Town" sing along with his crowd. That sing along actually came about because Daniel didn't want to do a encore after the show. At first he was trying to get me to go out on stage and do a song instead, but I refused (I knew the audience didn't want to hear me). I suggested a sing along as we heard people chanting "Devil Town! Devil Town!" Dan quickly warmed up to the idea and history was born. It truly was one of my favorite moments during my years with Daniel. The smiles on our faces in the photographs remind me of just how important it was to get Daniel out on the road to be with his fans.*

—DG

DANIEL JOHNSTON
Live in Stockholm

Allhuset 9 Feb. 2002

Biljetter: Pet Sounds & Record Hunter, www.welcome.to/tearcompany

All smiles in Sweden Thomas Borg

Jamming in Stockholm

A gracious and adoring Swedish audience

Gustav and Daniel

Daniel leads a *Devil Town* singalong

The best encore imaginable

Rejected/Unknown US Tour Part Two
Feb. 22-Mar. 15th, 2002

Emo's
Feb. 22 • Austin, Texas
Nita's
Feb. 25 • Phoenix, Arizona
Solar Cult
Feb. 26 • Tucson, Arizona
That Mexican Restaurant
Feb. 27 • San Diego, California
Knitting Factory
Feb. 28 • Los Angeles, California
Cafe Du Nord
Mar. 2 • San Francisco, CA
Blackbird
Mar. 4 • Portland, California
Richard On Richard's
Mar. 5 • Vancouver, British Columbia
The Crocodile Cafe
Mar. 6 • Seattle, Washington
Kilby Court
Mar. 8 • Salt Lake City, Utah
15th Street
Mar. 9 • Denver, Colorado
Launchpad
Mar. 10 • Albuquerque, New Mexico
The Scottish Rite Theatre
SXSW
Mar. 15 • Austin, Texas
Emo's
Mar. 22 • Austin, Texas

It was on this tour we got to hang with The Moldy Peaches, specifically Kimya Dawson and Toby Goodshank. Unfortunately, there are no photos from this tour.

Highlights:

To help kill time on the road, Daniel and I listened to music almost non-stop. We would only listen to bands with names that began with certain letters. Picking the letter "B" was a good choice for this tour as all the truck stops had lots of cassettes ranging from The Beatles, to Black Sabbath and Blondie, to the B52's. It was on this tour that I observed how Daniel attached himself to stuffed animals and various other truck stop knick knacks. Everything got named, and we would bring everyone and everything into our room each night to keep us company. They were like our entourage. When Daniel was feeling frustrated or upset about something, or someone, he would sometimes punch or kick into the air. It could get so intense when we were driving that I would have to pull over to the side of the road until it passed. He called it "punching ghosts." Talking about it always seemed to help, and I always kept a Bible with us for inspiration if we needed it.

–DG

On the Road

European Tour
Oct. 3-Nov. 20th, 2002

Take Root Tilburg
Oct. 3 • Tilburg The Netherlands
Take Root Shadow
Oct. 4 • The Netherlands
Take Root Festival
Oct. 5 • The Netherlands
Mousonturm
Oct. 7 • Frankfurt, Germany
Hundertmeister
Oct. 8 • Duisburg, Germany
Forum
Oct. 9 • Bielefeld, Germany
Manufaktur
Oct. 11 • Schorndorf, Germany
B72
Oc.t 13 • Vienna, Austria
Amerika-Haus
Oct. 14 • Munich, Germany
Passionskirche
Oct. 15 • Berlin, Germany
Star-Club
Oct. 17 • Dresden, Germany
Junges Theater
Oct. 19 • Bremen, Germany
Fabrik
Oct. 20 • Hamburg, Germany

This was both the longest and the absolute best tour I ever went on with Daniel. There were almost no problems at all, and we spent a lot of time together writing songs and just talking about life. I loved driving through Germany and listening to Dan talk to the trees.

Highlights:

The audiences throughout Germany were very respectful, and every place we visited had its own unique charm. The church Daniel performed in in Berlin was by far the most beautiful place I had ever seen Daniel sing and play. During sound check he practiced some piano pieces that sounded almost Jazz & Baroque-like. His piano playing was absolutely amazing, and I told him that he should incorporate those pieces into his performances. He laughed at me, and he said, "Why would anyone want to hear that kind of music!" Henning Ness, the promoter that helped put together the Why Me? CD from the famous 1999 German concert, was our host in Berlin. He was most gracious and accommodating. Henning even put a picture of Daniel's on a mug to promote an art show they were having while we were there. It was on this tour that Daniel refused to bring his false teeth. Because of this, he told me when he looked in the mirror he thought he was Adolf Hitler! Yikes!

-DG

Daniel on a mug in Berlin

Henning Ness and Daniel in Berlin

The most beautiful place I ever saw Daniel perform

Running water backstage in Germany

Bicycles in Amsterdam

Speeding Motorcycle

Rehearsal at the 013 in Tilburg

Walking the cow

A pit-stop

Japan
February 2003

Tokyo, Japan - Club Quattro
February 23 • 2003
Kyoto, Japan - Taku Taku
February 22 • 2003
Osaka, Japan - Bridge
February 21 • 2003

Daniel is truly a star in Japan. Bill took my place on this trip because he hadn't been to Japan since his service as a Flying Tiger in WWII, and he really wanted to go. Jordy Trachtenberg, from Gammon Records, also made the trip. Daniel's old friend Shizuka was on hand to help translate. The fans in Tokyo were so intense that Daniel had to stay back after a performance for almost two hours before he could leave. At every show, the fans gave very thoughtful gifts. He mostly ate McDonald's during the trip, because he didn't care for Japanese food. Unfortunately, this resulted in a case of gout.

A Daniel Johnston music stand

Daniel and his good friend Shizuka

Daniel and his father Bill take a break

Bill, Jordy, Daniel, & Shizuka

On the Road

This was a great tour. We hooked up with our new friend Kimya Dawson, and she opened for Dan at various shows. We also invited my dear friend, New York-singer-song writer Diane Cluck, to play some shows with us as well. Luckily, she and Daniel got along great. The New York photographer Maurice Narcis made it to the show in Philadelphia, and he took some amazing photos (you'll see many of them throughout this book.) It was there that one of my favorite concerts of all time happened: Diane Cluck, Daniel Smith, and Daniel Johnston all performing at the same show.

Highlights:

Dan and I did some great recording in our Chicago hotel room. We were seconds away from being struck by a stray bullet at some restaurant near Atomic Books in Baltimore. We got to hang out with Sumner Erickson (Roky Erickson's brother) at his father's amazing house in Pittsburgh, but Daniel was too spooked by some of Roky's posters and art for us to stay the night. I was happy to meet a bunch of Daniel's relatives who came to the show in Pittsburgh, and we took them all out to dinner. In Canada, Daniel sang a great version of "Speeding Motorcycle" with Yo La Tengo. I also believe this was the tour where Daniel and Steve Shelley reconnected since Daniel's episode in New York in 1988. I also got to meet Randy Kemper, Daniel's old friend and ex-manager whom he had hit with a lead pipe. It was good to see that Randy forgave him!

—DG

Fear Yourself US Tour Part One
April 9th-April 25th, 2003

Knitting Factory
April 9 • New York City
Higher Ground
April 10 • Winooski, New York
Middle East Downstairs
April 11 • Cambridge, Massachusetts
Iron Horse
April 12 • Northamton, Massachusetts
La Sala Rossa
April 13 • Montreal, Canada
The Phoenix
April 14 • Toronto, Canada
Bug Jar
April 15 • Rochester, New York
Mohawk Place
April 16 • Buffalo, New York
The Grog Shop
April 17 • Cleveland, Ohio
Little Brothers
April 18 • Columbus, Ohio
Schubas
April 19 • Chicago, Illinois
Southgate House
April 20 • Newport, Rhode Island
123 Pleasant Street
April 21 • Morgantown, West Virginia
Rex Theater
April 22 • Pittsburgh, Pennsylvania
Ottobar
April 24 • Baltimore, Maryland
First Unitarian Church
April 25 • Philadelphia, Pennsylvania

Diane Cluck and Daniel

Sprite!

Backstage with Georgia and James of Yo La Tengo

Daniel Smith, me, and Daniel in Philly

Television show in Canada

Pull over or the ducky gets it!

Daniel, me & Kimya Dawson

On the Road

This was the end of my travels with Daniel. We were having dinner with Matt Groening a few hours before Daniel was scheduled to go on at Spaceland, but Daniel ate a bad cocktail shrimp and history was made. He started complaining about his stomach hurting, so I drove him back to the Beverly Laurel Hotel where we always stayed when we were in L.A. He got extremely sick, and he threw up all night long. It was absolutely horrible. I held a cold compress on his forehead until he finally fell asleep, then I spent all night cleaning up the room. We missed the Spaceland show and the rest of the tour. When Dan woke up the next morning he decided he never wanted to tour like we had been ever again. I did everything I could to convince him otherwise (or at least to finish this tour) but he had made up his mind. The tour was over, and he wanted to go home. All the way back to Texas he told me that he couldn't take the long tours anymore. He confessed to me that he was sometimes scared being away from his mom and dad for so long. I knew that he and I had some amazing adventures, but a part of me really believed him. I made the best of our drive home and tried to forget about all the promoters and fans that were counting on us, not to mention all the money we were going to lose.

Dan talked a lot about wanting to do more recording and writing music, so we also made plans to finish our *Electric Ghosts* record the band we started on the road. Once I got him home to Texas we said our good byes. I cried on my way to return the rental car.

I did everything I could to take the best care of Dan while we were on the road together. I tried to make sure that he ate properly and got enough rest. I made sure people with drugs were kept away because his doctor told me that marijuana or other drugs could cause him seizures. I always did what I thought was best for him, and I do believe that our years of touring together were important for him. Not only did he get to see some of the world, but he reached thousands of people who love his music and would otherwise have never seen him perform. I am happy to report that his brother, Dick, has taken over my role as tour manager/caretaker, and with his assistance, Daniel still makes various appearances around the world. On page 129 there is a listing of appearances Daniel has done with him since our adventures ended.

Fear Yourself US Tour Part Two
May14-31st, 2003

Club Congress
May 14 • Tucson, Arizona
Spaceland CANCELED
May 16 • Los Angeles, California
Bottom of the Hill CANCELED
May 17 • San Francisco, California
Blackbird CANCELED
May 19 • Portland, Oregon
TI CANCELED
May 20 • Vancouver, BC
The Bottom Of the Hill
May 21 • Seattle, Washington
Kilby Court CANCELED
May 23 • Salt Lake City, Utah
Larimer Lounge CANCELED
May 24 • Denver, Colorado
Launchpad CANCELED
May 26 • Albuquerque, New Mexico
Green Door CANCELED
May 27 • Oklahoma City, Oklahoma
Rubber Gloves
May 28 • Denton, Texas
Emo's
May 29 • Austin, Texas
Rudyard's Pub
May 30 • Houston, Texas
Mermaid Lounge CANCELED
May 31 • New Orleans, Louisiana

Daniel with our entourage

Daniel in the Redwood Forest

Smiles and a Texas hat

At Atomic Books in Baltimore

Saluting at a tank museum

Peace in wartime

Saying goodbye

On the Road

Jongleur
2001 • Oct. 3 • London, England
Meltdown Festival
2002 • June 15th • London, England
Cactus Records
2003 • Jun 7 • Houston, Texas
Room 710
2003 • Jun 14 • Austin, Texas
AntiFolk Festival
2003 • June 25 • Paris, France
Evreux Festival
2003 • June 27 • Normandy, France
Roskilde Festival
2003 • June 28 • Roskilde, Denmark
Accelerator Festival
2003 • July 1 • Malmö, Sweden
Accelerator Festival
2003 • July 2 • Stockholm, Sweden
ICA Comica Festival
2003 • July 4 • London, United Kingdom
Quart Festival
2003 • July 5 • Oslo, Norway
Kalkscheune
2003 • July 8 • Berlin, Germany
Boa Goa Festival
2003 • July 10 • Genoa, Italy
Dour Festival
2003 • July 11 • Brussels, Belgium
Benicassim
2003 • Aug. 8 • Valencia, Spain
Stereo
2003 • Aug. 10 • Glasgow, Scotland
Matt & Phred's
2003 • Aug. 11 • Manchester, England
All Tomorrows Parties Festival
2003 • Nov. 8-9 • Los Angeles, California
Knitting Factory
2004 • Apr. 15 • New York City
State University of New York
2004 • Apr. 16 • Purchase, New York
TT's
2004 • Apr. 17 • Cambridge, Massachusetts
Iron Horse
2004 • Apr. 18 • Northampton, Massachusetts
Sundance Film Festival
2005 • Jan. 26 • Park City, Utah

Escapist
2005 • March 16 • Austin, Texas
Austin Music Awards
2005 • March 16 • Austin, Texas
Cactus Club
2005 • March 17 • Austin, Texas
Orange Show Centre for Visionary Arts
2005 • April 30 • Houston, Texas
Orange Evolution Festival
2005 • May 26 • Newcastle, United Kingdom
DNA
2005 • May 28 • Bologna, Italy
La Chatte à La Voisine
2005 • June 3 • Toulouse, France
Cafe de la Danse
2005 • June 5 • Paris, France
Apollo
2005 • June 6 • Barcelona, Spain
Barbican
2006 • Apr. 14 • London, England
Amoeba Music
2006 • May 5 • Los Angeles, California
Spaceland
2006 • May 5 • Los Angeles, California
Alamo Theatre Draft House
2006 • May 11 • Austin, Texas
Waterloo Records
2006 • May 11 • Austin, Texas
The Henry Rollins Show
2006 • July 1 • Los Angeles, California
Station Museum
2006 • July 8 • Houston, Texas

For more info on Daniel Johnston's travels please visit:
www.hihowareyou.com

The Devil and Daniel Johnston **movie poster**

10 | The Devil and Daniel Johnston

Director Jeff Feuerzeig
Tyler Hubby

Shooting the documentary
Henry Rosenthal

"Fly eye, fly eye
Fly eye, fly eye"
—Daniel Johnston

An interview with Jeff Feuerzeig, the director of *The Devil and Daniel Johnston*

DG: Do you remember where you were when you heard your first Daniel Johnston song?

JF: Good question.

DG: Do you remember the exact day, and the time, and the place … is your memory that detailed?

JF: Sort of. I remember I was either in Hoboken or Trenton, NJ. I'm sure it was *Hi, How Are You?* It had to be around 1985. I just remember listening to it from beginning to end and just being so taken especially by him singing over a jazz record on "Desperate Man Blues." I found out later, through researching the movie, that it was England's ambassador of jazz, Johnny Dankworth and his orchestra. "Keep Punching Joe" is on that record too, right?

DG: Absolutely.

JF: Yeah, "Keep Punching Joe" blew my mind. That just really spoke to me. Are "Hey Joe" and "Keep Punching Joe" both on the same record?

DG: They are.

JF: Yeah, "Hey Joe" is still one of my favorite songs both melodically and lyrically, and then he reprises the Joe theme in "Keep

Punching Joe," and there's the drawing on the back of the boxer. It came together for me sort of instantly.

DG: Right, [it came together] for me too. That album also has "Running Water."

JF: Yeah, "Running Water" blew my mind with the water running from the faucet. I could tell you about every nuance of that record if I had it in front of me. Read the titles off for me real quick.

DG: Well, it starts with "Poor You".

JF: Oh, "Poor You" is great. It's probably the most pitiful song, but he's doing that comedic voice! I was like, aw, this is great! Tragedy! What's next?

DG: "Big Business Monkey."

JF: "Big Business Monkey" is interesting… like, yeah, somebody is trying to exploit him.

DG: There is a rumor of who that's about.

JF: Yeah, that rumor is cracked in the movie. Daniel tells that story openly, so it's no secret. The song's about Dick, his brother. When [Dick] was young he did not understand his brother and did not encourage him. He tried to help [Daniel] that summer and give him a job in Texas,, but then Dick evicted him! So, there you go!

DG: And then of course we go into "Walking the Cow".

JF: "Walking the Cow" is great. We of course learn many years later that it's based on the cow from the Blue Bell ice cream wrapper in Virginia.

DG: Which I think the Johnstons still eat.

JF: The best part of my first trip down there was when Dick was driving us around Chester, and I think I saw a water tower or a barn with a Blue Bell cow. It was almost like a billboard, but somebody painted it. I saw that cow, and I just thought that it was like the Holy Grail. Of course, later, I got that ice cream wrapper, and we actually scanned it, and did a little animation where the ice cream wrapper starts animating to the song "Walking the Cow," but that didn't make the final cut [of the documentary]. That album is rich, isn't it?

DG: Well, you bring up a really interesting point, because, fortunately, my first Daniel Johnston album was *Yip/Jump [Music]*.

JF: Which is also a masterpiece. It's a chord organ masterpiece.

DG: What would have happened, do you think, if your first [Daniel] album had been maybe something not as strong? Because, *Yip/Jump Music* and *Hi, How Are You?* are two very powerful albums.

JF: Oh my God, it doesn't get better than those two. I literally heard *Yip/Jump Music* and *Hi How Are You?* on the same day. I bought all the cassettes the same day. Basically, almost all the cassettes, and I do mean almost all the cassettes, were already recorded before [Daniel] ever got to Austin. He recorded this monstrous body of work when he was basically graduating high school and going into college. So, to me, it's all one time period.

DG: It sounds like you were bit by the same bug that bit a lot of us… that you wanted to get as much of it as you could.

JF: Well, it touched me on a molecular level. Even now just talking about those particular songs again gives me a chill… that's how much I love that music [of Daniel's].

DG: Let's change gears a little bit and talk about [Daniel's] art. At what point did you figure out that Daniel was also an artist? Obviously, the cassettes had his artwork on them, but how much longer after that

did you figure out that he drew and he painted, and what made you decide to attack that side of things?

JF: The drawings on the cassettes were my only knowledge of his art, and I loved those drawings, but I wasn't as hip to art back then. My knowledge of art was very, very limited. Over the years, I've really come to understand much more about art, but initially, hearing the song "Keep Punching Joe" and seeing that drawing of the boxer on *Hi, How Are You?* really tied things together for me conceptually. I started linking all of those images to the music and to what he was writing about. I realized how he was self-documenting his life, like with the mom yelling, and I instantly took it as performance art. I certainly did not think of him as just a singer/songwriter after that moment. I loved the music, but it really was a performance art piece to me, it was like this triple threat.

DG: Did you research Daniel during that time? Did you try to find out more about him as a person?

JF: There wasn't much to hear about him, honestly. There were a couple articles about him, and I saved everything, so I guess the answer's yes. The best thing that came out at the time was the Chemical Imbalance magazine with Daniel on the cover and this huge article on him by Mike McGonical, which I saved to this day. That had the most information you could have about the guy. Of course, the Spin magazine article by Louis Black was also astounding.

DG: And this is all early '90s?

JF: No, this is late '80s. You know, I'm collecting this stuff in '85, '86.

DG: Now, are you making any films at that time? Are you experimenting with media?

JF: Yes, absolutely, I made my first music documentary about a gentleman named Ben Vaughn, and the Ben Vaughn combo. He went on to produce Ween, Charlie Feathers, and Arthur Alexander, and had a big solo career his whole life.

DG: So, would it be safe to say that at that point you were thinking about doing a project about Daniel?

JF: I was. I had all these postcards saved, and I got the idea to make a movie about Daniel the day of a WFMU radio broadcast, when he was promoting the album 1990. That's when the whole idea for this movie came together.

DG: Now, did you see Daniel live, or did you see footage of Daniel first?

JF: I never saw Daniel live until the year 2000. He never toured… he only played in Austin. So, if you were a New Yorker, or a Hoboken WFMU person (a huge contingent of Daniel fans), he was just an enigma. There was no Daniel Johnston to us except the voice on those tapes.

DG: Which probably added to some of the mystique.

JF: I can quote that [WFMU] show. I taped it live on the air, and everything I'd been thinking about Daniel was there on this one tape. On that broadcast he's interviewing himself and playing all the parts… including the female parts. His obsession with fame comes out on that tape. It was funny.

DG: Well, Daniel is a funny guy.

JF: I think Daniel's hilarious. He likes to be funny. Daniel was conscious of a lot of things, because he was a pop culture machine. I responded just as much to his sense of humor as I did to the unrequited love story of Laurie, to the documentation of his family, and to the self-documentation of his mental illness. They all went together into this incredible cocktail, and I was like,

wow, this guy is a force, you know?

DG: Well, I totally agree. I didn't realize how much he had studied even when he was in high school and college.

JF: That's true. That's all because of Dave Thornberry. He and Dave would discuss Kurt Vonnegut, and he was very conscious of Andy Warhol who grew up right up the river [from Daniel]. An early piece of his art was that Andy Warhol soup can, but he did like Cowhol… Andy Cowhol, or something.

DG: Not long after that "Dead Dog's Eyeball" came about.

JF: Exactly. I liked a lot of drawings of his from high school where he's drawing the story of Vincent van Gogh and talking about cutting off his own ear. [Daniel] wanted to be an artist, and he knew about Picasso. He knew about all these great artists. Jonathan Richman was into the same great artists.

DG: It's pretty safe to say he studied quite a bit before… well, I don't know exactly when that stopped, but I would say that probably a lot of it did [stop] after his breakdown.

JF: Yeah, no question. He studied hard, and he pursued it. My assessment is that, after his breakdown, it's just this incredible case of arrested development. The arrested development is interesting because it [makes his life like] Groundhog Day. He wakes up every morning, and it's like you weren't even there the day before. He'll say, "Hey, let's go for a Slushee," or, "Hey, let's go get some stickers at the five-and-dime store. Let's go get some Beatles bootlegs."

DG: Well, one thing I realized about Daniel is that he sometimes buys the same records over and over.

JF: Yes, he does, and buys the same comic books. I find it fascinating. One of the greatest nights of my entire life is at the end of the movie when Daniel is dancing in that garage. It's like his interpretive dance of his life, and being there with him, in that garage, at three in the morning, I realized that he's having a party in his head all the time. At night, alone in this garage, he's the happiest guy in the world. He's laughing, and he's playing these bootlegs that never sounded better to me than they did in Daniel's garage. All of the sudden, I was back in high school. Remember the years when you could just hang out and just listen to records all night long with friends till three in the morning? I was like, "Oh my God, his studio... his garage... is the greatest place on Earth. He's stuck in a beautiful place even though he is, you know, God's lonely man.

DG: I experienced a lot with him over the years on the road. There were lots of times when we were listening to music, or eating pizza, or drinking Coke, hanging out and being somewhat normal but there were also times that I saw some intense frustration.

JF: Oh, no doubt, he's incredibly frustrated.

DG: And, I think you did a wonderful job capturing that in the film, and doing it in a way that's very respectful.

JF: Well, respect is number one in my film.

DG: Why did you make this movie?

JF: Why did I make this movie? It's very simple: it's a love letter. Not only to Daniel Johnston, but it's a love letter to art, period. That's all it is. Daniel Johnston, in this film, starts off his opening line, "I am the ghost of Daniel Johnston." And it ends with Daniel Johnston dressed up as Casper flying through the air. In my mind, *The Devil and Daniel Johnston* is a portrait of a living ghost. That's why he's an enigma, and that's why he isn't interviewed in his own film. Instead, I've woven all his cassettes into a monologue which I think is much more powerful.

The Devil and Daniel Johnston

DG: I agree.

JF: We haven't seen a film like that before. We've seen older artists being interviewed and telling the worst stories of their life, but Daniel wasn't really able to do that in a way that was satisfying to a film, because he was medicated. He explains what it's like when his manic depression hits and he gets the tingles in his fingers, but he's telling that to his cassette tape as it happens. When he's diagnosing himself out of the DSM-4 psychology manual, that's actually happening. Audio is much more powerful than picture to me, and that's why the film is powerful, because Daniel self-documented and recorded himself.

DG: Did you feel a connection with Daniel when you found out he was a filmmaker? Did you realize, hey, here's a fellow filmmaker who was doing stuff so early on?

JF: Well, when he showed me those films for the first time, nobody knew that Daniel Johnston made films. It was not in any of the research anybody could know. You didn't know; I didn't know; nobody knew, and when he showed me those films, they blew my mind. I think "It Must Be Monday" is one of the greatest home ... I don't want to call it a "home movie"... it's a movie. It's a Super 8mm film made by a 13 year old boy, directing himself, playing multiple roles like Peter Sellers, playing his mom in drag. The scenes are brilliant. The acting is brilliant. It's like Buster Keaton, Woody Allen, and Charlie Chaplin all in one. Daniel pulled it off, and it blew my mind. The editing is great. The eye lines, screen direction, the colors, the wardrobe, the props! I mean, the guy did it all, and he's 13! I've seen a lot of student films in my life from students who are a lot older, and they don't hold a candle to Daniel Johnston's "It Must Be Monday." That Includes my own student films, for that matter.

DG: What are your thoughts about Daniel's relationship to the world?

JF: I don't look at Daniel's career as a series of failures; I look at it as a series of successes. I truly, truly do. I see each and every one of his creations as a success.

DG: Maybe I mean more commercially. I don't mean Daniel's work itself. I'm talking more about how Atlantic put out *Fun* and didn't know how to market it; so it ended up in the childrens section of record stores.

JF: What happened then was that Daniel was not well. He got that record deal because an outside influence, Kurt Cobain, wore his tee shirt, and Atlantic Records came in. Daniel was not well when he recorded not a great record in the garage: *Fun* with Paul Leary. Daniel didn't even play on the record. Daniel does sings on the record, but Paul Leary plays almost all the guitar parts and things like that. I didn't like that record when it came out, because it's not a great record... period! End of story! It was misguided. I don't see it as a failure, I see it as Fulton's Folly.

DG: What is the film going to do for Daniel? What are your predictions?

JF: The film is a love letter to this man and his art and his music, and I believe that his art is his second act in life. Music was his first act, and he will continue to make music, but he's not gonna have a musical impact. I think that his old recordings are his great body of work, and I think that everybody should hear them. His art will be his second act. It's gonna be like Crumb! You know, Crumb was being collected all over the world after the movie Crumb came out, and I think that's so beautiful. Based on his health, and his age, that's a great thing to happen to an artist.

DG: Right, he is very young...

JF: Even recently he surprised me. A few months ago I saw a show over at Bergamot Station, in LA. Ron English was there, and

Daniel did some larger paintings that were all blue. They were watercolor. His line power, the themes, and the colors… he really took me. I was like, "Wow, Daniel really knocked it out of the park with some of this new art." Anyway, the film is not a music documentary. It's a portrait of an artist. Of course, music is art, but it's [Daniel's] art that is going to end up outliving all of us.

DG: You think his art will do that more than the music?

JF: No, the old music of course will outlive us all. What I'm trying to say is that he can continue making a good living out of his art,, and that's amazing.

DG: Obviously, working with Daniel can be very frustrating. What did you do to keep going through the rougher times of making this film?

JF: It was tough. It was like five years of my life. I was determined to make this movie, and I'm a guy that just finishes things. I wanted to say what I wanted to about this person. I wanted to make the portrait of a living ghost, an enigma, and keep him that way.

DG: What do we have to look forward to in extra footage in the DVD?

JF: Deleted scenes and commentary. A lot of fun deleted scenes that are really very interesting. There's a great scene that links Daniel's manic depression illness to his grandma Boyles. We see a photograph of Grandma Boyles, who looks like Daniel in every physical attribute: her weight, the size of her hands, the way she curls her hands, at a piano. It's like Daniel has Grandma Boyles' DNA in him. There's even a newspaper article [about Grandma Boyles], and how she developed her own system of music on a piano. She transposed sharps to flats, and that was brilliant.

DG: Anything else you want to add?

JF: Well, I feel great about the film, and I feel very satisfied about how it turned out. I hope the world can experience Daniel Johnston and be touched. I want people to share what you and I have shared through this great work. When they pop in that song and hear "Keep Punching Joe" I hope they'll want to keep punching Joe. I hope they'll want to keep moving on with their lives no matter what obstacles are in their way. That's the answer to the question, "How did I keep going?" I had to keep punching Joe.

Jeff Feuerzeig and his Bolex

Jeff Feuerzeig preparing a scene

Jeff and Daniel in the recreation of Daniel's studio in his brother's garage

Daniel and Jeff

Director Jeff Feuerzeig, Producer Henry Rosenthal, and Daniel Johnston

Daniel in his garage studio

Daniel in Waller, Texas

Bill and Mabel Johnston

Jeff, Daniel, Bill, & Mabel

Danny and the Nightmares

Jeff Tartakov

At the Sundance premiere of *The Devil and Daniel Johnston*

All photos by Don Goede

Signing autographs after the movie

Laughing out loud

Father and son

Editor Tyler Hubby cuts away

Looking for a good seat

Jeff Feuerzeig greets the Johnstons after the film

Jeff Feuerzeig hugs Mabel Johnston after the film

Dan and Don together again

Jeff Tartakov, Jeff Feuerzeig, & Henry Rosenthal

Bill, Mabel, and Margy Johnston

Jamming on the chord organ

Director Jeff Feuerzeig and producer Henry Rosenthal

Sally, Margy, Daniel, Jeff, Dick, & Drew

Like a monkey in a zoo

Asleep after a long day in Utah

"It must have been a happy time"
—Daniel Johnston

All photos Johnston Archive

Daniel at 18 Johnston Archive

Diane Cluck and Daniel on the road Don Goede

Yip/Jump baby: Daniel's godson, Max Don Goede

Having fun Yves Beauvais

Rock n' Roll Yves Beauvais

NYC 1988 Monica Dee

Daniel and Dave Thornberry Dave Thornberry

Daniel and Kathy McCarty Johnston Archive

Philadelphia 2003 Maurice Narcis

Hear the voice of the Bard!
Who Present, past, and Future sees,
Whose ears have heard
The Holy Word
That walked among the ancient trees,

—William Blake

"Drove those demons out of my head
With an ice pick and a pencil full of lead
And when I'm dead hope to have it said
'He drove those demons out of his head'
I'm a loser, I'm a sorry entertainer"

—Daniel Johnston

11 | Walking the Cow

By Andrew Hultkrans
Photos by Wyatt McFadden

From
Mondo 2000 #8
1992
Reprinted by permission
from the author

In my opinion, this is my best interview ever done with Daniel by the same author of *Forever Changes (2003)*, Andrew Hultkrans. I just had to put it in the book.
—DG

Daniel Johnston's Visionary Universe

Oft referred to as "the legendary Austin singer/songwriter," Daniel Johnston is an oddity in an industry that defines itself by cynicism and ironic distance. He's

Andrew Hultkrans

a shuddering nerve plexus, a throbbing vein of sincerity. And his visionary genius has made him an inspiration to many. His fans are legion, ranging from the technically agile to the achingly hip to the faux naif.

I DON'T REMEMBER MY DREAMS,

BUT SOME PEOPLE DO.

SOME PEOPLE REMEMBER

MY DREAMS FOR ME

Underground luminaries such as fIREHOSE, Yo La Tengo, The Reivers, Moe Tucker, and The Pastels have covered his songs, and he has collaborated with kindred spirit Jad Fair, Bongwater/Shimmy-Disc guru Kramer, and members of Sonic Youth. A New York choreographer, Bill T. Jones, recently staged a ballet to Daniel's Yip/Jump Music in France [!], and his Blake-meets-Kirby paintings and drawings have been exhibited in Los Angeles, Zurich, and Berlin.

Originally from West Virginia, Daniel's music gives new meaning to the "high lonesome sound" that emanated from those hills long ago. On his early home recordings, Daniel made use of the piano, guitar, and various toy instruments (including a four-string Smurf guitar) to accompany his plaintive voice. His signature sound comes from the aggressive treatment of a Fisher-Price toy chord organ. On Yip/Jump Music in particular, his beating on the keys of the plastic instrument stretches its limits from a simple harmonic toy to a resonant percussion box. Daniel's high warbly voice—an instrument of naked emotion—arches over this distinctive sound. Even those comfortable with Robert Johnson, Skip James or Neil Young at their darkest will find Daniel's delivery harrowing.

With early cassette titles like Songs of Pain and More Songs of Pain, Daniel seems to be the classic poète maudit or tortured artist. Daniel's work, however, dwarfs the puny pretenses of so many art school casualties with fashionable drug problems. His problems are authentic. His mental condition, diagnosed inaccurately as "manic depression," defies stock clinical categorization. He has been institutionalized several times for aberrant—sometimes dangerous—behavior, always to return to a period of peak creativity.

Daniel's sensibility is like a child's—an wide-open, porous receptor for the physical and imaginary world. An antic simplicimus. Strangely, Daniel shares his birthdate with another childlike visionary—Lewis Carroll, who, in turn, was a hero to Daniel's own musical inspiration—John Lennon. Commenting on this coincidence, Daniel observed "It's kind of like a trilogy."

I spoke with Daniel on two afternoons during the last two weeks of his latest spell at the State Mental Hospital at Austin. His spirits were high, and he was looking forward to finding an apartment—and a new life—for himself in his favorite town. Since then, he has performed in Dallas in front of his largest audience ever, garnering enthusiastic reviews. Currently, he's banished his demons with a new electric piano and a batch of new songs.

Original Artwork by Daniel Johnston

Walking the Cow

MONDO 2000: Hi, How are you? Are you glad to be back in Austin?
DANIEL JOHNSTON: Yes, I am. I didn't want to come here under these circumstances though, having to come back to the old looney bin. But that's just part of my manic depression. Manic depression is a frustrated mess.

M2: There are several recurring characters in your songs—notably Casper the Friendly Ghost. Tell me why you're interested in Casper, King Kong and these other characters?
DJ: In the Beatles' songs, you know how they'd refer to different things in another song? Like John Lennon said, "The walrus was Paul." I started referring to other songs I'd written and started to make an epic of songs that were referring to each other. Then I'd have the drawings referring to the songs, and vice versa.

M2: Casper is everywhere...
DJ: A long time ago when there was God and there was Jeremiah the Bullfrog, Satan entered Lucifer and made him jealous of Jeremiah. Lucifer said something like, "He thinks he's better than him." And God killed Jeremiah. And Jeremiah's ghost is Casper the Friendly Ghost. And Jeremiah is John Belushi.

M2: So you think about Casper a lot.
DJ: Yeah, he's a personal friend of mine.

M2: You're definitely interested in comics.
DJ: Oh yeah, Jack Kirby's my favorite.

M2: I know you're particularly interested in Captain America. Can you tell me why?
DJ: To me, Captain America is a symbol of the glory of the red, white and blue—of the American dream. That it's still true today. There's still the Bill of Rights.

M2: So Captain America is still something we can look towards as an ideal?
DJ: Captain America will return. In the flesh. In the Great Tribulation there will be a great Captain America who will save many from total doom.

M2: That's a good thing to hear. What about some of the other early Marvel heroes—the Incredible Hulk, the Mighty Thor?
DJ: The Incredible Hulk is Frankenstein. A lot of people forget that. And when John Buscema would draw the Hulk, it was always with that big "Aaargh!" The Hulk didn't always look like that. He was a very thinking and compassionate guy. And he didn't like evil people—that's why he'd *smash* them.

M2: He's like Frankenstein because he's the product of science gone awry? Bruce Banner was near a nuclear test explosion...
DJ: Right. But see, the comic book characters exist on another plane—as prophecies of future heroes to come.

M2: Now they're myth, soon they'll be history.
DJ: They'll be superheroes for real during the time of the Great Tribulation. They'll be great, mighty superheroes. God will not forget the friends of the Ghost.

M2: What about these heroes—like the Hulk, Spider Man and Iron Man—who have problems? Stan Lee and Jack Kirby introduced the superhero with an Achilles heel.
DJ: Well, *everybody* has problems.

M2: But they made the heroes more human, more *real* that way.
DJ: Well, a lot of superheroes in the Bible started out human. A lot of the great prophets like Elijah were just human beings that grew up in faith and became superheroes.

M2: So you see comic characters as Biblical prophets...
DJ: As a mirror to the future and the past. Because the artwork was so great, it wasn't just that the man was inspired by doing acid. He was a prophet.

M2: Jack Kirby was just transmitting the Word of God...
DJ: Just like I do in my cartoons

Captain America will return. In the flesh. During the Great Tribulation

Comic book characters exist on another plane—as prophecies of future heroes

and in my songs. They write themselves. The good ones just really come. I plan to start writing songs again once I get a hold of my guitar—songs for a live album called *Frankenstein Love*.

M2: Why *Frankenstein Love*?

DJ: 'Cause I love Frankenstein. 'Cause I love me.

M2: I want to ask you about some of your drawn characters. The frog creature with the eye stalks, what's his name?

DJ: That's Jeremiah. God only chose Jeremiah because I said, "Listen, if Satan gets in here and they accuse me, kill me." And he said, "God, I brainwashed him," and I said, "Hey, listen, if he's in here, you kill me first because if you don't kill me, they will and I'll be dead for sure. But I know that I'll live on because love never dies."

M2: And when Jeremiah gets killed, he becomes Casper the Friendly Ghost.

DJ: Right. I am the Pontius of Jeremiah.

M2: What about the flying eye?

DJ: Well, it's kind of a movie—the show that everybody sees. That's why the photography is so wild, because they fly it back and forth and do different angles and God edits it—puts it together on a big mixing board.

M2: Which film are you talking about?

DJ: I'm on film 24 hours a day, where everybody sees me.

M2: But you have a song called "Fly Eye."

DJ: [*Sings*] Fly Eye, Into the Night, Fly Eye, It's All Right... See, these eyes get tired of filming me all the time, because I get depressed, and they have a hard job to do. They're working overtime. It's very hard work, but they do a fine job. I'd like to commend The Order of Fly Eyes, because they have a personality all their own.

M2: Are they menacing to you?

DJ: Well, at first I didn't know what they were, and then somebody told me, "Those are the eyes of Satan," and I said "Thank you." But they're my friends 'cause they're always there and they're filming me and they're entertaining a lot of people.

M2: What about musical influences? I know you love the Beatles.

DJ: The Beatles are the greatest. The Beatles are still together. John, Paul, George and Ringo are recording all the time, and they're recording albums for when the Great Tribulation is over, and the 10,000 years of Christ they'll be jamming...

M2: The Beatles will be back in the endtimes too?

DJ: They'll be back and they'll be back sooner. Everyone is going to come back and they'll be better. Marilyn Monroe will be back. I'm bringing all kinds of people back... sort of a family reunion.

M2: In the song, "The Beatles," you say "and I really wanted to be like him, but he died." Was John your favorite Beatle?

DJ: Yes, he is. He was really like my father. I was born in heaven before I was born here. He was my father and Paul McCartney was my twin brother.

M2: I see. John's lyrics were stranger than Paul's...

DJ: But Paul McCartney wrote "Hey Jude." But who wrote

Walking the Cow

"Yesterday"? Was it Frankenstein or Paul McCartney? I can't get over this. Listen to those lyrics. I know that Frankenstein will write a song never before hearing "Yesterday." He'll pick up his guitar and he'll say, [sings] "Yesterday, all my troubles seemed so far away/Now I need a place to hide away/Oh, I believe in yesterday." He won't be remembering the song… *he'll be writing it!* Paul McCartney just wrote the melody and lyrics. Who wrote it? Who wrote what? When I hear a song on the radio, am *I* writing it? Some people believe this kind of stuff. My one friend is always running around saying "I'm producing this video, this television show, this *is* me singing this." And I think, "That's what *I* used to think, *but it sure sounds crazy.*"

M2: What's "I Killed the Monster" about?

DJ: It was written by Frankenstein. Right before Jesus returns, Frankenstein will kill the monster.

M2: I see. And who is the monster? Satan?

DJ: Vile Corrupt takes on many forms. He's my enemy, but he doesn't bother me anymore. He wants me to be happy to write songs because he loves me to do drawings and write songs. He wants me to be productive so he can live. He wants me to sing a song about him. So he can fight his battles in the drawings.

M2: Did you *really* meet Roky Erickson?

DJ: I knew him when he used to live here in Austin. The song tells the whole story.

M2: You used to watch horror movies together?…

DJ: Yes. We watched *Third House on the Left*. He really liked that one. When it got to the end when all the people were killed, he kept rewinding it.

M2: Did you play music with him?

DJ: No. That was my intention, but we never got around to it. I played piano with his mother once. She was real nice. They were a very friendly family.

M2: What about your cover of "Tomorrow Never Knows"? You do it straight, then you stop and yell, "No, no, no, don't go down, don't give in!"

DJ: That was my opinion at the time, that some people might have been taking that old song in the opposite way of what was originally intended. They can take a regular lyric and say, "This is what this means, and think about it that way," and they twist it inside out. Then they tell the singer to sing it again, and they're thinking that thought. And they sing it again, and everybody says, "Yeah, it sounds like that's what he means." It's lies. Lies are terrible. Lies are black holes. Don't fall into that void, you'll never come back.

M2: What about some of Lennon's other lyrics, like "I Am the Walrus"?

DJ: You *see* with dead dog's eyes…

M2: Right. You have several songs, like "King Kong," where you retell the story of a misunderstood individual. Who else has been misrepresented by stories?

DJ: Captain America. He's suffered the most.

M2: How's that?

DJ: He was the greatest hero of all time.

M2: But did Stan Lee and Jack Kirby misrepresent him?

DJ: Captain America's my father.

M2: Is that right? In the song "Rocket Ship" you sing "My bags are packed, I'm ready to go." It sounds like Peter, Paul and Mary, but you're getting into a rocket ship rather than a jet plane. Have you ever wanted to go to space?

DJ: One day I will. I'll go to Mars or something.

M2: How?

DJ: When I'm Frankenstein, I'll go to Mars.

M2: Do you like science-fiction movies?

DJ: Yes, *2001*. *Planet of the Apes*. When the United States is blown up the apes will take over.

M2: You think so?

DJ: Yeah, just like in the movies. Just another one of them prophecies.

M2: So you believe in predestination.

DJ: Yeah, I'm already there. I'm in the future. I'm gone. I don't dwell in the past. I live in the past too.

M2: Tell me more about the Great Tribulation, the endtimes.

DJ: It's all in the Book of Revelations.

M2: What about the superheroes?

DJ: Many superheroes are described. They talk about the angels. It's all there if you read it with an open mind. I mean, God wouldn't let a Great Tribulation go by without some superheroes running around.

M2: That's true. "Don't Play Cards With Satan, He'll Deal You an Awful Hand" is a very powerful song. Have you ever have been through that situation?

DJ: It's a mistake when you try to deal with the Devil. You shouldn't give him any credit or any ground to stand on. You just don't play cards with Satan because he cheats. And you don't want to play cards with a cheater. You shouldn't gamble anyway—always hoping to get something for nothing. You should try to live an honest life—get what you pay for and pay what you get for.

M2: There are some people writing books claiming to have channeled John Lennon's spirit, that John Lennon is speaking to them.

DJ: Those are just like the false

> The only reason I tried to claim that I wasn't Daniel Johnston was to step out of myself for a brief break from infinity

prophets you see on TV. They say they've got the Holy Ghost and they're taking people's money. All they talk about is money.

M2: So you don't believe in televangelists.

DJ: No. Anyone who has the gift wouldn't bastardize it like that. John Lennon wouldn't talk to someone who'd bastardize it. I imagine he'd talk to me.

M2: What do you think of the ballet that's being done in France to *Yip/Jump Music*?

DJ: I think it's funny. I haven't seen it yet.

M2: Why do you think they picked that album?

DJ: Maybe because it's a celibate album. When you have leotards on you're supposed to be celibate or something.

M2: Is that how you thought of *Yip/Jump* while you were doing it?

DJ: Yeah, it was a celibacy album. I thought I'd try it. And all the songs are cheerful. It was really a step up from the way I was feeling.

M2: You were writing the songs to cheer yourself up.

DJ: Yeah, I changed the subject. Instead of singing about funeral homes, I thought I'd sing about speeding motorcycles. I read in the newspaper that some carnival had a speeding motorcycle, and I underlined it. Different songs from that period were about just trying to change the subject, which is what I need to do now. I was working on this album before I was incarcerated in the hospital called *Frankenstein Love*. I was writing some cool songs about Frankenstein. With these cool chords. And now I'm getting all these sappy love songs. It's not quite up to par.

M2: What happened to the songs from *Frankenstein Love*?

DJ: They're all half-finished.

M2: What's the tone?

DJ: Serious.

M2: Pre-apocalyptic? What kind of role does Frankenstein play? Is he a good guy or a bad guy?

DJ: When I die, there'll be no music. 100 years after I'm dead they'll resurrect my body and turn me into Frankenstein. Then I'll tour with the Beatles and the Butthole Surfers. There'll be music *like there's never been music before!*

M2: We had the Butthole Surfers in MONDO #3. Gibby's into computer graphics—he submitted some of his work to illustrate the article.

DJ: He's the greatest. He's beyond a clown. He's the ultimate warrior's apprentice. He's King Gibby. The man is a god. They're all gods, the Butthole Surfers. And anybody who worships the Surfers can be gods too.

M2: Tell me how you began drawing.

DJ: I was drawing before I was writing songs. My aspirations were to be a comic book writer. I never thought I'd be a musician until I heard the Beatles.

M2: You were inspired by Jack Kirby.

DJ: I studied his drawings 24 hours a day. I know my drawings don't look anything like Jack Kirby's, but he's the greatest artist of all time. He's right up there with Salvador Dali.

M2: But your drawings have a very specific personal element.

DJ: It's a surreal play inside my mind that even I don't understand. It's more real than I am. It's more real than the things I do. This cartoon world that goes on, it's just of itself. I'm not making it up. The pictures draw themselves. I only

Walking the Cow

look and reflect and try to interpret what's going on. That may be a frightening notion for anyone who'd consider being my friend. I live in another world, another plane. I'm not Daniel Johnston at all.

M2: Who are you then?

DJ: I've sinned against myself. I'm Daniel Johnston and I've always been Daniel Johnston. The only reason that I tried to claim that I wasn't Daniel Johnston was to try to step out of myself for a minute for a brief break from infinity. It would never last. I can't get away from being Daniel Johnston.

M2: But the dramatic progression in your drawings—the boxing matches. Are you perpetually boxing with Vile Corrupt, and is that the only way you battle him?

DJ: Well, originally this creature was evolving from the innocent frog, and I thought to myself that I'd *like* an innocent frog. I thought it would have to develop and have more eyes so it wouldn't be naive anymore. But I didn't want it to become a monster like everyone else. But there was this Vile Corrupt that I invented that ended up on the back cover. When I started drawing again I was boxing this thing. Without even thinking, I was fighting this thing, whatever it was. I had a girlfriend, and I'd never had a girlfriend before, and I hadn't had much sex, and I became a monster. She didn't give me enough love—all I got was sex—and I became a monster. I was battling myself. It was a nightmare. This Vile Corrupt was me at this point. But then there was another point when I thought I was Satan. I don't fight anymore. I'm not boxing anymore. Of course, I'm not *drawing* anymore either. I thought I had it all figured out. You'd probably do a lot better than me if you were interviewed.

M2: Nobody ever has it all figured out. So the drawings were like dreams. Did you dream some of this stuff back then?

DJ: I don't remember my dreams, but some people do. Some people remember my dreams for me.

M2: Did you put together the collage on the cover of *Artistic Vice*?

DJ: I did.

M2: Where did you get the photograph of Jack Kirby?

DJ: From a 50 cent Kamanda comic book special. I'm going to name my first son Kamanda, the Last Boy on Earth. I mean, I won't call him Kamanda, the Last Boy on Earth, I'll call him Kamanda Johnston.

M2: And then there's you standing next to a statue of George Washington. Do you like George Washington?

DJ: He reminds me of my friend Ron Harris—the man who discovered "Grievances." You know the song "Grievances" on *Songs of Pain*? All my songs are based on it. He discovered that song. I played it and he said "Play it again." So I kept improving it, and it became my song of songs that all my songs are based on. Songs like "Almost Got Hit by a Truck."

M2: That's one of my favorites.

DJ: It's all true.

M2: Did that happen to you?

DJ: Lots of times. In the song I describe three or four times. Each one is true.

M2: Are you wandering around in the street on purpose or are you spacing out?

DJ: I'm always wandering around. I'm sort of an idiot savant, I suppose. I'm not too smart.

M2: I think you're pretty smart.

DJ: I fooled you.

[*Emphatically*] If there was something I could say to make anyone reading this right now feel relaxed and entertained. These are words being printed right now. I'm actually saying them now, but you'll be reading them later. I just want to entertain you, everybody, and that's what I'm trying to do with my songs. For me, the horror movies and the Twilight Zones and the comedy and the good times, it's real, and it's the ultimate for me to be able to express these things in my art because it makes them real for me. It's not real until I put a frame around it. I'm excited now to have the opportunity to entertain and be able to get on stage and put on a show.

M2: What does "Walking the Cow" mean?

DJ: There was that Borden ice cream that had the little girl walking the cow on the wrapper. I cut it out and glued it on my notebook. And later when I picked up my chord organ and started writing songs, I looked at that and I wrote "Walking the Cow." When I'd finished I thought I'd done something pretty cool.

M2: In "Keep Punching Joe," you say "I've been singing the blues and walking the cow." Does walking the cow represent the blues for you?

DJ: What it represents is walking your responsibility. It's like a burden—walking the cow is like bearing your cross. "I don't want to stay here, but I'm walking the cow."

M2: So it's just living out life, carrying on. You've been filmed before. Do you mind being filmed?

DJ: I love it. I live for that moment when I can be part of a production of art—a drawing or recording a song. When that video camera is on, I'm ready. I become my true crazy self.

M2: You're a born star.

DJ: Well, a ham maybe.

A distinct pen and ink style of Daniel Johnston

Inside Daniel's studio
1999-2003

Photos by Don Goede

Drawings of hope

When Daniel and I ate together on the road I often would ask him how he came up with his song ideas. He would draw the ideas out on our place-mats, and I, of course, saved them all. While we were driving, he also doodled a lot of drawings of me and sometimes my dog Oblio. Here also are some doodles I found from his Bible lesson books.

—DG

Coming Events

THE DREAMER WAKES UP

BEN, WE'RE HAVING COFFEE IN THE OTHER ROOM...

OH, I WON'T DISTURB HIM! HE'S FAST ASLEEP!

Quality — we never miss

THE SWIFTSET ROTARY NEWS

HUMOR

WHAT GOES HA-HA FLOP? — A MAN LAUGHING HIS HEAD OFF

COMICS

What the heck?

SOCIAL ACTIVITIES

HUBA HUBA YIP YIP

WAH! HAVE HARD

BOOKS
BOOKS
BOOKS

Here are Don and Rae Davis in their cozy Hollywood Towers apartment. They are in the midst of nine different one-man-band setups, all of which enable the Davises to "combine music and drama, art and sculpture, science, athletics [etc.]".

12 | The Notebooks

"The dreamer wakes up"
—Daniel Johnston

I first saw "The Notebooks" early one morning when Daniel and I were hanging out in his garage/studio listening to music and talking (a ritual we played out many times after our tour was over). They were stored away in an area that was a segue to the half of the garage where Bill, Dan's father, parked the family car. I noticed in various boxes, loads of spiral bound notebooks. Daniel let me pull them out and go through them. It seemed that, in addition to Daniel's obsessive tape recording, for years he had been logging his thoughts in any type of notebook he could get his hands on. They contained drawings, collages, poems, ramblings, and cut out images from every source imaginable. I sat there in complete and utter awe as I flipped through what seemed to be the resting place for his innermost feelings; a net for his soul. The contents ranged from a simple notation about the weather to the detail of someone's sweater. The entries confessed both his secret thoughts and his delusions of grandeur. They seemed endless, and I was completely blown away by their honesty.

-DG

THE NAME OF THIS SONG IS... DANNY'S WORLD

OCT. 1982

I'M A DREAMER WAS A'M DREAMING

IDEA! Ren Dimey on the Cover of T.V. Guide

Ask Cam Kirk tomorrow
if I can help work.

Saturday Nov. 20th

Wake up! with King Kong anymore, I had a thousand dreams of wind blowing. Mom said she did too. Parents leave to go get grandpa at a hospital. I leave later walk to Stills, and call Jodi Fair and tell her I'm going to watch "KING KONG" on her video-machine. Kevin Stills brother gives me a ride. He was in the play the nite before, then we watch KING KONG the GREAT MOVIE! and talk with Mr. Fair about it. John Fair comes over. Jodi makes chicken. Claudette and Jodi play tape they made up. I laugh out of control when John asks me if Pee-Wee Herman is RETARDED. (said he reminded him of me) They said I could ride home when they took Claudette home. But the evening got later and later, and Claudette refuses to go so I left and walked by the old school (everythings the same) Hitchhike. Home again. mm Pizza and A NEW CAR — we're trying out. et. Girl on Saturday & Squeeze. — Difference the movie. Finished Bookman ad to take to Capt. Kirk tomorrow. 3:30

You look so good
But don't let it go to your head
You look so good
Did you hear what I said
Don't let it go to your head

(spoken interlude, almost sung)
I always did, I think you knew that I did

ADDITIONAL LYRICS

You look so nice.
You look so nice
You look so nice I
just gotta look twice
You look so nice.

(I always did)
You look so good
(I think you knew)
(that I did)

You look so good
You must be the pride of your neighborhood.
You look so good, that all the other girls wear
their faces and bodies as hand-me-downs

I ONLY WANTED TO BE LOVED

THIS MUST BE THE END

OR

THE BEG[INNING]

I know you can get tired of me? I get tired of me too.

BUT IF you REALLY ARE TIRED OF ME you MUST BE SICK OF you

I LOVE HIM SO... I'M AFRAID SOMETHING WILL HAPPEN TO HIM!

KENT STATE UNIVERSITY GRADE REPORT — REGISTRAR'S OFFICE

DEPT	DESCRIPTIVE TITLE	COURSE NUMBER	GRADE	HOURS	POINTS
ART	PAINTING I	14060	C	03	06
ART	VISUAL ORGANIZATION II	13001	F	03	00
ART	ART EXPERIENCES	21001	C	03	06
ENG	COLLEGE ENGLISH II	10002	F	03	00
PEB	DEVELOPMENT+CONDITIONING	10020	C	01	02
PSYC	ABNORMAL PSYCHOLOGY	40111	C	03	06

HRS EARNED-SEM 16.00 CUM 48.00 FINAL GRADES
ACADEMIC PROBATION

SPRING 1981
234-08-5616
FPA M
E LIVERPOOL

JOHNSTON DANIEL D
50246 DUKE ROAD
EAST LIVERPOOL OH 43920

	HOURS	POINTS	AVERAGE
CURRENT TERM	16.00	20.00	1.25
ACCUMULATED TOTALS	48.00	92.00	1.91

MAJOR 900

My life
 my life
 for a 29 cent pen

Today is the last day of the rest of your life.
(Yesterday was the next to the last day)

"Still that same gal you're trying to impress?"

I SURRENDER

"Trying to avoid me, eh?" he accused

I WAS ACCUSED
OF TRYING TO AVOID YOU
I HOPE YOU'LL BE
FLATTERED

He couldn't avoid this encounter forever. He walked slowly toward the rear, still not knowing what to say. In contrast to the warm, brightly lighted store, this room was cold and shrouded with gloom. There, behind a wall of

ILLUSION STOOD THE BEAUTY QUEEN FASHION MAGAZINE

usual smile.

His expression was positively belligerent. ...u in if you don't give yourself up."

GIVE IN OR GIVE UP
SURRENDER I'LL SURRENDER
IF YOU WILL
I'LL SURRENDER IF YOU WILL

BOY MINUS GIRL

BOY MINUS GIRL EQUALS ZERO
I WOULDN'T WANNA FACE THAT
BUT COULD I FACE YOU
FOR A LIFETIME OR
EVEN AN HOUR?

felt numb with surprise.

I HOPE YOU'RE FLATTERED
I REMEMBER WHEN I WAS
A LITTLE KID
I'M ALWAYS REMEMBERING WHEN
I WAS A LITTLE KID

THERE WAS MADNESS
IN ME AT THAT TIME

HE DIED A
VIRGIN
GOD BLESS HIM

WHY I WORRY
BECAUSE I'M AFRAID
I'LL BE LEFT ALONE

IN A
WAY

ILLUSTRATED HUMOR

"GIVE ME A KISS"

"Do you know my jokes?"

COMICS CODE

HARVEY COMICS GEORGE BAKER

THE SARGE

HI FI TWEETER

THE GENERAL

SLOB SLOBINSKY

MAKE WAR SOME MORE

MUTSY

Sunday — Nov. 15th

A GOOD DAY YEAH!

Shower, computer kids.
Piano church, Sad Sack comic books
I tell Winona Kay I bought
something for her at rummage
Lunch, burger
more piano sleep
old box of stuff
from grievance period
James Thurber short story
Sad Sack
sleep
Church
I get Winona Kay
"He is stay younger, beautier"
Hope she will, know she won't
I read scripture in front of church
after church.
Scott returns electric piano
and I go to Bill's and Winona's house,
Bill bass, McCartney
popcorn game, Brownie, Ice tea
Bill okays the movie
we talk
broken tie, the Man of San Limbo
Sunday
my life with Kay
I draw Sad Sack for Bill
Have an a half

TV9 — JUST WATCH US NOW!

NEWS NINE NEWS TEAM

- **RED DONLEY** — Live from Steubenville
- **KEN KADAR** — Live from Wheeling
- **ED WARREN** — Complete Sports Coverage
- **MARK FUCHS** — Ohio Valley's Only Meteorologist

Ohio Valley's Finest Hour
6 P.M.

- Dan Johnston — Live from New Cumberland
- Brett Hackenback — Live from Missouri
- Ron Harris — Complete Sports Coverage
- Jim Skafetti — East Liverpool's Only Council Member
- Tom Crim — Ohio Valley's Only Folk Singer
- Dave Thornberry — Ohio Valley's Only Married Man

OHIO VALLEY'S FINEST

LET THE SUN SHINE IN

FUN Keep on Truckin' ACHCHOO X-RAY GOGS

He would never dare, of course, but it was fun to build up the scene in his imagination. He was still dreaming when he heard someone outside his door. Mother, no doubt.

" I AM BEAUTIFUL

" I AM BEAUTIFUL, OH MORTALS,
AS A DREAM OF STONE,
AND MY BREAST,
WHERE ON EACH DIES IN HIS TURN,
IS MADE TO INSPIRE IN THE POET
A LOVE
AS ETERNAL AND SILENT
AS THE SUBSTANCE ITSELF."

FROM BAUDELAIRE'S
"LA BEAUTÉ"

ITALO MEETING
TAPE BY:
NOV 27TH

HA! HA!

25TH
WEEK OF THANKSGIVING

2 TAPES

TDK/SAX-60
TWO TAPES
ONE
OR
MASTER

♪ Nothing's too good for me and my gal ♪

I USED TO NOT MAKE FUN OF PEOPLE... BUT PEOPLE ARE SO FUNNY THESE DAYS

After Dali

I'M ON AN ACID TRIP RIGHT NOW

I NEVER GET HIGH!

WHAT MADE YOU SAY THAT?

694 - FROST
702 - RHYTHM CITY
730 - BOTTOM OF PAGE

ALL RIGHT SO I TAKE A FEW DRUGS —

SO WHAT!?

I EAT DRUGS MORNING, NOON AND NITE

WHY IS HE SAD ?

MONDAY / OCT 23RD

WOKE UP
HORRIBLY DEPRESSED
MOVED BOXES TO NEW
ATTIC ROOM
PROF. ELATOU
(PINK PANTHER)
I AM OUT OF MY
 MIND
PARENTS LEAVE
 TO BUY NEW
 CAR AND MALL
I GO THRU BAGS.
AND THE PRESIDENT
COMES ON THE T.V.
AND SAYS WE
COULD ALL BLOW UP.
HOPE NOT
B SALLEY CALLS
ASK ME IF MY MEDIUM IS LIMITED
RIP MASH / N#4 NEWHART GOOD
PIANO / START NEW NOTEBOOK
DRAW LETTERMAN / FRANK FOR CORPORA
I LAUGH AT SAD SACK **THE END** THANK GOD
THIS IS

STANDING IN LINE
THE ENVIRONMENT WAS
FILLED

"MY NERVES ARE SHOT TO HELL"

KENT 3'S 100'S
LONG
WHITE CREEM
WITH NAVY BLUE
ON THE SIDES
I PACK

I'LL GET YOU IN THE END OH YEAH

I love you

WHEN YOU BELIEVE YOU HAVE TO, YOU WILL

BRETT,
 HERE'S ANOTHER LETTER WITH ONE OF THOSE STUPID "LOVE" STAMPS. I HATE THEM. THEY LOOK SO STUPID ON THE LETTERS. BUT WE STILL HAVE ALOT OF THEM TO USE UP.

 HI AGAIN
 RIGHT NOW
 I'M SITTING AT
 THE FEET OF THE
 BEST PIANO IN TOWN
 AT THE HOME OF
 THE CIGGERETT BUTT
 GIRL.

No I'm the cig. butt girl. Made jam. trip try that tune ? times that we all know and lov. he realy does. have cig. butts for me. know what I line about his song, their is realy werd except I'm not poor.

STILL UNSTABLE

> THERE'S SO MANY THINGS BEING SAID BY SO MANY PEOPLE I DON'T KNOW WHO TO BELIEVE OR WHAT TO DO I'M SO CONFUSED...

TO BE CONTINUED →

THE END

The Arner Families
Wish You a Blessed Holiday Season!

Alvin and Ruth

Pete and Nene

Pete, Laurie and Kylene
Doug, Greg and George

ARNER
FUNERAL CHAPELS, INC.

1900 — 1982

13 | In Daniel's Words

*"You are a writer.
You are a writer,
but you better write fast,
'cause your paper's on fire"*
—Daniel Johnston

Daniel Johnston has a wit like no other writer I have ever read. His writings can be very disturbing at times, but also quite clever and fascinating. This chapter is comprised of examples of Daniel's writing including biographies written about himself, each from the perspective of a different one of his contemporaries. For example: Daniel wrote "The Daniel Johnston I know" from the perspective of Kathy McCarthy, and "The Daniel Johnston Story As I See It" is written by Daniel from the perspective of Gibby Haynes. There are also samples of schoolwork and outlines for film/video projects. Daniel's writing style embodies traits often associated with megalomania, but it is also symptomatic of his manic depression (bipolar disorder); much of his writing is done during periods of extreme elevation or mania. Here are just few pages into the mind of Daniel Johnston. They are typed as close to how the originals are written as possible.

—DG

The Daniel Johnston I Know
By Kathy McCarthy (written by Daniel Johnston) of Glass Eye

1. I'll never forget this "weird guy" who came up to me after a show and gave me a tape entitled "*Retired Boxer.*" He was going on and on, nervously, telling me how great we were, stuttering and tripping over his own feet. He seemed to have a tremendous amount of energy, but in no way did I have a notion that this young man would become a <u>MAJOR</u> figure in my life.
2. Soon afterwards I listened to the tape. I thought it was all right.
3. So, at our next show, Daniel excitedly came up to me once again, with yet another tape. This time the tape was *Hi, How Are You?* His masterpiece.
4. I listened to it in Stella's car on the way to Houston one day. I thought to myself, "I've got to get to know this guy."

"I'll never marry, I'll never wed."
Nobody wants to kiss you when you're dead.

5. And, so I turned on the rest of the group of Glass Eye to Daniel's tapes. They took a liking to him instantly.
6. And, so we called Daniel at work, The Old Horse Sandwich Shop, where he lived upstairs. He was thrilled. He said, "This is like getting a call from The Beatles."
7. That night we went to visit him in his small room. There were Beatles albums and posters everywhere and comic books by his favorite artist, Jack Kirby.
8. It was the most fascinating evening of my life! He played us tapes and showed drawings both of which he seemed to have thousands. He even recorded us as we talked the whole night. And, he played some songs for us on guitar with great ease. He was very at ease and un-self conscious. He made a joke when Brian looked at the window. He was referring to a song we did that we got our name from, Glass Eye, that had a line in it, "I think you should know you're in my window." He was snappy and manic like that. He was often as quick as a pistol and very funny.
9. Of course, the idea came up to have Daniel open up for us. He played guitar but not very well. Anyway, he began practicing. He had never played in front of an audience before in his life.
10. I must confess that I almost immediately fell in love with Daniel Johnston. He was very kind to me and he was encouraging about my songwriting. I really respected his opinion. He seemed to have so many of the opinions

In Daniel's Words

and ideas coming out of his head like water from a faucet with no apparent, at least little, effort on his part at all.

11. And, so after two months when we came back from a tour of the east, Daniel opened for us at the Beach. I took him aside to give a speech about performing, but he was very aloof… like he didn't want to hear it. He seemed to have no fear, like Superman or Jesus Christ or Something.

12. He sat strumming by himself on the side of the stage. An impressive amount of local musicians and writers and almost the entire staff of *The Austin Chronicle* were in the audience. Most of which he had put on the guest list. Daniel had given out hundreds of tapes for free, and he already had a strong following. Without fanfare, or introduction, the slight, obviously nervous, singer took the stage. His playing was shaky. His voice was near quaking.

13. Almost instantly the audience was quiet and spellbound. At the end of the first song the room burst into applause. What I thought was really cool was when Daniel played his song "Marching Guitars." The crowd applauded before he finished the song, which resulted in applause twice as loud as the first time.

14. So, this, is his Austin debut, I thought had gone rather well. But, in the truck on the way home he said to me, "I don't care what they think about me. I don't' care how bad I messed up. Nobody can stop me. It's going to be like nothing you've ever seen." He was definitely still in his manic stage.

15. It was at this time that Daniel and I began our "relationship." He was very nice and considerate, but he seemed to be pre-occupied with sex.

16. He would draw hundreds of pictures of naked girls wearing my glasses. I didn't know exactly what to think of it.

17. It sort of bothered me about Daniel's sudden rise to fame, almost overnight, because I had been struggling for years in Austin with music and bands, and it took so long before I was finally successful. He was getting write-ups in the local papers and all sorts of notoriety.

18. But, Daniel assured me that he himself had struggled for years in private, in poverty, traveling with a carnival, suffering from many nervous breakdowns, and persecutions from his family who all told him constantly that he was a lazy bum and would "never get anywhere" with his art or music.

19. It was around this time that I discovered that Daniel was a very strong and moody <u>MANIC-DEPRESSIVE.</u> Suddenly, almost overnight, he became severely depressed and emotionally upset about our breaking up. He would call me constantly on the phone and come over to our house at all hours of the night. He was really a pest. I felt bad enough that things didn't work out. He was always twisting my arm to try and get what he wanted. He wrote a song that said he had a girlfriend that made him scared of the world. The way it sounded when he wrote it down made me hate that girl

(myself). When I saw him I'd let my guard down. I was kicking the dog. I was doing wrong. We'd walk around and try to talk. He wanted to know who were those people I liked so much better than him. He was twisting my broken arm. He was twisting my broken arm. He was kicking the dog. He was doing wrong.

20. Amazingly, after only playing out for two months, Daniel was chosen (along with Poison 13, Timbuck 3, and others) for MTV's *The Cutting Edge* show special on Austin music. All his worming his way into shows, and manipulating people, and playing up to the press, had apparently paid off.
21. Almost immediately after the show was aired on MTV on August 25th, 1985, Daniel quit playing out. Disillusioned about our relationship and freaked out about all the attention, he continued harassing me for a number of months. I would visit him occasionally, but he would always try to come on to me. All he wanted was my body. He had changed from a saint-like gentleman to a sex-starved maniac creep low life scum… from sweetheart to monster.
22. When *the Cutting Edge* show was aired on August 25th, 1985, Daniel was in another manic state again. Driving around in a car all over town the day before the show yelling at passers by (especially females), "Hey, my name is Daniel Johnston, and I'm going to be on MTV tonight!"
23. When I came back from Anaheim tour, I found out he now had a manager, and was smoking marijuana, and making videos with his new best friend and constant companion, Randy Kemper.
24. Apparently, Randy was giving him lots of money, buying him expensive meals, and giving him lots of various drugs like pot and mushrooms.
25. He even got a video he directed on MTV's THE *Cutting Edge* again. It was a song he wrote about me entitled "Hardtime." He was throwing his fist into the air and shaking his leg like Elvis.
26. At this period, to my disgust, Daniel had many new girlfriends from one week to another. He never seemed satisfied. One of these girlfriends turned Daniel onto acid. It was Alice thru the looking glass for sure.
27. It was on one of these acid trips that Daniel completely lost his mind. At a Butthole Surfers concert.
28. Less than a week later he was taken to a mental institution. I went to visit him. He was heavily medicated and disillusioned.
29. The members of Glass Eye, some other people, and myself, and his new manager (Jeff Tartacov) all came to Daniel's trial where the judge would decide whether he should be released or not. *The Austin Chronicle* had arranged for Daniel to have a lawyer. Daniel was calm and collected, and after his testimony, the judge allowed Daniel to be released.
30. Daniel was obsessed with ideas he believed to be revelations about God and the Devil. He believed the food and water was poisoned. He was like

In Daniel's Words

a zombie… Casper the disoriented ghost.

31. I didn't see much of Daniel over this period, but I heard through the music grapevine that he was making new videos and recording with the Butthole Surfers (who were his new biggest heros right up there with The Beatles. He would often say they were the greatest band in the world).
32. Before I knew it, he had gone back to West Virginia with his dad, and everyone was talking and wondering about him.
33. I didn't hear much about him, or from him, for a long time 'till I finally called him in the middle of 1987. It was good to hear his voice, but I was shocked when he told me, "I have lost my soul to the Devil."
34. I didn't hear from him again until I saw him again in New York in April of 1988. He came to one of our shows, of course. As usual, it was almost like the old Daniel only lot-lots better. He looked great and healthy. He was in town recording with Sonic Youth, Jad Fair of Half Japanese, and Moe Tucker of The Velvet Underground.
35. He wanted to open for us, but the club owners of the Knitting Factory wouldn't let him. He came up after the show and said, "You guys are the greatest band in the world." I guess we were his New Favorite Band.
36. I thought it was strange when Brian played me the song he wrote for Daniel called "Come Back" with the lyrics: "Come back, come back into Satan's Arms. I will shield you from evil and I love all your songs." I thought it was strange, so I asked Brian about it, but he was very evasive.
37. I wrote a song about him too on our new album *Bent By Nature* on Bare-None Records. The song is called "Kicking the Dog" which sort of told our story. I was afraid he wouldn't like it, but he said that that song and the song "Come Back" were his "favorite" songs on the album.
38. And, so now I hear that Daniel is going on tour with the Butthole Surfers to Europe in September, and he is also recording an album with them in June. To say the least, I am impressed. We also plan to record an album with him in mid 1989. He is very ambitious.
39. So, this is the Daniel Johnston I've come to know. I'm sorry now, but I've got to go. I've got people to see and things to do. Maybe someday I may meet you, and you can tell me what you think… give me everything but the kitchen sink.

Love,
Kathy McCarthy

Daniel Johnston:
A Documentary

Beginning Documentary:

When song starts
Shots of me performing
Close up of my face
Me on MTV smiling
Holding my album cover
Playing piano in red shirt
In white looking spooky
Featuring (show the faces quickly):
(In Order of Appearance)

Gibby Haynes
Theresa Coffee
Paul Leary
Jeffery Pinkus
King Koffee
Kathy McCarthy
Brian Beattie, Glass Eye
Timbuck 3
Louis Black
Mike C---------
My Mother
Dad
Grampa
Gerald
Ronald
Mrs. Harris
Lisa
Frank Higg
Will McG--------
School Teachers: Mr. Stevens, others
Chester Jr. High
Mrs. White, Earl, others
Oak Glen. Mrs. Smith, Mrs. Stump
Palo, Heyward, McDevitt (Art) Princton?
Band Director, others, Mrs. Jester
Kent State, Al, Dr. Smith? King? Earl?
Janitor?

Some
People
Silent
Outsitde
Boone cam
On
Overlook
David Thornberry
On
Pike's
Peak
With
Wife
Have T.V.
Trailer
Rusty
Jim Poruskus
Randy Depee
Brett
Boat
Doug Smill
Dreg Drey
Mrs. H----------
Gretchin
B---- Mc----
*Laurie Arner**
Ron Miller & wife
Fred Stevens
Carl Miller
Willma McMann
Others.
Carrie Michaels
Sarah Free------
Mike West, Tammy Stevens
Spin the bottle
And
Randy Yost?
News
Quaker State & TWA ---------

The Daniel Johnston Story As I See It

Written and Illustrated
by Gibby Haynes
(written by Daniel Johnston)

1. The 1st time I heard of Daniel Johnston was in Athens, Georgia. Glass Eye came to town and brought us Daniel's tape *Hi, How Are You?* I was Intrigued.
2. The 1st time I met Daniel was at a Butthole Surfers show in Austin, Texas. He came back stage after the show. He was very hyperactive. He said, "Hi, I'm Daniel Johnston. You guys are the greatest band in the world."
3. I immediately said unto him, "We ought to record something."
4. He promptly started to jump about and was posing, flexing his muscles for photographers. He was very excitable.
5. After we moved to Austin, he would come to every one of our shows, and he would come to us afterwards full of praise and enthusiasm and bearing gifts and *Hi, How Are You?* T-shirts, tapes, and comic books.
6. I was surprised when I read in **the Austin Chronicle** that he had won the Songwriter of the Year ad. Folk Singer of the Year in the 1985-86 *Austin Chronicle* "Reader's Poll." Only from less than a year of playing out live. I thought that was amazing.
7. Well, much time went by, and Daniel continued working at McDonalds. He was always poor and starving all begging to get on the guest list, and filling his palm full of Coca-Cola. All the bars would feed him for free since he was such a "celebrity."
8. During all the time that I knew him during this period he never played our. He would hide in seclusion with all his "girlfriends."
9. Sometime during 1986 Theresa, one of our drummers from the group, made a video with Daniel entitled "Continued Story." It was about a girl dressed in black stabbing Daniel repeatedly as she chased him throughout town.
10. Then Daniel began to get heavy into "Pot" smoking

once again. Or, as he called them, "Happy Smokes." His new manager was a pot dealer, which was convenient for Daniel, because he got all he could smoke for free.
11. During this period Daniel made a number of videos with Randy Kemper, his manager. He even got a video he directed on *The Cutting Edge*. It was his 2nd appearance on MTV. (Drawing of Butthole Surfers watching T.V.) Lyrics from the song we sang went: "I have been so glad crushed by my ego can you imagine the weight upon me?"
12. It was not long after this that Daniel began experimenting with acid with one of his new girlfriend. She was also into black magic and witchcraft.
13. It was on one of these alleged acid trips, at one of our concerts, that Daniel had a nervous breakdown. He claimed that when the music started he got a revelation from the Devil.
14. Next thing we knew Daniel wound up in the local mental hospital. After he was released we went to see him in his apartment NO. 7.
15. We took him with us for the whole day and bought him food and pizza. He drank all of our Dr. Pepper and smoked more than his share of marijuana.
16. We had got him to come to our house because a friend of ours was visiting from Holland and wanted to film Daniel for a movie he was making.
17. We ended up recording a bunch of songs with Daniel. The best of which was "Walking The Cow." Also recorded was "Don't Play Cards With Satan," "Running Water," and his favorite song, "Grievances," which had the amusing chorus of "I don't want to die and forever I will shine. I will never die."
18. Less than a week later we found out that Daniel had fled back home to the hills and safety of West Virginia. We soon heard from him though, and later released some of the material we

had done on our "Texas Trip Compilation." We really liked what we had done, and so did he.
19. He was especially pleased with the money he received after a while he was bubbling with ideas and projects about albums, and videos, and even movies one in which he wanted me to play the part of Satan.
20. And, so our phone would ring at least once a week, and of course it was always Daniel with the latest.
21. The next event was Daniel's now legendary trip to New York. He began recording his new songs, mostly about the devil, with Mark Kramer of Shimmy Disc Records at Noise NY Studios. Mark was former bass player of the Butthole Surfers and also Shockabilly. He recorded with Sonic Youth, Moe Tucker of The Velvet Underground, and Jad Fair of Half Japanese all within the space of a few weeks. He sang backup in Moe Tucker's version of "Pale Blue Eyes" on which Lou Reed had recorded the day before. He also opened for Fire House at CeCe's and the----- in various other shows and "open mikes. He was mentioned in the Village Voice that said about him, "There's never been anyone like him." He also did radio shows, numerous interviews and photos for Option Magazine, Pulse Beat, and Chemical Unbalance Magazine. This was Daniel Johnston, Rising Superstar. "Daniel Johnston, Superstar, who in the hell do you think you are?"
22. So, now we have big plans to go see New York in June to record an album with Daniel. And, also we are going to take Daniel on tour in America and Europe in September. So, this is the story of Daniel Johnston as I see it. Damn me to hell if over a word of it isn't true. I worked real hard just to bring it to you. Cut it out and have it framed. Listen to his albums, and memorize his name.

Dale Dudgeon
"out of the darkness, into the light"

(picture of me at 6 years smiling)

1. Daniel was born into a Christian family January 22nd 1961 in Sacremento, California.
2. Moved to Utah, Brigham City... a Morman town.
3. Moved to W.V. at the age of 4
4. Brought up in THE church (Church of Christ).
5. Baptised when he was 12
6. Nervous breakdown at age 13 1/2
7. 3 Years in the darkness of insanity
8. His recovery thru the ------- if art
9. When I met him in 1977 in Spanish class
10. His essay on the Roman Catholic Church
11. Our disagreements on instrumental music
12. Ron Harris
13. The Beatles, who is Bob Dylan?
14. Mrs. --------
15. His drawings
16. His music
17. Daniel work, the Summer College Scholarship in Quaker State
18. Off to Abilene
19. Homesick returns home to work in p---iery
20. Kent State
21. Laurie Allen
22. Haunted House
23. Driving around in his dusty, Juice Box, Steely Dan, "no pan/ no pain? Our theme song, the Sex Pistols.
24. Danny's Religious beliefs at the time
25. David Thornberry, seven-up?
26. Danny becomes Daniel. His return to Texas in the summer of 1983
27. Working at Astroworld in Houston, Texas. Living with his brother and sister in law, Sarah. Playing chord organ in their garage.
28. They told him he'd never go anywhere with his music or his art.
29. *Yip/Jump Music*
30. He moves to San Marcus, Texas, September 1983

31. *Hi, How Are You?*
32. The Crazy Carnival
33. Austin, Texas
34. Daniel Johnston on MTV
35. Daniel Johnston in *Rolling Stone* and *Spin Magazine*. Singer and Songwriter of the year 1986-86
36. The Sex, the Drugs, the Darkness… pornograpy, x-rated films, his naked lady, and his sexual drawings
37. Marijuana and Acid
38. The Butthole Surfers
39. "All his friends were Satanists"
40. The insane asylum
41. His return to W.VA
42. His year of torment, heavily medicated. He'd lie in bed thinking, "I'm going to hell, I'm going to hell."
43. He claimed he lost his soul to the Devil. Verses about blasphemests and the Holy Ghost. Verses about muses.
44. The "Light was Gone" from his eyes. He said the Satanists could see. That they could see the light was gone from his eyes. "Acts 2:38 "repent and be baptized and ye shall receive the gift of the Holy Ghost."
45. The Darkness
 a. He thinks, believes all shall be damned (verses)
 b. Eternal Damnation in Hell
 the bottomless pit (verses)
 c. Satan: the Prince of the World
 deceiver of the whole world (verses)
 d. Satan was cast out
 of Heaven (verses)
46. The Light
 a. God the Father–creator of the universe (verses)
 b. Jesus Christ the Son, the Savior, the true Messiah the one and only mediator between God and Man
 c. The Holy Ghost
 the power of the Holy Ghost
 d. Satan is phony compared to
 God the Almighty

 e. Baptism (immersion) and forgiveness of sins
 f. Eternal life with the Holy Trinity
 g. Praises to the lamb with the saints thru-out all eternity
47. Daniel off the medication. The old Danny is back once again writing songs and drawing pictures. All his songs and drawings are about the Devil.
48. Daniel's trip to New York
 a. Recording with Sonic Youth
 b. Jad Fair of ½ Japanese
 c. Moe Tucker of The Velvet Underground. Daniel sings a version of "Pale Blue Eyes" on which Lou Reed plays guitar.
 e. Kicked out in the streets with no money
 f. He said he was on a mission from God
 g. His manager and parents arrange for Daniel to be arrested and taken to a mental hospital
 h. Daniel falls in love (again)
49. Dan returns home
50. His new songs are about Jesus Christ
51. The power of the holy Ghost returned by the grace of God
52. His Gospel album project… many years in the making. His own compositions, but mostly Gospel standards.
53. Ron, Dave, & Dan: Fun times at the mall & movies
54. Dan wants to become a preacher
55. Dan's certain he will receive his rewarded in heaven
56. Album and tour with the Butthole surfers
57. He would come "out of darkness" and into the light

In Daniel's Words

My Funeral
Video

1. Someone puts a pen in my hand... moves arm to autograph album. "He'll sign it," "This will be worth some money."
2. (Filmed separately)
 Mom: "He always wanted to do his own thing, and look where it got him."
 Dad
 Grandpa
 Esta, Shelly, Bridgett
 Frank H-------- : "May God have mercy on his soul."
 Will M-------: "may he rest in peace."
 Ron Miller: "He was a funny guy. I thought he should go to Heaven." Uncle Jack
3. Pay the price of an evening service (Funeral)
4. 1st Filming:
 a. Mr. Hood (Have him do the sign of the Devil)
 b. Ron and Dale sing "Grievance."
 "If he had his own way
 he'd be here with us today,
 but he rarely has his own way.
 I guess that's why he's not here with us today.
 And, we saw him at the funeral.
 He was lying there like a pimple.
 We said, "Hi, How are you? Hello,"
 but he just layed there in the casket
 he was resting in."
5. Jim Scaffetti and Brett
 Brett: "------ said 'please don't go!'"
 Jim: "Goodbye to them, but he had to go. Now he's…"
 (Together): "Casper the Friendly Ghost."
 (Together):
 "Funeral Home, Funeral Home
 Going to the Funeral Home
 Got me a coffin, shiny and black
 I'm going to the funeral and I'm never coming back."
6. In black suit. At the end of the video I get up from coffin and say, "What's going on here? What are these people doing here? I had a dream that I died and went to Heaven, but Jesus told me to come back. Was I really dead, or was this some kind of elaborate joke? Dave! Are you behind this? This is really wild. Hi, Laurie. Hi, Pete," shakes hands, "Mr. Arner, I just had the weirdest dream. What am I doing here anyway? How did I get in here? Did somebody die? I must still be dreaming."
7. Shots of Laurie crying by coffin.
8. Laurie giggling by coffin.
9. Starring.
10. Yawning.
11. Combing Hair.
12. Straightening Tie.

1. My Funeral
 May God rest his soul.
 "Why must the flowers die?
 Isn't it enough to be dead than to have flowers die for you?"
 ---- and Dave duet (sing it solo than have it over dubbed):
 "Funeral Home, Funeral Home
 Going to the Funeral Home
 Got me a coffin, shiny and black
 I'm going to the Funeral Home.
 Complete "Casper Song" with extra verses (repeat during song)
 My Funeral, My Funeral," and sing, "Going to the Funeral Home."
 Satan, Jesus
 Heaven, Hell

THE SOUND OF MY HAPPY SOUL
Daniel Johnston
EYE

① I GOT A MIND BLOWING PHILOSPHY
I DON'T KNOW EXACTLY WHAT IT IS
BUT I FEEL IT IN MY HEAD
DOWN TO MY TOES
AND YOU CAN HEAR IT IN MY ROCK AND ROLL
IT'S COOL
IT'S COOL
THE SOUND OF MY HAPPY SOUL

② SHE HAS SUCH PRETTY FLESH
JUST THE THOUGHT OF TOUCHING HER
MAKES ME FEEL COMPLETE
I NEVER MET A GIRL I DIDN'T MEAT
I FEEL SO STRONG, I USED TO BE SO WEAK
IT'S COOL
IT'S COOL
THE SOUND OF MY HAPPY SOUL

③ DEEP WITHIN MY MIND MY SECRET HEART BLEEDS
BUT YOU'RE THE ONLY ONE WHO CAN SHOW ME
WHEN I SEE MY REFLECTION IN YOUR EYES
I KNOW THAT I DON'T WANT TO DIE
IT'S COOL
IT'S COOL
THE SOUND OF MY HAPPY SOUL

④ I'M WRITING SO MANY SONGS AT A ALARMING RATE
IT SOAKS UP THE TEARS AND EVAPORATES THE HATE
AND I KNOW IT'S NOT TOO LATE
FOR ME AND ALL MY FRIENDS
IT'S COOL
IT'S COOL
THE SOUND OF MY HAPPY SOUL

BLUE SKIES WILL HAUNT YOU FROM NOW ON
Daniel Johnston
E C D C / G C C G G

① YOU SAY YOUR HEAD
IS FULL OF TROUBLE
AND EVIL
HAS BROUGHT YOU DOWN
YOU FEEL SO TERRIBLE
BUT DON'T BLAME IT ALL
ON THE DEVIL
CAUSE

CHORUS
BLUE SKIES
WILL HAUNT YOU FROM NOW ON
BABY BLUE SKIES
WILL SET YOU FREE
SET YOU FREE

② YOU BETTER GET
YOURSELF TOGETHER BEFORE YOU
ALL FALL APART
DON'T DENY THE FEELING
GROWING IN YOUR HEART
BABY

③ LET IT GO
LET ALL YOUR WORRIES GO
LET IT FLOW
CAUSE DARLING DON'T YOU KNOW

④ JUST OVER THE HORIZON
BLUE SKIES ARE COMING GIRL
JUST HANG ON A LITTLE BIT LONGER
BELIEVE ME, THERE'S HOPE
HELP IS ON THE WAY
CAUSE

BLUE SKIES WILL HAUNT YOU
FROM NOW ON
FOREVER

> BLUE SKIES WILL HAUNT YOU EVERYONE OF YOU FROM NOW ON

Various lyrics

LOVE FIX
G C D C D / HERE'S A SONG BY ADOLF HITLER

WHY CAN'T YOU SEE MY GOOD SIDE
I'M NOT TRYING TO HIDE VERY MUCH
BUT I KNOW THIS LONLINESS WON'T LEAVE ME ALONE
WON'T YOU JUST STOP AND TALK TO ME ON THE TELEPHONE
LOVE CAN FIX JUST ABOUT ANYTHING
IT'S A TRICK THAT REALLY WORKS
JUST TRY IT ON YOUR FRIENDS
AND YOU'D BE SURPRISED
A LITTLE BIT OF KINDNESS GOES A LONG WAY
IT MAKES A DIFFERENCE I SUPPOSE
LOVE IS A MANY SPECIAL THING
IT'S NOT REALLY A DIAMOND RING
BUT IT SHINES BRIGHTER
THAN ANY STAR — LOVE THAN JUST ANY—
THERE'S FAR GREATER
NOW —BIBLE SAY—
DON'T GET ME WRONG NOW I DO BELIEVE
BUT YOU AND I SHOULD SURELY GRIEVE
FOR WE KNOW NOT WHAT WE DO
BUT WE DO IT ANY-WAY
AND GOD STILL LOVES US
AND JESUS STILL BLESS'S US
AND BUT WE REALLY DON'T DESERVE
AND BELIEVE ME WE'RE ALL GONNA DIE AND GO TO HELL
FOR SOMEDAY—ANYHOW
G D D7
AND HELL IS A FURNACE YOU'RE SURE TO ENJOY

LOVE IS CRUEL
AND LOVE IS KIND
LOVE IS MAMA
SPANKING YOUR BEHIND
BUT IF YOU WANT TO UNWIND READING A COMIC BOOK
JUST TAKE A LOOK BACK THE PAST HAPPENED FIRST
I BELIEVE THE TRUTH
MORE THAN YOU THINK
EVERYBODY TASTE THE GOOD LIFE IN THE UNITED STATES
AND I KNOW IT HURTS
BUT THERE'S NOTHING WORSE
AT THEN THE CURSE OF THE POISON CHURCH

LOVE IS FOREVER
THAT'S GOOD NEWS
YOU'LL MAKE IT IF YOUR CLEVER
DOWN WITH THE JEWS
AND I LOVE YOU ALL
BUT I GOTTA SAY
SEE YA AT THE JUDGEMENT
NA NA NA NA NA NA NA NA DAY

EM
G C D

In Daniel's words

THE AGONY OF ACNE

PEEING AT MY REFLECTION IN THE TOILET
WHAT'S THE USE OF BEING
WITHOUT A GOOD COMPLECTION,
AND I KNOW THAT
EVEN WHEN I'M OLD I'LL STILL HAVE THE SCARS.
TAKING OUT MY EMOTIONS ON THE MIRROR
(KRACK!)

HOPING SOMEDAY MY FACE MIGHT CLEAR
WHY SHOULD SUCH A THING HAPPEN TO ME?
WHY HAVE I BEEN CURSED WITH ACNE?
LIKE I'VE EVEN GOT PIMPLES ON THE BACK OF MY NECK
ALL I HAVE TO DO IS LOOK AT CHOCOLATE,
AND THE ZITS'LL START POPPIN'
BUT WHAT'S THE USE OF FIGHTIN'
ACNE IS MY FATE
I'VE SEEN IT WRITTEN IN THE STARS

ACNE IS A TERMINIAL DISEASE
IT'LL KILL YOU MENTALLY
IT'LL DESTROY YOUR FACE
AND PUT YOUR BRAIN OUT OF PLACE
IT'LL TROW YOU ON YOUR KNEES
HAVE YOU BEGGING PLEASE
LORD, HELP ME

A GOOD FRIEND OF MINE
GOT TIRED OF LOOKING
AT HIS ACNE FACE ALL HIS LIFE,
SO HE TAKE IT OFF WITH A KNIFE
GOD PRAY THERE BE
 NO ACNE
 IN HEAVEN
PERHAPS NOW HE'S FOUND HIS PEACE OF MIND.

Daniel Johnston

AWARENESS EXERCISE

This exercise is designed to help you become more aware of how everyday situations can needlessly make you a victim. First, study each situation. Next, prioritize the list by placing #1 in the square opposite the statement that is most likely to turn you into a victim, a #2 opposite the next most likely situation and so on. Please add your own "touchy" points at the bottom.

- ☐ Embarrassing yourself by becoming publically upset over slow service.
- ☐ Replaying a minor human relations mistake in your mind until you lose sleep over it.
- ☐ Refusing to apologize over a small human relations error.
- ☐ Holding a grudge over a simple mistake made by another person.
- ☐ Refusing to let another person apologize for being insensitive to you.
- ☐ Becoming furious over a bill that seems too large, or was sent in error.
- ☐ Over-committing to one co-worker at the expense of damaging good relationships with other team members.
- ☐ Getting frustrated with a computer or other device because it will not work properly for you.
- ☐ Becoming frustrated trying to fight the bureaucracy at "city hall."
- ☐ Allowing someone who doesn't follow-through to your expectations to increase your blood pressure.

OTHER SITUATIONS:
- ☐ _____
- ☐ _____
- ☐ _____

HOW LONG MUST I BEAR PAIN IN MY SOUL,
AND HAVE SORROW IN MY HEART ALL DAY?
PSALMS 13: 2-6

HOW LONG SHALL MY ENEMY BE EXALTED OVER ME?
CONSIDER AND ANSWER ME, OH LORD, MY GOD;
LIGHTEN MY EYES,
LEST I SLEEP THE SLEEP OF DEATH,
LEST MY ENEMY SAY, "I HAVE PREVAILED OVER HIM";
LEST MY FOES REJOICE BECAUSE I AM SHAKEN.
BUT I HAVE TRUSTED IN THY STEADFAST LOVE;
MY HEART SHALL REJOICE IN THY SALVATION.
I WILL SING TO THE LORD,
BECAUSE HE HAS DEALT BOUNTIFULLY WITH ME.

In Daniel's words

A HISTORY OF MYSELF

HISTORY IS THE WRITTEN WORD OF THE PAST OR PRESENT OR JUST WHAT HAPPENED & WHAT IS HAPPENING. THERE ARE MANY DIFFERENT KINDS OF HISTORY; THE HISTORY OF THE UNITED STATES, EUROPEAN HISTORY, THE HISTORY OF SCIENCE, OF MATHEMATICS, ART, ENGINERING, NAVY, etc... MANY THINGS HAVE BEEN WRITTEN ABOUT HISTORY BECAUSE MAN AS A WHOLE NEEDS ANSWERS TO HIS QUESTIONS & TO LEARN FROM THE PAST. WITHOUT HISTORY OR KNOWLEDGE OF THE PAST EACH GENERATION WOULD HAVE TO START FROM SCRATCH. FOR THIS AND MANY OTHER REASONS HISTORY IS THE BASIC FOUNDATION FROM WHICH EACH NEW GENERATION BUILDS UPON. WE WRITE THOUSANDS AND THOUSANDS OF BOOKS ON HISTORY EACH YEAR, WE CONSTANTLY TEACH AND STUDY HISTORY IN SCHOOLS & INSTI. HISTORY HAS STOOD THE TEST OF TIME MAINLY BECAUSE THAT IS JUST WHAT HISTORY IS: TIME! HISTORY HAS SEEN MEN COME AND GO, SEEN NATIONS RISE AND FALL, & NATURE REPEAT ITS CYCLES THRU-OUT CENTURIES. MY HISTORY BEGAN ABOUT 15 YEARS AGO IN A TOWN THAT AT THAT TIME WAS QUITE LARGE FOR ITS AGE. THIS TOWN WAS SACREMENTO AND IT STOOD ABOUT 100 MILES FROM THE CALIFORNIA SHORE. I DIDN'T QUITE UNDERSTAND WHAT WAS GOING ON JUST THEN BUT I SOON CAME TO REALIZE THAT I HAD 3 SISTERS & ONE BROTHER, ALL OF WHICH WERE EXTREMELY EXCITED ABOUT ME BEING AROUND. (AT 1st ANYWAY) BEFORE I KNEW I WAS 15 & HERE I AM!

LATER WE MOVED TO RARELY. THEN WE MOVED AGAIN
I GREW UP IN CHUGGINGHAM, UTAH, WHEN I WAS AROUND 4 OR MAYBE 5 & IT HAS BEEN HERE THAT WE HAVE LIVED UNTILL NOW. WHEN WE 1st ARRIVED THEY WAS NO OTHER KIDS AROUND IN THE NEIGHBOR-KIDS TO GOOF AROUND WITH. MY BROTHER & 3 SISTERS WERE ALL OFF TO SCHOOL EACH & EVERY DAY IT SEEMED & I WAS LEFT ALONE AT HOME WITH NOTHING ELSE TO DO BUT FIDDLE WITH MY TOYS & WATCH EXTREMLY BORING SOAP OPERAS. I WAS USED TO THE GOOD LIFE IN UTAH, WHERE I WAS ALWAYS SURROUNDED BY LOYAL CHUMS & BOSOM BUDDIES. IT WAS ONE BIG BLAST AFTER ANOTHER BACK THERE, & FOR THIS I SINCERELY MISS UTAH. FOR SOMETIME UNTILL SCHOOL STARTED, IT WAS NOT THE STATE I MISSED, NOR WAS IT THE TOWN, OR MY HOME, IT WAS THE PEOPLE. THE HOPE FOR A KID MY AGE (4) TO MOVE NEAR GREW MORE HOPELESS, & HOPELESS, UNTILL HOPE WAS ALMOST GONE, I WAS JUST A LITTLE KID & VERY VULABLE TO LONELINESS. MEANWHILE ALL THIS TIME, I HAD BEEN DOODLING ON THIS NOTE-TABLET MOM HAD BOUGHT (ANOTHER PROJECT SHE DEVISED) AND I WAS LEARNING OR BEGINNING TO UNDERSTAND THE ART OF SELF-ENTERTAINING. THERE WERE JUST THOUSANDS OF CHARACTERS, WEIRD CREATURES WAITING TO BE RELEASED FROM MY PENCIL. THERE WERE A THOUSAND ADVENTURES TO EXPLORE ON PAPER. IT WAS A WAY OF RELEASING TENSION AND IT KEPT ME BUSY UNTILL I FOUND SOME KIDS TO SPEND MY TIME WITH. WELL ANYWAY, WHAT I'M TRYING TO SAY IS THAT IF I HAPPEN TO CATCH ME SCRIBBLING IN YOUR ENGLISH CLASS; TAKE HEED! DONT GET UPSET OR RESENT MY PRESENCE. BE UNDERSTANDING. I'M ONLY ENTERTAINING MYSELF.

Daniel draws Laurie

A-Laurie-saved drawing

Discography

Albums

1981	*Songs of Pain*
1982	*Don't be scared*
1983	*The What of Whom*
1983	*More Songs of Pain*
1983	*Yip / Jump Music*
1983	*Hi, How Are You?*
1987	*The Lost Recordings*
1987	*The Lost Recordings II*
1984	*Retired Boxer*
1985	*Respect*
1985	*Continued Story*
1988	*Merry Christmas*
1989	*It's Spooky* w/ Jad Fair
1990	*Live at SXSW*
1990	*1990*
1991	*Artistic Vice*
1991	*Hi, How Are You? / Continued Story CD*
1992	*Frankenstein Love*
1994	*Fun*
1999	*Rejected Unknown*
1999	*Danny and the Nightmares*
1999	*Why Me?*
2000	*Live In Berlin*
2000	*Hyperjinx Tricycle* w/ Ron English, Jack Medicine
2001	*Lucky Sperms*
2001	*Rejected Unknown*
2001	*Please Don't Feed the Ego* (bootleg)
2002	*Oh Yea! B-Sides and Rarities* (bootleg)
2002	*Happy Heart*
2002	*Greetings from the Hyperjinx Tricycle (7")*
2003	*Fear Yourself*
2003	*Early Recordings Vol 1*
2003	*The End Is Near Again* (Danny and the Nightmares)
2003	*Alien Mind Control* Hyperjinx Tricycle (mini CD)
2004	*White Magic*
2005	*Freak Brain* (Danny and the Nightmares)
2006	*Welcome To My World* (greatist hits)
2006	*Lost and Found* [UK only]
2006	*The Electric Ghosts* w/ Jack Medicine

Singles

1988	"Casper The Friendly Ghost"
1990	"Speeding Motorcycle" with Yo La Tengo
1991	"The River of No Return"
1991	"Big Big World"
1991	"The making of an album with Jad Fair"
1992	"Laurie"
1994	"Happy Time"
1998	"Dream Scream"
2001	"Rejected Unknown: Impossible Love"
2001	"Natzi"
2002	"Sinning is Easy"
2002	"Greeting From the Hyperjinx Tricycle: Love Lost Love"
2002	"Mountain Top / Living It For The Moment"
2003	"Alien Mind Control"
2002	"Fish"

Compilations • Collaborations Songs

1985	*Woodshock '85*
1987	*A Texas Trip*
1989	*Mondostereo*
1989	*Life in Exile after Abdication*
1989	*Breath On The Living*
1990	*What Else Do You Do?*
1991	*Rutles Highway Revisited*
1991	*Flat Volume 1: The Art of Truncation*
1991	*The Cassette Mythos Audio Alchemy*
1991	*What?*
1992	*The Ruta 66 Album*
1993	*Chords of Fame*
1993	*They Came, They Played, They Blocked the Driveway*

Discography

1993	*Goobers: A Collection of Kids Songs*
1994	*Spew 7*
1994	*CMJ Compilation Certain Damage!*
1995	*School House Rock! Rocks*
1995	*Kristen's Best Shots*
1995	*So This Is Christmas: Alternative Christmas Hits*
1996	*Genius + Love = Yo La Tengo*
1998	*Ear Juice*
1998	*What Else Do You Do?*
1998	*POPaganda*
1998	*NxNW T/K Sampler*
1998	*KVRX Local Live Volume 3*
1999	*Revelations Book II*
2002	*Call It What You Want This Is Antifolk*
1999	*Cool Beans #10*
1999	*Santa Monika*
2000	*Songs in the Key of Z*
2000	*Everybody Wants to be Like Jed*
2001	*Cool Beans #14*
2002	*Humpty Dumpty LSD*
2005	*Counter Culture*
2005	*Go, Team!*
2006	*All Tomorrow's Parties 3.1*

Movies/Soundtracks

1994	*Return of the Texas Chainsaw Massacre* "Careless Soul"
1995	*Empire Records* "Rock n' Roll / Ega"
1995	"My So-Called Life" "Come See Me Tonight"
1995	*Kids* "Casper" "Casper the friendly Ghost"
1995	*Before Sunrise* "Living Life" (Kathy McCarty)
1996	*Schoolhouse Rock! Rocks* "Adjectives"
2003	*Alles Wie Immer* ("Same as always")
2004	*The Two Lucies* - Max Fierst "Walking the Cow"
2005	*Le Grand Bassin* "Funeral Girl"
2005	*The Devil and Daniel Johnston* Excerpts from a total of 30 pieces by Daniel
2005	"The O.C." (Fox TV series) "True Love Will Find You In The End" performed by Beck
2005	"The Mountain" (WB TV) "Living Life" (series canceled)

Special Collections

Daniel Johnston Archive Rarities
Volume 1-13
Compiled by Gavin and Silke

Tributes

1999	A Tribute to Daniel Johnston Volume 1-3 (7")
2004	*Discovered Covered The Late Great Daniel Johnston*
2006	*I Killed the Monster*

For more info about Daniel Johnston's music please visit:

www.hihowareyou.com

Gallery Listing

Solo Shows

March 16 - April 15, 2006
"The Story of An Artist -
a Daniel Johnston Retrospective"
Clementine Gallery
New York City, NY

September 4 - 23, 2005
"Excuse Me I'm Famous!"
Art's Factory
Paris, France

September 1 - 30, 2005
"Exposition Daniel Johnston"
Mediatheque Associative de
Musicopages
Toulouse, France

February 12 - March 13, 2005
"Last Night Daniel Johnston
Saved My Life"
Librairie/Bookshop "Le bleu
fouillis des mots"
Chateauroux, France

November 4 - December 3, 2003
Bookshop Florence Loewy
Paris, France

December 7, 2001 - January 13, 2002
"He's either on his way to
Heaven or Hell"
art&com
Brussels, Belgium

March 8, 2000
Lo and Behold Gallery
Austin, Texas

November 20, 1999 - Feb. 1, 2000
"The Good Fight"
The Night and Day Cafe
Manchester, England.

March 14 - April 7, 1999
"The Daniel Johnston Show"
Peninsula Gallery
Eindhoven, Netherlands

October 3 - October 18, 1998
Rampe 02
Berlin, Germany

October 9 - 19, 1991
Daniel's first one man show,
Kunsthaus, Oerlikon
Zurich, Switzerland

Group shows

March 2 - May 28, 2006
Whitney Biennial 2006:
"Day For Night"
Whitney Museum of American Art,
New York City

October 15 - December 17, 2005
"Le Jeune, le vivace et le bel
aujourd'hui", Maison Populaire Centre
d'art Mira Philaina
Montreuil (Paris), France

October 10 - 23, 2005
"Sidelines"
Flanders Film Festival
Ghent, Belgium

September 17 - October 15, 2005
Group show with Ron English and
Mark Mothersbaugh
Copro/Nason Gallery
Santa Monica, California

April 16 - July 2, 2005
"Le Jeune, le vivace et le bel
aujourd'hui"
Maison Populaire Centre d'art
Mira Philaina
Montreuil (Paris), France

Gallery Listing

April 15 - May 31, 2005
Inside-Outside Art Gallery
Cleveland, Ohio

March 16 - May 1, 2005
"Superheroes of the Subversive"
Daniel Johnston and Ron English
Escapist Artspace
Austin, Texas

January 27 - March 26, 2005
"Stranger Town"
Curated by Taylor McKimens
Dinter Fine Art, New York City

January 8 - April 2, 2005
"Le Jeune, le vivace et le bel aujourd'hui",
Maison Populaire Centre d'art
Mira Philaina
Montreuil (Paris), France

January 6 - February 5, 2005
R. Crumb et l'underground américain
Galerie Aline Vidal
Paris, France

October 14 - December 15, 2004
Ernst Huber Gallery
Frankfurt, Germany

August 20 and 21, 2004
Mud Pie Gallery
Norcross, Georgia

June 25 - October 3, 2004
ARC, Musée d'Art Moderne de la Villa de Paris
Paris, France

February 17 - March 5, 2004
"These Are a Few of Our Favorite Things"
Spitz Gallery
London, England

October 15 - December 15, 2003
"Cultura Basura"
Vitoria Centro Cultural
Montehermoso
Vitoria, Spain

September 14 - October 11, 2003
"American Outsider Artists"
Paris Arts Factory
Paris, France

September 2003
Long Night Museum
Munster, Germany

May 21 - August 31, 2003
"Cultura Basura"
C.C.C.B.
(Centro Cultura Contemporania de Barcelona)
Barcelona, Spain

April 13 - May 11, 2002
The Royal
Berlin, Germany

July 7th - July 30th, 2001
"The Art of Ron English and Daniel Johnston"
Zero One Gallery
7025 Melrose Av
Los Angeles, California

June 1st - June 29th, 2001
"Destroy All Monsters"
"The Art of Ron English and Daniel Johnston"
Space 1026
Philadelphia, Pennsylvania

November 4 - December 2, 2000
"Felt Tip"
Zwemmer's
London, England

Gallery Listing

May 27th, 2000
"The Art of Ron English and Daniel Johnston"
Zero One Gallery
7025 Melrose Ave
Los Angeles, California

May 18th, 2000 (one night only)
"The Art of Ron English and Daniel Johnston"
SubTonic
107 Norfolk St, NYC
Curated by Don Goede

June 18, 1999
"The Art of Daniel Johnston and Stephen Tomkins"
Ironwood Industries
Austin, Texas, USA

May 7th - May 30th, 1999
"Pop Art Surrealism Show"
Anthony Ausgang, Ron English, Daniel Johnston, Michael Reidy, Clark & Hogan
MOCA
(Museum of Contemporary Art)
1054 31st St. NW
Washington, DC

February 1st - 26th, 1999
Popaganda/Rejected II
"The Art of Ron English and Daniel Johnston"
CBGB's Gallery,
313 Bowery St., NYC
Curated by Jonathan LeVine

April 25 - June 6, 1998
Daniel Johnston, Jad Fair and Jutta Brandt
Artefakt Galerie
Mulheim-Ruhr, Germany

March 27 - May 15, 1998
De Leia Contemporary/Cultural Machine Complex
Cincinnati, Ohio

April 1 - May 5, 1994
"Artists of Vision and Purpose"
Carleton Art Gallery
Northfield, Minnesota

April 18 - May 20, 1990
"Frontier Tales"
L.A.C.E.
(Los Angeles Contemporary Exhibits)
Los Angeles, California

For more info about Daniel Johnston's art please visit:

www.hihowareyou.com

For more information on Daniel Johnston:

Rent the Sony Classics documentary
The Devil and Daniel Johnston
Directed by Jeff Feuerzeig

For the art and music of Daniel Johnston please visit the family run websites:

www.rejectedunknown.com
www.hihowareyou.com

For a introduction to the music of Daniel Johnston we recommend:

Welcome to My World
The Music of Daniel Johnston

GOOD BYE
LIFE
HELLO FAME

Daniel Johnston

Don Goede, Tarssa Yazdani, & Daniel Johnston, 1999

Tarssa Yazdani is a writer and editor who focuses on art, music, and popular culture. She lives in New Jersey with her husband, artist Ron English, and their two children.

Don Goede is one of the original founders of New York's Soft Skull Press. Since his adventures with Daniel Johnston he has relocated to Colorado from Brooklyn where he has started a multi-media company with Kat Tudor called Smokemuse. He resides in Manitou Springs with his wife Jeana, and his two sons Sawyer and Maximus.
e-mail: don.goede@smokemuse.com